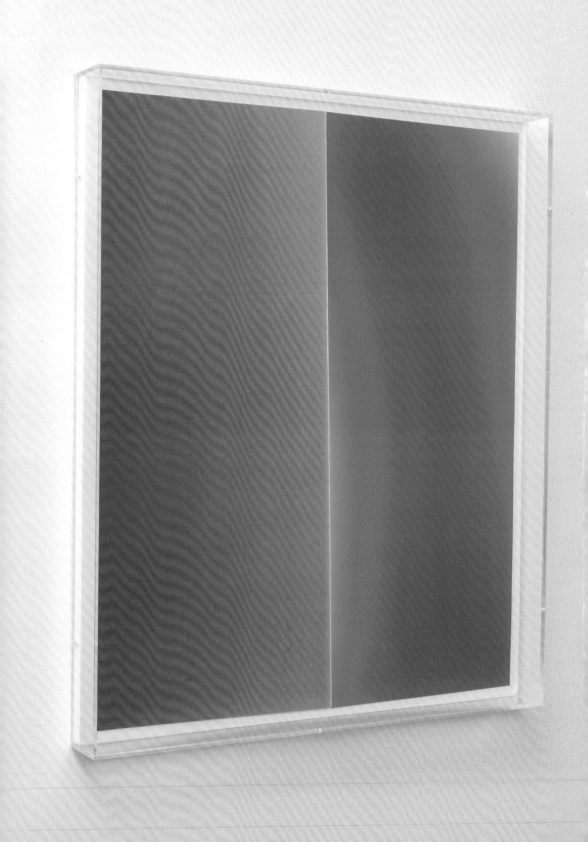

Wolfgang Tillmans 2017

edited by
Chris Dercon and Helen Sainsbury
with Wolfgang Tillmans

contributions by
Mark Godfrey
Tom Holert

TATE PUBLISHING

Contents

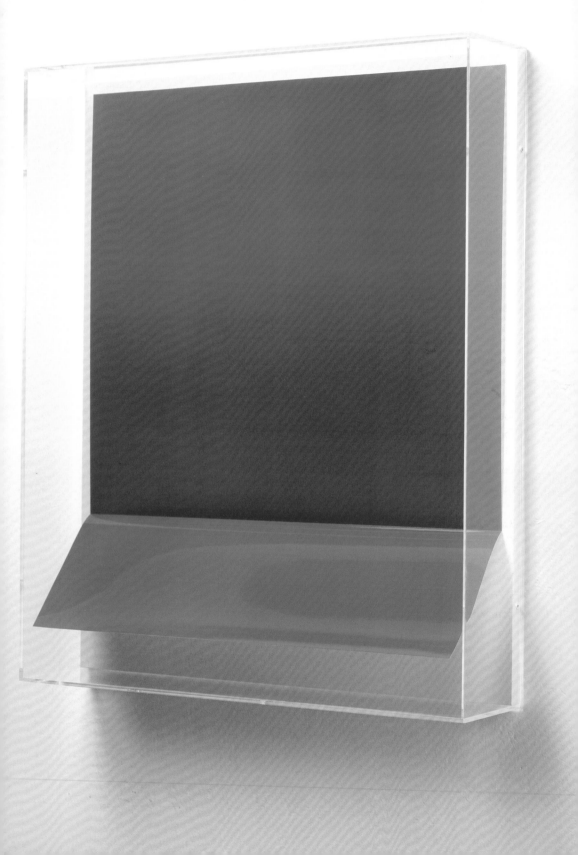

Sponsor's foreword

Hyundai Card is delighted to sponsor Tate Modern's major exhibition of the work of pioneering artist Wolfgang Tillmans.

This exhibition will explore how Tillmans's work responds to the world around us. Conceived in close collaboration with the artist, this unique installation will offer a rare opportunity for visitors to see the true breadth of his practice, bringing together his work in various fields, including photography, video, music and printed matter. We hope that visitors will be engaged and their curiosities kindled by the dynamic and boundary-pushing work of this important artist.

As Korea's leading issuer of premium credit cards, Hyundai Card is committed to broadening public understanding of the effect that contemporary art and design have on our lives. Whether we're exhibiting tomorrow's leading artists at our art spaces, building libraries on music, design and travel, or designing credit cards as beautiful as they are functional, our most inventive endeavours all draw from the creative well that the arts provide.

We are proud to present this exhibition as part of a three-year commitment to Tate Modern's expanding exploration of photography.

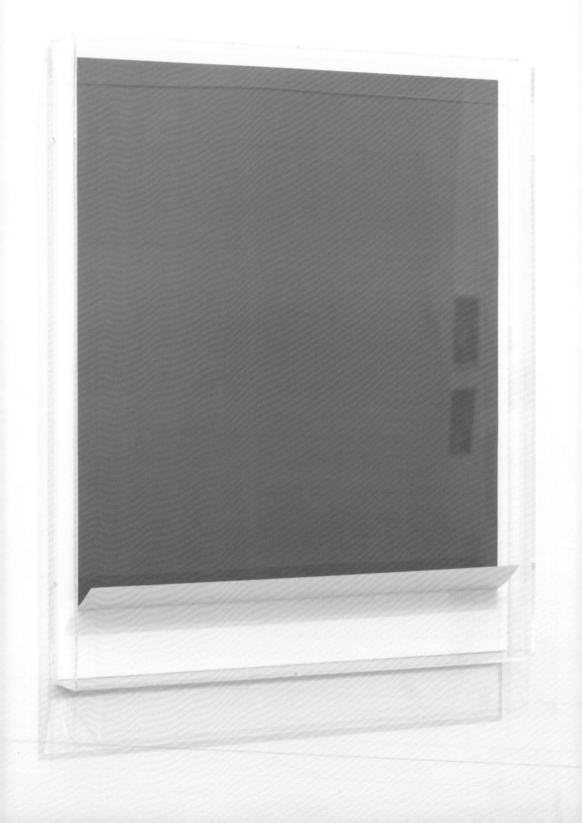

Director's foreword
Frances Morris

If you type the name Wolfgang Tillmans into any search engine you will quickly see how impossible it would be to make an exhibition of his work in 2017 without representing the multi-faceted nature of his practice. You might come across the opening of a new exhibition, the release of an EP of his own music or a poster campaign on an issue that concerns him. Driven by an enduring interest in who we are and how we interface with the wider world, not to mention a healthy resistance to being categorised, Tillmans continues to push the boundaries of what it means to be an artist today.

Tillmans is well known for his striking photographic images and his innovative methods of display, as well as his sublime abstract works, made without a camera by manipulating light directly on photographic paper. His work also encompasses mass-produced printed matter such as artist's books and specially commissioned layouts for newspapers and magazines. Between Bridges, an experimental gallery space that he opened in London in 2006 and has since transferred to Berlin, provides a platform for exhibitions and events. His work in video has been seen in exhibitions and screenings, and a recent project included an architectural intervention. More recently he has begun to make his own music following a hiatus of over twenty years. It is small wonder that when Chris Dercon conceived the idea for the exhibition during his tenure as Director of Tate Modern, he was keen to show the true breadth of Tillmans's extended practice.

Wolfgang Tillmans has also played multiple roles within Tate's recent history. In 2000 he became both the first non-British artist and the first working primarily with photography to win the Turner Prize. His 2003 show at Tate Britain, *if one thing matters, everything matters*, consolidated his reputation as one of the most exciting of exhibition makers. He went on to become one of Tate's Artist Trustees, where he was greatly valued for his knowledge, insight and passion for making art accessible to all. We are especially pleased to stage this exhibition in the newly expanded Tate Modern, the creation of which would not have been possible without the courage and commitment of Trustees past and present.

We would like to thank the curators of this important exhibition, Chris Dercon, Director of the Volksbühne Berlin, and Helen Sainsbury, Head of Programme Realisation at Tate Modern. They have been ably assisted by Emma Lewis, Assistant Curator, and Travis Miles, Exhibitions Registrar. The realisation of the exhibition would not have been possible without the encouragement and guidance of Achim Borchardt-Hume, Director of Exhibitions, and Nicholas Serota, Director, Tate. In the curatorial team, Rachel Kent, Programme Manager, Phil Monk, Installation Manager, and Judith Bowdler, Production Manager, have provided invaluable senior support. Thanks are also due to Aïcha Mehrez, Nick Dawe, Justina Budd, Neil Casey and Stephanie Busson.

We are grateful to the exhibition sponsor, Hyundai Card, for enabling us not only to showcase the remarkable achievements of Tillmans in the field of photography but also to demonstrate the sheer diversity of his practice. This exhibition marks the second in a three-year partnership with Hyundai Card to support acquisitions and exhibitions of photography, and we are extremely thankful for their ongoing commitment to Tate.

We are also very grateful to Tate International Council and Tate Patrons for their generous support, which has helped to make this exhibition possible. The catalogue is edited by Chris Dercon and Helen Sainsbury in close collaboration with the artist and is designed by Tillmans himself. We would like to thank Mark Godfrey and Tom Holert for leading us on two very different journeys through key aspects of Tillmans's work, aided and abetted by the editorial skills of Tas Skorupa and Nicola Bion, Project Editor, along with Bill Jones, Production Manager. All works are reproduced courtesy of the artist, Maureen Paley, London; Galerie Buchholz, Berlin; and David Zwirner, New York.

This exhibition and publication could not have been realised without the remarkable efforts of all at Studio Wolfgang Tillmans in Berlin and London, in particular Michael Amstad, Maria Bierwirth, Sarah Bohn, Federico Gargalione, Konstantin Gebser, Armin Lorenz Gerold, Lisa Herfeldt, Paul Hutchinson, Dan Ipp, Samuel Jeffery, Annett Kottek, Evelyn Marwehe, Marilyn Meerschiff and Shahin Zarinbal. Thanks also to Anders Clausen,

Previous pages:
Lighter, orange blue I, 2011

Lighter, yellow up I, 2010

Lighter, green IV, 2010

Lighter, blue up IX, 2013

Juan Pablo Echeverri and Federico Martelli for helping us to shape the installation. Further invaluable advice and support has been provided by Maureen Paley, Oliver Evans and Simona Zemaityte at Maureen Paley, London, as well as Lena Zimmermann at Galerie Buchholz, Berlin.

We are especially grateful to the artist and Sprengel Museum Hannover for their loans to the exhibition. Thanks too to Kamal Ackarie for his advice and input into the programme of live events and Sam Strang at 4AD Records for his support. We are very grateful to Bowers & Wilkins for providing the audio realisation of Tillmans's *Playback Room*.

The exhibition has been made possible by the provision of insurance through the Government Indemnity Scheme. Tate Modern would like to thank HM Government for providing Government Indemnity and the Department for Culture, Media and Sport and Arts Council England for arranging the indemnity.

No exhibition can be realised without the combined efforts of teams across Tate, for which we are very grateful. Appreciation goes to our colleagues in Tate Learning, especially Simon Bolitho, Minnie Scott, Joseph Kendra and Emily Stone, and to colleagues in the Conservation team, especially Sophie Sarkodie, Carla Flack, Jack McConchie and Francesca Colussi, likewise Gerry Moore for his technical support. Development colleagues Alice Crockett and Charlotte Reeves were instrumental in securing support for the exhibition. The show will be communicated through the combined efforts of many including Rob Baker, Elli Cartwright and Livia Ratcliffe in Marketing, Nicholas Bennett in Design, Sofie Roberts and Maria Kennedy in Digital Programmes, Cecily Carbone in the Press Office and Hannah Morgan in External Relations. Thanks also to the very many colleagues in Visitor Experience, Operations and Estates who enable us to present the exhibition to our visitors.

Finally, we would like to emphasise our deep gratitude to Wolfgang Tillmans himself for not only accepting our invitation to make an exhibition but also for extending this commitment to include the stunning design of this catalogue and the creation of a rich programme of live events to amplify and enrich the experience of our visitors. It has been our great pleasure to work with him and to present this groundbreaking exhibition.

Lighter, black V, 2009; Lighter, black concave
III, 2009; Lighter 76, 2008 and Lighter,
white convex I, 2009 in *Fare Mondi –
Making Worlds*, 53rd Venice Biennale, 2009

Mark Godfrey
Worldview

Prelude

In 2012, Wolfgang Tillmans spoke to Michelle Kuo, editor of *Artforum*, to discuss inkjet printing and the way this technology was being used by artists who considered their works to be 'paintings' and by others who professed to creating 'photographs'. Noting that many 'paintings' and 'photographs' made and sold today are materially and technically identical, Tillmans said the hierarchies that still exist around the mediums made no sense to him. This was not the most compelling part of their discussion, though. Addressing new photographs Tillmans had made especially for the article that showed fragments of various artworks by David Hockney, Seth Price and Tillmans himself, Kuo asked why he had focused on 'the edges and corners'. 'Because that's really where the picture begins and ends, where it meets the real world around it', Tillmans replied. 'It is a crucial point – where the reality of the body of the work, so to speak, manifests itself.'[1]

This little remark reveals a surprising amount about Tillmans's thinking. Importantly, Tillmans's language shows that he thinks through analogies: one thing is like another; in this case, a photograph is like a body.[2] This sense of things sharing properties with other things rather than being distinct is the philosophical beginning point of an empathetic understanding of the world.[3] Tillmans's words also show that for him, the artwork is not only very material, but something with a body that will be most exposed at its limits – its corners and edges. 'I think of a sheet of photographic paper as an extension in and of itself, and as an object', he has written elsewhere. 'This has always been my basic understanding of what photographs are; I never thought of a picture as being bodyless.'[4] As a body, the photograph is vulnerable to knocks, tears, creases and to fading. The artwork is also a body entangled in the world. It does not just exist passively – it is a sociable and open body that actively '*meets* the real world around it.' These ideas can serve as a very useful entry point to Tillmans's worldview, which, as I hope to show, is expressed by every aspect of his practice.

Paper

From my first encounters with Tillmans's installations to my most recent visits to his exhibitions, what I have always experienced most vividly first of all is a powerful sense of materiality. Of course, there are always plenty of images, but before I take them in, I see different 'bodies': massive, naked inkjet prints attached to the walls with bulldog clips, bowing slightly along their edges; enlarged photographs of photocopies; magazine pages; printed sheets under glass on wooden tables; small pharmacy-shop-type prints stuck onto the wall with Scotch tape; monochromes mounted onto aluminium and framed; and, in his *Lighter* series, crumpled or folded C-type prints encased in deep Plexiglas frames. (Note that there are no pins; Tillmans refrains from using them because of his reluctance to pierce the body of the photograph. Nor does he paste photographs to walls: they could not be removed intact.) If, for a moment, I became immune to all these papers, fixtures and frames, his pictures focus attention back onto materials. There are the *paper drops*, for instance, showing

paper drop (London) II, 2011

elegant curves of photographic paper, curled into drop-like tubes that catch and reflect the light off their glossy surfaces; or photographs of toner cartridges, stacks of wrapped books and disassembled printers. Quite recently, a new photograph, *Studio*, 2012, seemed to be an abstract pattern of white lines on a black surface. In fact, it showed lengths of Scotch tape stuck to black trousers, probably unused after a day's work testing out an exhibition. Materiality is palpable, then, and made visible, but what is crucial is that it is always connected both to a sense of vulnerability *and* to a radical and optimistic idea of openness. It is not necessary to understand the specific chemical make-up of each print type to sense that Tillmans's pictures, like most works on paper, will inevitably fade: this is also part of the artist's ethos. 'Impermanence is actually part of the work. I know that they will deteriorate, but there is nothing I can do about it.'[5] Even the introduction around 2000 of painted white wooden frames and glazing for some photographs in his installations served to emphasise rather than to detract from this sense of materiality by drawing attention to the lack of such protection around other photographs. These frames also did nothing to diminish the material sense of openness because everywhere on a wall – whether they are taped down or curling from their bulldog clips – his photographs' edges are exposed. This means not only that they seem more open to the environment; they are also open to other images around them. 'Meeting the world' can refer to the way they share the space of the wall with their neighbours and come together to create transient gatherings. It can also refer to the way they meet us, their viewers, sharing a space with us as they do.[6]

Before asking *why* Tillmans links photographic materiality to ideas of vulnerability and openness, it's useful to bring into the discussion two other family groups of Tillmans's photographs, because they are also images of skins and surfaces, and they play a connected role in this aspect of his thinking. First, there are the images of fruits and fruit skins, sometimes darkening on tabletops and windowsills.[7] The fruit skins are not just studies of textures and colours but remind us of the pleasures of consuming and of inevitable processes of decay.[8] Second, there is the *Faltenwurf* series, photographs of crumpled clothes, trousers hung over banisters, socks and sports shorts over radiators and related images like the white semen-stained T-shirt. These images are sometimes sculptural stand-ins for the body, and often suggest the prelude to or aftermath of moments of intimacy. With the *Faltenwurf* series, Tillmans adds his own images to the rich art-historical tradition of pictures linking folded drapery and clothing to desire, but as with the fruit skins, he also creates analogies for photography, just as photographs are analogies for bodies. The two series show surfaces that have properties Tillmans feels are shared with photographs: like fruit skins, photographs discolour and grow brittle; just as a cast-off T-shirt is a layer peeled off when one body opens up to another, the photograph is open and exposed to other bodies.

What context would account for this linkage in Tillmans's worldview between photographic materiality and the twinned concepts of vulnerability and openness? One explanatory route would be to recall the dominant mode of photography around the time of Tillmans's emergence in the late 1980s. In Andreas Gursky's exhibitions, for instance, each large-scale print was self-contained in its own frame, self-confident in its physical robustness. Rather than seeking to meet the world, each photograph created its own often artificially perfect, closed world for a viewer to peer into. The same could be said for Jeff Wall's and Paul Graham's works, but whether constructed or documentary, Studio, 2012

Installation view of *Studio*, Galerie Buchholz, Berlin, 2016

The Blue Oyster Bar, Saint Petersburg,
2014; outside The Blue Oyster Bar, a
and b, 2014 and Greifbar 40 (Tangible
40), 2015 in *Wolfgang Tillmans*, Regen
Projects, Los Angeles, 2016

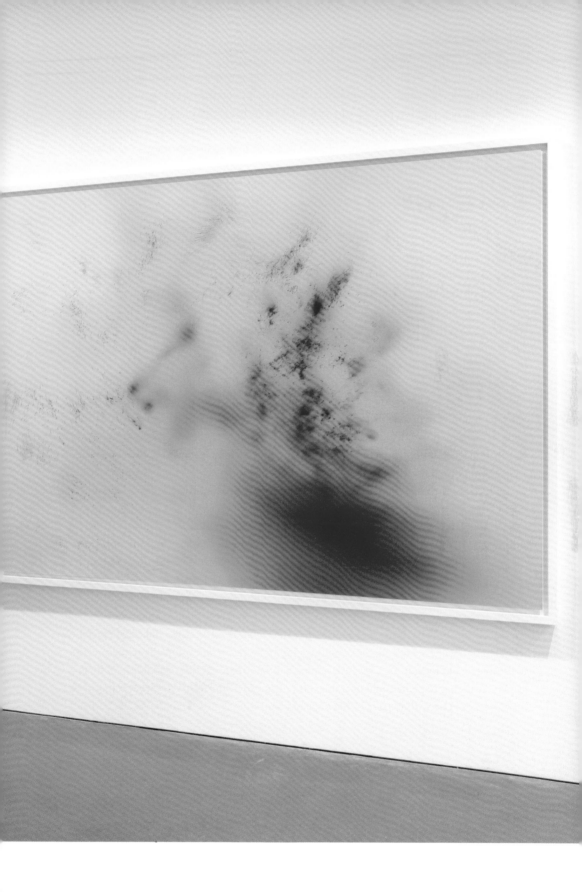

usually their 1980s worlds were imperfect. Materially speaking, Tillmans's approach could not be more distinct from that of these three artists. But it would be misleading to argue that Tillmans developed his position merely as a reaction to prevailing trends and as a way of distancing himself from the Düsseldorf School and other large-scale photographic work. Indeed, Tillmans does not think this way at all: perhaps – as a consequence of *not* studying at a famous art school – he neither occupies himself with forging his way through generational struggles nor with making knowing references to predecessors.

Towards the end of *Burg*, Tillmans's second Taschen book, we see two members of the 'image-families' I mentioned just now: a still life showing cherries and scooped-out grapefruit halves, single red and white roses resting beside them, and two pages later, a wrinkled T-shirt cast off on the floor. Between the fruit and the T-shirt is one of Tillmans's most poignant images, and again it is about skins: it shows him holding the hand of his partner, Jochen Klein, across the sheets of a hospital bed, hours before Klein's death. I think this sequence provides the answer to the question I have been posing: Tillmans's linkage of materiality, vulnerability and openness has to be understood in connection to his experience of the AIDS crisis. From the very moment of his sexual awakening, Tillmans had 'an acute awareness that this disease, AIDS, affects me.'[9] Vulnerability was a condition of living and loving; there has never been intimacy without the worry of infection; there have been moments of great personal loss. Experiencing life in this way, it comes as no surprise that Tillmans thinks about vulnerability, and that for him the photographic object is understood to be susceptible to risks just like a body. I am not arguing that Tillmans ever tried consciously to find a material way to reflect upon or analogise the AIDS crisis as, for instance, General Idea did when they appropriated Robert Indiana's *LOVE* design and spread it like a virus (Tillmans photographed one of their sculptures); but rather that as soon as he started working with cameras, paper and images, no approach to the photographic object was possible, nor credible, than for it to have the kind of impermanence that he felt that life had, too.

Openness and a kind of insistent *joie de vivre* is the flipside to vulnerability. Living in the shadow of AIDS (and deciding not to despair, not to lock oneself away from the world), at the very same time that all relationships appear desperately fragile, so they become that much more urgent because they are precarious. Opening oneself up to the world, trying to connect to people, and enabling photographs to share space with other photographs and with other people in the way he does – all this takes on a new kind of necessity and meaning, even with all the risk of pain and loss. It has been argued that Felix Gonzalez-Torres also linked vulnerability to a kind of openness, creating the conditions for his works to be continually reinterpreted, redistributed and remade after he died, hoping and knowing that they would live on in an active way even though he could not; this was one model Tillmans had for what it meant to make work infused with hope (and the hope of connecting to others) in the face of despair.[10]

People

Tillmans sees his photographs as bodies meeting other bodies – we should take this thinking through analogies very seriously – but in terms of their images, they also frequently show actual people, from carefully made, one-off portraits of architects, artists, musicians, models and family members,

grey jeans over stair post, 1991

Für immer Burgen (Forever Fortresses), 1997

Milkspritz, 1992

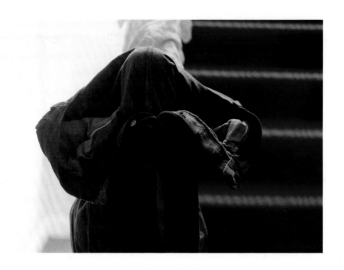

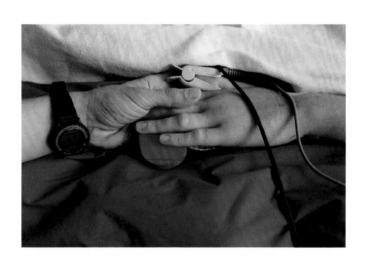

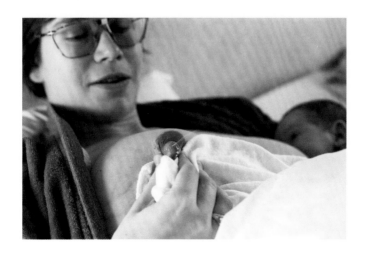

often shot in studios or on set-up sessions; to images of particular friends and lovers taken over periods of months or years in all kinds of conditions; to scenes of club nights, casual sex partners, parties, park life, carnivals; to people on protest marches; to strangers in streets and markets. Tillmans is interested in social life in its broadest meaning: our participation in a society. In Tillmans's images, people are doing pretty much everything people do: working, shopping, fooling around, having sex, sleeping, bathing, dressing up, partying, campaigning … There is no impetus to follow in August Sander's footsteps and to classify, but it is similarly encyclopaedic of what life involves. The ideas of vulnerability and openness are also linked in this body of his work.

In fact, the word 'vulnerability' occurs frequently in Tillmans's own accounts of making portraits:

> It's so embarrassing to approach someone and say you want to look at them. But without risk-taking, nothing can happen, so I have to make myself vulnerable. What I think is the unifying aspect in people that I like is that they have a sense of their own vulnerability, and I respond to that.[11]

Elsewhere he insists, 'The actual dynamics of vulnerability and exposure and embarrassment and honesty do not change, ever.' Though Tillmans's earliest published images did not always capture this dynamic (many subjects seemed too intent on scowling or posing as in any other photo shoot), the most compelling images did, such as the portrait of Michael Stipe from 1997, where one can really sense the awkwardness of the 'portrait encounter'. In this image, as with most that have followed, one has a strong sense of what is at stake when someone lays themselves open to scrutiny.

Openness is there too, and what this refers to is Tillmans's preparedness to photograph all kinds of individuals and communities. He has always been very honest about his openness even though he suspects that others will be scornful of what could seem like a positivist streak in his thinking:

> I think, corny as this sounds, I need to love, respect, or in some way embrace all the people that I photograph … The bottom line is that I genuinely love people. I think they are incredibly tender beings, so in a way I portray people as untouchable. For a person to communicate this basic fragility and insecurity to me, as I do to him or her, is the foundation of most of my pictures.[12]

The dynamic of vulnerability and openness that structures Tillmans's approach to photographing people relates to the inclusiveness of his worldview. Tillmans not only welcomes all sorts of people before his camera lens: his work welcomes all kinds of viewers. When I look at his pictures of people from my viewpoint as a white, straight, middle-class male a few years younger than the artist, I never feel excluded from them even though they sometimes show communities with whom I have no links. Instead, I think back to my own friends and experiences. Maybe because so many of Tillmans's subjects feel vulnerable, or maybe because there are so many kinds of people, there is this sense of inclusion rather than of exclusivity, which is what I often sense when I look at more autobiographical photographs by other artists Tillmans admires, such as Nan Goldin. Certainly, like Goldin and others, Tillmans has

Morrissey, 2003

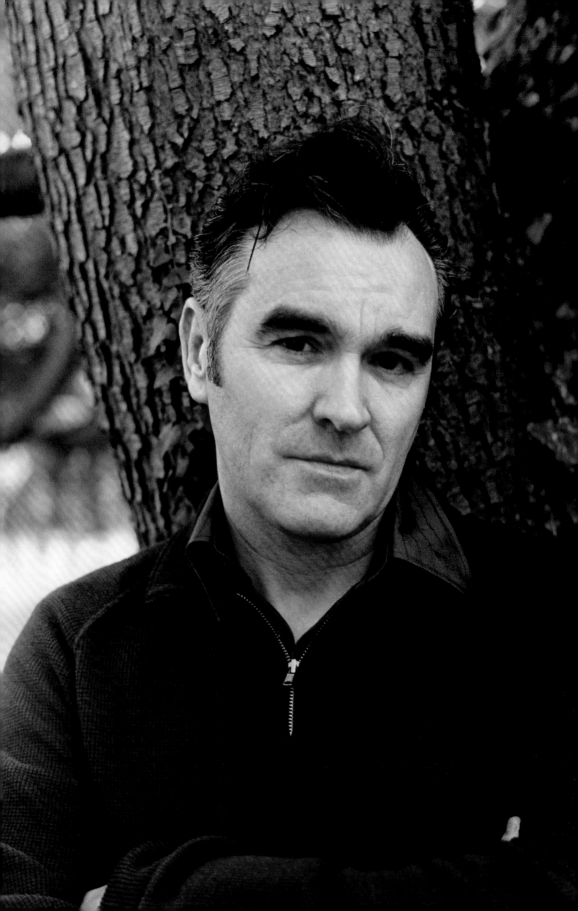

been interested in documenting people who chose to live a life that resists bourgeois norms:

> I was always interested in the free, or at least non-branded, activities that functioned outside control and marketing. Those pockets of self-organization – free partying, free sex, free leisure time – are on the retreat. A less commercial spirit of togetherness is worth defending against the market realities, which are the result of the implementation of an atomized, privatized model of society.[13]

But the point I am making is that the images also welcome viewers who live a life more ordinary. When asked about the inclusiveness and welcome of his work, Tillmans described an early ambition:

> In my head, I was always cooking up a new brew, which I dreamed of: a fusion of my Lutheran church-inspired, grass-roots, egalitarian, soft, all-inclusive Christianity, [and] Italo-disco, gay clubs, wild dressing up and inner city cool.[14]

Without wanting to be overly biographical, I think it is important to state that this dream was only possible because Tillmans was in the first generation of gay artists who could come out at a time when there was acceptance for his sexuality by those in his immediate environment. As such there was never a pressing need to outright reject the values of his family and of the wider institutions – educational, political, religious – that surrounded him, but instead a desire to update and improve them. At times his work contains monuments to this grounding, such as his 1994 portrait of his mother: back straight, collars pressed, smiling, rooted between branches of a fir tree.[15] The deep humanism at the heart of Tillmans's thinking, inherited from what he sees as a kind of socialism at the heart of Judeo-Christian ethics, is quite distinct from the outlook of many other artists whose work he may have admired, who worked from a position of exclusion (for instance, David Wojnarowicz[16]) or whose intellectual outlook was formed in MFA programmes where an intake of post-structuralist theory led them to embark on artworks that encapsulated a critique of the values and structures that underlie Western male heterosexual subjectivity. Tillmans's humanism and desire to connect to people could seem a more traditional starting place for an art practice, but the openness that this humanism enables has been put to very important projects.[17]

Thinking about Tillmans's outlook, I realise why his images of drug-driven dancing and sex never seem sensationalist. To record people and social life in photographs will mean celebrating long-standing friendships; it will mean appreciating professional colleagues (for instance, the wonderful recent photograph of Tacita Dean in a shaft of sunlight); but it will also involve making pictures of clubbing and partying, getting a blow job or producing an intimate study of a lover's naked body (*nackt, 2*, 2014). ('I wanted to see sex as this normal part of life and not as being an extraordinary part', he told Julia Peyton-Jones and Hans Ulrich Obrist.[18]) Tillmans's photographs of clubbing and sex sometimes occupy the same space as images of protestors on political marches, but they are not a frivolous counterpoint to them. Many artists who have concerned themselves with protest movements have no room within their oeuvre for

Alex, 1997

Mami, 1994

Anders on train, 2011

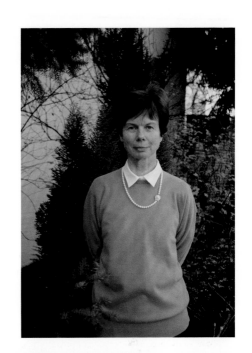
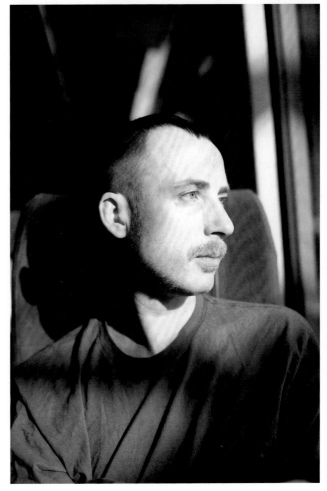

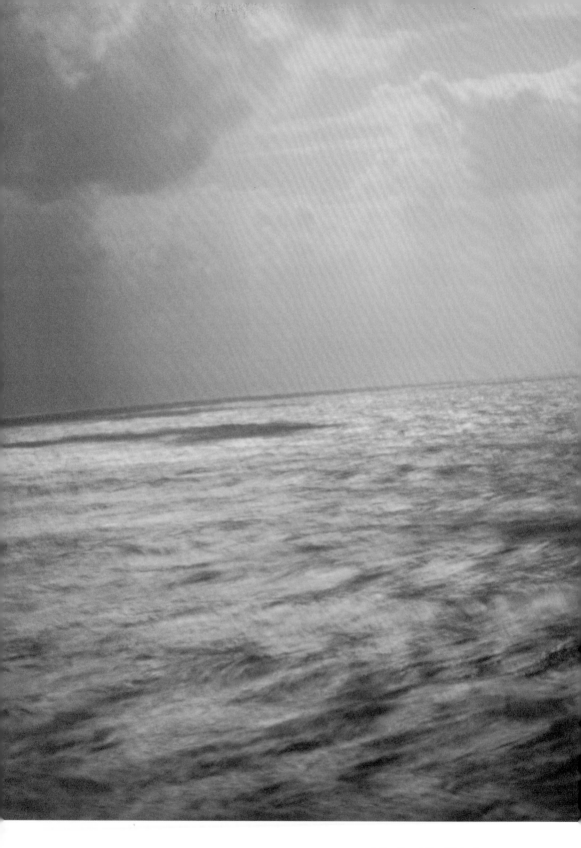

Italian Coastal Guard Flying Rescue
Mission off Lampedusa, 2008

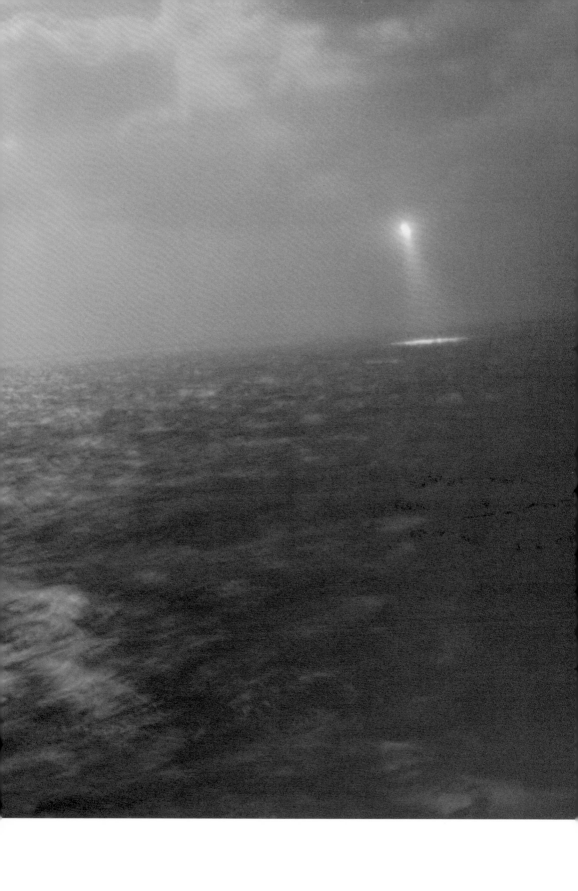

pleasure just as some artists who concentrate on sex do not really document protest. Tillmans insists such images should live together. After all, are not so many of the protestors hoping eventually for a world where people are free and economically secure enough to express and enjoy themselves as they wish? And in sex, and clubbing, do we not experience moments when discreet subjectivity (the driving force of competition) blends into being-with-others, when singular viewpoints melt away?

Another outcome of Tillmans's humanism is his rejection of the prohibitions that earlier generations of artists placed on photographing strangers without their permission, particularly those from cultures other than the artist's own. This was a position promoted by figures such as Martha Rosler and Allan Sekula looking critically at the use of photography in anthropology, documentary photography, photojournalism and other practices, and who felt that too often, photographers objectified and exoticised those of 'other' cultures. Fully aware of their critique, and defending his preparedness, particularly in his *Neue Welt* project, to make non-sensationalist photographs of market traders in Ethiopia, a man washing his body from a bucket on the street in India or a group of friends crouching to play a checkerboard game on a hot Shanghai night, Tillmans claims 'I think the unobserved photographing of people in their everyday life can contribute to a more empathetic understanding of the world.'[19]

Platforms

This discussion of materiality and of how Tillmans represents social life leads into the broader question of where politics resides in his work, and though it may only be quite recently that Tillmans has launched overt campaigns (for instance, about the UK's EU referendum, which I will come to later), his political impulse has run through his work from its outset. A quick list of Tillmans's 'political' images could include the photograph first published in *The Big Issue* of a homeless man sleeping on the pavement adjacent to pyramidal bumps designed by planners to prevent rough sleeping; the image in *Neue Welt* of an Italian border helicopter shining a beam into the Mediterranean to locate a boatload of migrants; Dimitry and Ivan, proudly embracing despite all they face as a gay couple in Putin's Russia; and protestors on a Black Lives Matter march. However, rather than number the crises and campaigns Tillmans has tried to amplify in his practice, we might do better by asking how Tillmans has approached the idea of *platforms*. What can be the carrier of a message, how can ideas be distributed, and how can a platform create the space for meaning or indeed for not knowing? He is certainly aware and critical of the ways that the establishment distributes ideas – for instance, he has sometimes reproduced copies of the letter he wrote in 2002 to the Chief Executive of British Airways (see page 203) to ask why it was that only the *Daily Mail* was freely circulated to passengers, seeing this was an insidious promotion of a xenophobic and homophobic worldview.[20] So how to create counter-platforms?

Tillmans's attempts began with his work for *i-D* magazine, a phase of his career dismissed by some early critics as mere fashion work. But Tillmans gravitated to *i-D* because it was a magazine devoted to self-definition, to a non-hierarchical approach to fashion in which one's own home-made clothes could be worn with thrift-store bargains and luxury brands, and from the very beginning, he approached his assignments for the magazine inspired by artists such as Barbara Kruger and Jenny Holzer and the way

Lutz & Alex sitting in the trees, 1992

Fuck Men, 1992

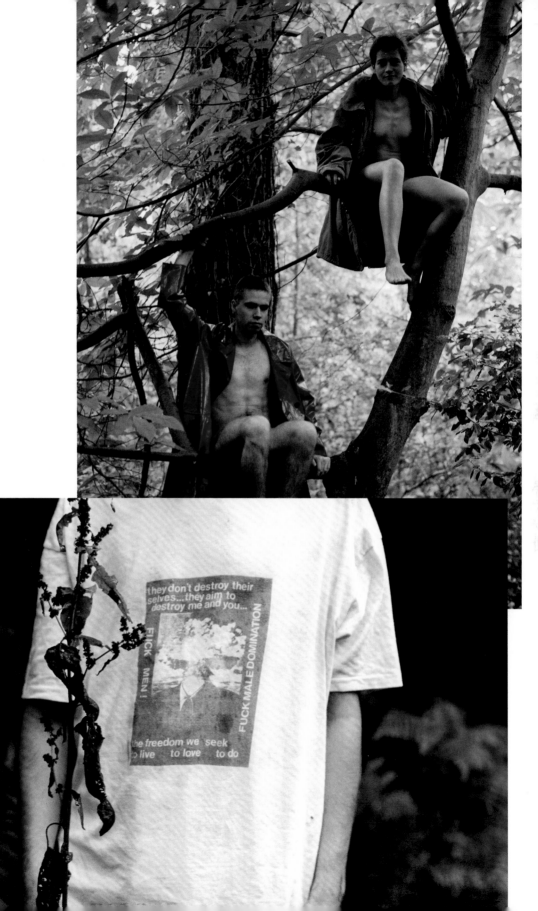

they combined texts and images, inserting ideas into different contexts. One of his most famous *i-D* stories 'Like Brother Like Sister', published on 10 November 1992, includes the now-iconic image of Alex and Lutz up a tree, but it begins with a close-up of a T-shirt. He had this garment especially printed for the photo shoot, and it bears the slogan 'FUCK MALE DOMINATION'. Evidently, Tillmans was inserting a text into a photograph itself carried on the platform of a magazine and thinking how a mass medium could distribute this slogan.

With more recognition and opportunities, Tillmans was able to use and indeed create different platforms; in his mind this became his responsibility as an increasingly public figure. One was the exhibition catalogue, and with his first opportunity, for the Kunsthalle Zürich in 1995, he created a book in which black-and-white images of his photographs intersected with copies of handwritten or printed texts, photocopies of book pages and newspaper articles. The effect was to create jarring juxtapositions bringing the more radical aspirations of the 1990s into confrontation with reactionary realities: for instance, 'Wer Liebe Wagt Lebt Morgen' [Who dares to love lives tomorrow] opposite a New York *Daily News* cover celebrating the return of the death penalty. Tillmans has continued to use books to distribute images and ideas: for instance, *Why we must provide HIV treatment information*, created specifically to inform and educate individuals, doctors and health workers, which combined portraits taken in clinics and conferences with clearly designed short texts; the book was freely distributed by organisations such as the Treatment Action Campaign in South Africa.

Tillmans's platforms have included billboards, book spines, exhibition titles, newspaper inserts, supplements, magazines, posters and records (his EP *2016/1986* included a track whose lyric is 'What we do here is a crime in most countries; but it's not. There is no victim. Leave us alone'). Sometimes he uses a platform anonymously as in his recent billboard project in Mexico City where a twisted cactus appears with the question '¿dónde estamos?'; other times he will very much leverage his position as a respected artist to access space in magazines, as when he published interviews with members of the LGBTQ community in Russia in *i-D* in 2015. Another platform is his space Between Bridges, first opened in London in 2006 and later in Berlin, where he shows other artists whose ideas he wants to share; the programme began with Wojnarowicz and today hosts as many seminars and lectures as it does art exhibitions. But the most often employed of Tillmans's platforms continues to be the gallery installation, and he finds as much potential in a free-to-enter 'private' gallery space as in a ticketed museum. Tillmans's worldview is expressed in different ways in these installations. In the most literal sense, they give an impression of how he actually looks at his environment, taking notice of objects, landscapes, textures below, above and around him, noticing people and things near and far. In another sense his installations express his worldview because they are temporary public spaces where Tillmans can devote room to images of causes he wishes to amplify. But most importantly, the installations express his worldview through their non-hierarchical organisation.[21]

I have already discussed a non-hierarchical approach to materials and the way framed C-prints, inkjet prints, magazine pages and photocopies co-exist alongside each other. Tillmans will also use all the parts of the room – hanging photographs right into a corner, above a doorframe, or by an entrance – making

Dimitry & Ivan, St. Petersburg, 2014

Protest, Houston Street, a, 2014

Spread from *Wolfgang Tillmans* (exh. cat.), Kunsthalle Zürich, 1995

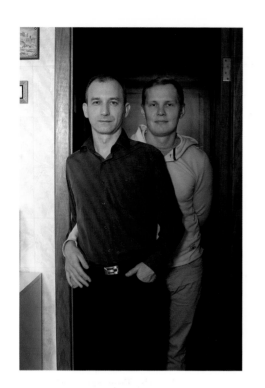
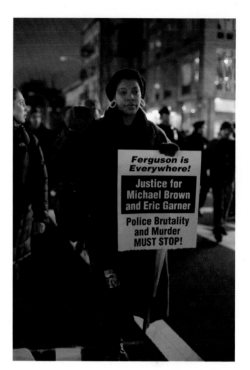
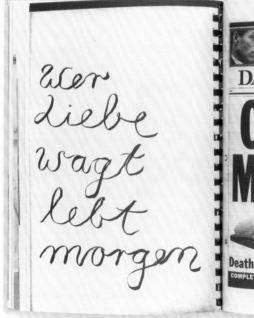
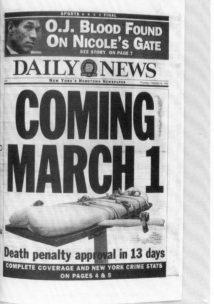

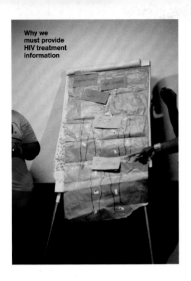

Why we must provide HIV treatment information

Vuyiseka Dubula
South Africa

Many nurses not trained in HIV. They are seeing patients with opportunistic infections but they are not allowed to prescribe certain medications – fluconazole, for example – because only doctors can prescribe it. But the doctor only comes once a month. The nurses see people who are sick but can't help them. They tell them "Go home, there are no fluconazole tablets."

If a nurse tells you there is no medication and turns you away, then the next time you won't spend your money for transportation. So, you take a five minute walk, and see a friendly face of the traditional healer. They will take time with the patient and that patient may not go back to the HIV clinic. That's why some people will opt for spiritual healing and look for purification with bleach or something like that.

Our treatment literacy practitioners are in the clinic to educate people about what to expect before they start treatment. There is limited time to explain everything; when a patient sees the nurse, but if the treatment literacy practitioner has explained things the nurse can spend only five minutes instead of an hour. Treatment literacy practitioners can also do voluntary counselling and testing (VCT) and relieve the burden on nurses. There is only one pharmacist for HIV people so our practitioners can also be trained as assistant pharmacists. Treatment literacy practitioners are now participating in some clinic committees.

90% of people using public healthcare system are poor people. Only 10% in our population uses the private sector – but more money is allocated for the private sector than the public.

In the private sector you will not come into contact with a treatment literacy practitioner and you may never hear about side effects and have the things you need to know. So going in the private sector also has disadvantages.

A big problem for us in South Africa is our president and our Minister of Health. Our president says there is no health care crisis in our country. But isn't having only one nurse for 500 people a crisis?

Loon Gangte
India

Rajiv Kafle
Nepal

I know four families who sold everything they owned to get ARV drugs for a family member with HIV. They didn't know that treatment was for life, and when they used up their money, the HIV virus level bounced back and two of them died.

We have come out with ten booklets and several fact sheets. We were influenced by the early TAC posters. In our next set of posters we will have people representing the messages in the posters. We use a lot of materials from TAC. We need other sources like I-Base to make our training manual and treatment literacy books. We wanted to share our materials with our Indian friends so we'll use translated the materials into Hindi so they will get inspired to make treatment materials.

I went to a TB conference last year and they talked about the rewards they give patients for taking their drugs, and the high tech bottles that beep and have LCDs in the top that tell when you opened it. Isn't it better for people to understand why they are taking their drugs instead of giving them rewards for taking the drugs?

After producing five books, our volunteers have learned so much. It is really empowering for them. We talk about every detail down to the kind of paper we use.

We had to work with the language. A lot of the I-Base concepts seem specific to the UK and we had to change those. Many of the brand name drugs mentioned are not available to us, so we use the generic names. There are possible double meanings and difficult grammatical points. Someone translated the meaning of "prevention during labour" in the booklet as "preventing HIV while at work."

Spreads from *Why we must provide HIV treatment information*, 2006

¿dónde estamos?, 2016 at Sonora 128, Mexico City, 2016, photo: Omar Luis Olguín

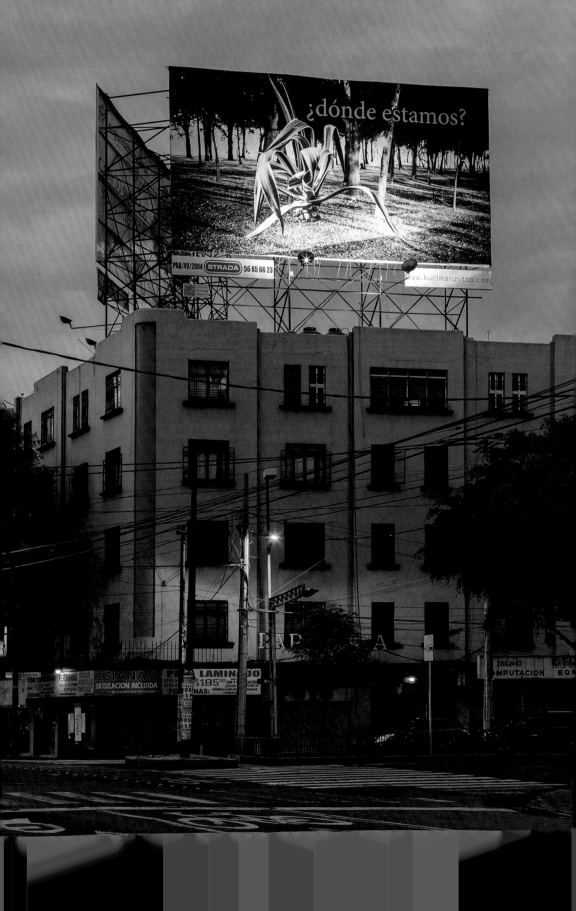

use of 'minor' parts of architecture that many other artists would shun. In terms of scale, Tillmans will sometimes print huge enlargements of small things and beside them, show small photographs of crowd scenes: the result is that viewers focus and refocus attention, often adjusting their distance from the walls and moving from the side to the middle of the space and then back to another point elsewhere along the periphery. Perhaps most compellingly, Tillmans also assigns equal importance to iconic and more ordinary images.

As so many have recognised, the artist has an incredible facility to make extremely memorable and affecting photographs. Different critics and viewers will have their own lists of Tillmans's most memorable images, and for many, the most iconic are those which lack obvious staging and which picture everyday scenes but which seem at once casual, timeless and monumental. I find I am most drawn to those where there is a kind of energy across a diagonal axis: for instance, *Deer Hirsch*, 1995, where a diagonal line links the eyes of the deer and the man; *JAL*, 1997, with the plane's wing stretching at an angle across the horizon line; *Untitled (La Gomera)*, 1997, where the wavy line in the sand created by two men and a dog at the bottom right of the image rhymes with an actual wave breaking at the top left; and *Jochen taking a bath*, 1997, where again an invisible slant connects the painter's head to a leaf of a living plant that turns a humdrum bathroom into a safe haven, a place of growth. This structure continues to serve Tillmans well: for instance, in the line of Anders's look that continues the slant of his lower left leg in *Anders pulling splinter from his foot*, 2004; *Ushuaia Digitalis*, 2010; or *Tukan*, 2010, where the invisible diagonal line connecting the two blue ceramic feeding plates is picked up by the slant of the bird's beak and the corner of the food container (the toucan's blue iris also rhymes with the ceramic glaze).

A complex formal appreciation of any of these photographs is possible, but the point I want to make here is that within Tillmans's installations these iconic images are never privileged. Indeed, Tillmans sometimes seems to fight against these images becoming dominant, balancing them with so many other images; printing them sometimes quite small, and refraining from using them in adverts and invitations. Tillmans once titled an exhibition 'If one thing matters, everything matters'. This is exactly the affect achieved by his non-hierarchical arrangements. Tillmans is obviously extremely precise in his installations, to the extent that no one photograph could swap places with any other when an installation is complete, but because of these different non-hierarchical organisations, despite *his* precision as their creator, there is a feeling of great freedom. There are no set sequences of images, no narratives to follow, no particular photographs to look at more than any others. The viewer enjoys a sense of permission to navigate the space according to their own interests and desires, and to forge their own meanings and indeed doubts while looking at the material that is presented.

In 2005, having from time to time included long vitrines within his installations, Tillmans introduced a new element, a series of pine wood tables criss-crossing at various points, slightly varying in height. He called the installation a *truth study center*, and it became a new element within his vocabulary of display; he has shown these tables frequently since, using them as platforms – in a more literal sense of the term 'platform' than usual – to arrange photographs, photocopied newspapers, printed emails, drawings, sheets of paper and, occasionally, objects from wherever he was exhibiting. One notable aspect of the works is that without making hierarchies, Tillmans places his

JAL, 1997

Untitled (La Gomera), 1997

Deer Hirsch, 1995

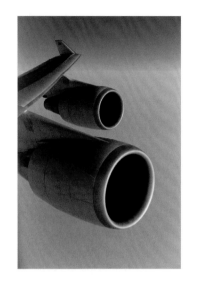

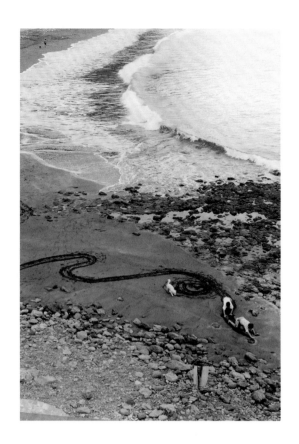

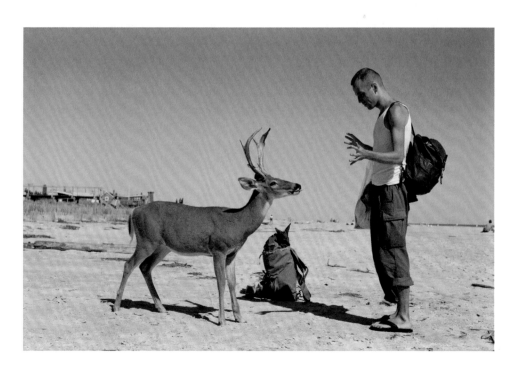

own output alongside the work of writers, photojournalists, politicians and so on, not so much to give 'background' to his own interests but as if to offer up his own production as just one way of reflecting on the world among many others, indeed as if to open his work to critical scrutiny within such a mix.[22] Sometimes Tillmans has given space to news images that have touched him and that he does not need to repeat, a reminder of his appreciation of the work of journalists like Arturo Rodriguez who photographed a tourist on a beach on the Canaries giving water to a West African migrant washed up there. At times his arrangements have created painful juxtapositions – for instance, a table installed in Munich in 2007 included a spread from an issue of *Die Zeit* guest edited by Tillmans where an advert for Patek Philippe watches showing a dad helping his son with homework sits below a photograph of hangmen preparing to execute two gay teenagers in Iran,[23] so that a viewer has to confront the simultaneity of this somewhat kitschy, constructed image of nurturing in the modern family and a real scene where 'taking care' of young men means adjusting their blindfolds before killing them.[24]

But as much as the juxtapositions trigger new ways of reading images, so too, as the critic Tom McDonough has argued, do Tillmans's selections and their spacing disallow the communication of straightforward meaning.[25] Instead the *truth study centers* create opportunities for what Tillmans calls 'not knowing' and 'embracing doubt'.[26] McDonough concentrates a lot on the gaps between items on the tabletops; it is also interesting to contrast the overall format of the *truth study centers* with that of the newspaper pages that they so often contain where information is presented in columns. Unlike newspaper columns, Tillmans's tables stretch across vertical and horizontal axes, and since they can be read from both sides, there will be people facing in all directions as they negotiate the space; through their arrangement, the *centers* therefore encourage a kind of non-linear study from all directions. Tillmans works with time as well. While the newspapers and photographs concentrate our attention on 'current events', in recent iterations Tillmans has populated the tables with texts asking us to imagine different kinds of time spans ('1969 was 24 years away from 1945 / 24 years back from now is 1992'). Such texts work against the newspapers' and photographs' immediacy by connecting meaningfully long passages of typical human lifespan to 'historic' time: the effect is somehow to make us more aware of our agency within larger historical processes.

Many commentators as well as Tillmans himself have commented that the *truth study centers* emerged in his practice in the mid-2000s in the aftermath of 9/11 and the 'War on Terror', and that they were motivated by Tillmans's desire to question the worldview shared by different individuals and groups who claimed to know 'the truth': religious fundamentalists knowing God's will and how to implement it; Bush and Blair professing to know the truth about Iraq's WMDs; Thabo Mbeki's certainty that HIV was not linked to AIDS. But importantly in the foreword to his book *manual*, the first major publication on the *truth study centers*, the 'truths' that Tillmans questioned concerned standard economic practices in democratic countries:

> There is a wide consensus about the inevitability of widely implemented economic decisions, which are largely hailed as 'flexible' but are utterly unprogressive. Rather than advance quality of life for all, the aims are to drive down

Time / Mirrored, TSC 225 (detail), 2015

Truth Study Center (Osaka), TSC 216 (detail), 2015

1969 was 24 years away from 1945

24 years back from now is 1992

oday is

26 year

1989 w

1981 /

vears

in 2017 as many years will have passed

Now 1975 is as long ago, as World War II was in 1975.

1969 was 24 years away from 1945

24 years back from now is 1992

1914 is 1

1815, the

1969 was 2

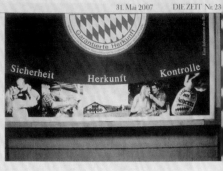

Religion

von Polly Toynbee

Vor zehn Jahren hatte die Aufklärung gesiegt, und Europa war ihr Fackelträger. Wohin auch immer sich Freiheit, Bildung und Demokratie ausbreiteten – überall bedeutete es den Niedergang von Religion und Aberglauben. Dieser Kontinent mit seiner ungeheuren Vielfalt an neuromanischen Kirchen und Kathedralen aus vergangenen Zeitaltern erlebte nun, wie diese Gebäude häufiger von Touristen aufgesucht wurden als von Betenden. Der Anblick ständig schrumpfender Grüppchen alter Menschen auf den Knien, denen ebenso alte Priester den Segen erteilten, gehörte zu den Reisen einer alten Welt – mehr aber auch nicht.

In der neuen europäischen Welt war die Religion ein Thema von und für Minderheiten geworden. Die Vernunft hatte die Magische besiegt. Es wäre exzentrisch erschienen, hätte man sich noch als Atheist oder Säkularist bezeichnet. Die wichtigsten Konfliktlinien in unseren weltlichen Demokratien verlaufen zwischen Links und Rechts, Progressiven und Konservativen, Reichen und Armen. Die schwindenden Scharen der Gläubigen haben von Generation zu Generation immer mehr an Einfluss eingebüßt. Die Jahrtausend-Umfrage des Meinungsforschungsinstituts Gallup International hat ergeben, dass Europa im weltweiten Vergleich die niedrigste Zahl von Gottesdienstbesuchern besitzt – ganze 17 Prozent der Menschen suchen hier mindestens einmal pro Woche einen Gottesdienst auf. Am höchsten ist der Anteil der aktiven Kirchgänger mit 87 Prozent in Westafrika, während Schweden das Land mit den meisten Ungläubigen ist. Im globalen Vergleich zeigt sich, dass die am wenigsten gebildeten Menschen zugleich am religiösesten sind. Ungeachtet ihrer mehrheitlich weltlichen Orientierung meinen die Europäer laut Eurobarometer allerdings zugleich, dass dem Religiösen heute eine zu hohe Bedeutung zukomme.

Es ist leicht einzusehen, warum. Religion ist wieder auf dem Vormarsch. In politischer Hinsicht ist das ein ebenso seltsames wie Besorgnis erregendes Phänomen. Religiöse Konflikte waren im Kern immer Auseinandersetzungen zwischen Clans und Stämmen, stets ging es dabei um Nationalismus und Kultur. Und konfessionelle Bekenntnisse waren die willkommenen Banner, unter denen gemeinschaftliche Identitäten geschaffen wurden. Jetzt passiert dasselbe wieder. Die meisten europäischen Staaten beherbergen heute beträchtliche muslimische Minderheiten. In dieser Situation bringt die Angst vor dem Terrorismus oder auch nur vor dem Fremden eine auf künstliche Weise christliche Reaktion hervor. Erneut wird uns die alles holzschnittartige Geschichte vom Kampf der Kulturen erzählt.

Kopftuch tragende Frauen, zuweilen sogar gänzlich verschleierte Frauen oder Frauen, die uns einen Schritt hinter ihrem Ehemann zu gehen und auch im Übrigen zu gehorchen haben – das alles bedeutet einen direkten Affront gegen den Kampf der Aufklärung für Frauenrechte. Diesen Kampf zu gewinnen dauerte ein Jahrhundert. Patriarchalische Familienstrukturen, besonders unter Familien aus den ländlichen Gebieten der islamischen Länder, wirken aus europäischer Sicht unzeitgemäß. Fälle von erzwungenen Hochzeiten und Ehrenmorden ziehen die ständig zunehmende Aufmerksamkeit schockierter Medien auf sich – mehr Aufmerksamkeit jedenfalls als die häufigen häuslichen Morde im Rest der Gesellschaft. Solche Morde werden in Großbritannien durchschnittlich zweimal pro Woche verübt, ohne dass die Presse ihnen nennenswerte Beachtung schenkte.

Hinzu kommen die vielfältigen Ängste vor geheimen Zellen extremistischer Dschihadisten, denen die muslimischen Bevölkerungsgruppen mutmaßlich Unterschlupf und Obhut gewähren. Solche Fundamentalisten sind, wie die Anschläge von London, Madrid und anderswo gezeigt haben, wild entschlossen, sich durch terroristische Morde an Unschuldigen auf schnellstmöglichem Weg in den Himmel zu befördern. Hier kommt ein explosives Gemisch zusammen. Selbst islamische Gelehrte, die Gewalt ablehnen, erklären zugleich häufig, die Demokratie sei es westliches, dem Koran fremdes Konstrukt. An ihre Stelle befürworten sie die Rückkehr zur halbmythischen Idee eines nichtdemokratischen Kalifatstaates.

Ebenfalls ins Spiel kommen die demografischen Trends: Eine aktuelle Untersuchung der britischen Organisation Christian Research sagt voraus, dass bis zum Jahr 2040 fast doppelt so viele Muslime freitags in Großbritanniens Moscheen beten werden wie sonntags Christen in den Kirchen. Nur noch zwei Prozent der Bevölkerung werden dann die christlichen Gottesdienste besuchen, und das Durchschnittsalter dieser Menschen wird 64 Jahre betragen.

Alle diese Entwicklungen führen zu Ängsten und defensiven Reaktionen. Menschen, die Meinungsforscher früher erklärt hätten, sie seien nicht religiös, bezeichnen sich nun auf einmal als „christlich". Legt man ihnen eine Liste von Glaubensrichtungen vor, die auch die muslimische enthält, entscheiden sie sich für die Religion, denen ihre Großeltern anhingen. So wie einst greifen sie heute wieder zur Religion, um sich selbst in kultureller, nationaler und ethnischer Hinsicht zu definieren – selbst wenn sie in Wirklichkeit gar nicht religiös sind und keinen Glauben ausüben.

Europas Regierungen haben auf verschiedene Weise reagiert. Einige sprechen sich für die Religion aus. Valéry Giscard d'Estaing etwa sprach sich im Verlauf seiner Arbeit am Verfassungsentwurf der Europäischen Union gegen den Eintritt der Türkei in die EU aus. „Europa" bedeute notwendigerweise „Christentum", behauptete er. Angela Merkel schlug in die gleiche Kerbe und versuchte, Gott in die Verfassung hineinschreiben zu lassen. Papst Benedikt wiederum griff unlängst anlässlich des 50. Geburtstags der EU heftig deren Berliner Erklärung an. Dort finde sich bei der Benennung der europäischen Werte keinerlei Hinweis auf Gott und Europas christliche Wurzeln. Benedikt erklärte dies für „Apostasie" – die Europäer fielen von ihrem Glauben ab.

Jedoch besitzt gerade der Heilige Stuhl keinerlei Recht, über die Werte die Europäische Union zu bestimmen. Der Vatikan ist der einzige Staat in Europa, der die Europäische Menschenrechtskonvention nicht unterzeichnet hat – eine grundlegende Voraussetzung für den Beitritt zur EU. Die Türkei hat diese Bedingung – wenn auch unter Mühen – erfüllt, um sich Zugang nach Europa zu verschaffen. Der Heilige Stuhl hingegen wäre schon deshalb von vornherein disqualifiziert, weil der Vatikan keine Demokratie ist. Dennoch versteht er sich darauf, die Entscheidungsfindung der Europäischen Union zu beeinflussen, nicht zuletzt weil ein weit überproportionaler Anteil der Abgeordneten des EU-Parlaments der katholischen Kirche angehört.

Um die Freiheit, die schleichend wachsende Macht der Religionen anzufechten, ist es nicht gut bestellt. Gerade jene, die Säkularismus lautstark verteidigen sollten, verhalten sich merkwürdig still. Die Vertreter der liberalen Aufklärung haben sich in der Debatte über den Islam hoffnungslos in intellektuelle Widersprüche verwickelt. Sie wollen antirassistisch und multikulturell sein. Sie sehen, dass es in ihren Ländern muslimische Minderheiten gibt, die sich bedroht fühlen. Völlig zu Recht sagt ihnen daher ihr Instinkt, dass es immer der Underdog ist, der verteidigt werden muss. Aber das bedeutet, dass die liberalen Aufklärer oftmals zugleich bereit sind, in Fragen der Rede- und Meinungsfreiheit ein Auge zuzudrücken. Es bedeutet, dass sie bereit sind, die Rechte von Menschen innerhalb religiöser Gemeinschaften zu ignorieren: Unangemessen eifrig darauf bedacht, unterdrückerische und patriarchalische Verhältnisse zu „respektieren", vergessen sie die Menschenrechte von Frauen oder Homosexuellen.

Es waren diese fortschrittlichen Liberalen, die den Kampf um Gesetze gegen die Rassendiskriminierung und für die Beachtung universeller Menschenrechte gewannen. Inzwischen jedoch erlebt man, wie sie – wenn auch unschlüssig – für die Rechte religiöser Gruppen Partei ergreifen, die angeblich nicht „gekränkt" werden dürften. Denn wer den religiösen Glauben „kränkt", gilt heute nahezu als Rassist. „Islamophobie" ist ein besonders aufschlussreiches neues Wort. Es verkündet, dass jegliche Kritik am Islam gleichbedeutend sei mit rassistischer Beleidigung. Wer sich nach vor Jahren in der guten Tradition Voltaires über das Christentum lustig zu machen pflegte, verdonnert sich heute selbst zum Schweigen, wenn es darum geht, den blühenden Unfug anderer Religionen aufzuspießen. Die dänischen Karikaturen waren gewiss dumm und nicht der Veröffentlichung wert – aber gerade das ist nicht das Argument derjenigen, die im Namen des Islam lang für die Meinungsfreiheit gekämpft haben. Die neuen Konservs lauten stattdessen, dass Zensur akzeptabel ist. Der Vatikan hat jüngst den Versuch unternommen, die Vereinten Nationen und die Europäische Union dazu zu bewegen, den Tatbestand der „Christianophobie" in derselben Weise anzuerkennen und zu verbieten, wie Muslime „Islamophobie" verbieten lassen wollen. Und warum schließlich auch nicht? Allerdings: Wenn es erst einmal ein Menschenrecht ist, sich nicht mehr durch Kritik am eigenen Glauben „kränken" zu lassen zu müssen, wird jede Debatte unter den Menschen schlagartig zum Erliegen kommen.

Das Appeasement gegenüber dem religiösen Eiferertum geht in Großbritannien bereits so weit, dass die Regierung rund neue muslimische Schulen genehmigt, damit die Schüler über den Wert ihrer eigenen Kultur unterrichtet werden können. Die Schulpflicht für die naturwissenschaftlichen Fächer lehren nun oftmals Kreationismus anstelle von Evolution. An fehlt an Empörung über diese Segregation und die Schwierigkeiten, die sie in Zukunft noch schaffen wird. Wo sind die Stimmen der Aufklärung jetzt? Aus merkwürdigen historischen Gründen wird heute bereits ein Drittel der staatlichen britischen Schulen von der katholischen Kirche oder von protestantischen Kirchen betrieben – und das in einem Land der Ungläubigen. Es sind überwiegend auch gar nicht Kinder aus religiösen Familien, die diese Schulen besuchen. Vielmehr tun die Familien nur für eine Weile so, als wendeten sie sich der Religion zu, damit sie ihre Kinder auf kirchliche Schulen schicken können. Diese sind qualitativ besser, weil die Sozialauswahl ihrer Schüler günstiger ist. Liberale fragen man zu Recht, wie man den Muslimen verweigern könne, was die Christen bereits haben. Die einzig richtige Antwort darauf lautet, dass sämtliche staatlichen Schulen in Europa weltliche Schulen sein sollten.

* Die christlichen Kirchen spüren, dass sie die religiöse Inbrunst der Gläubigen ausnutzen können, um ihre eigenen Anliegen und das Religiöse überhaupt voranzubringen. Ein unheiliges Bündnis aller Glaubensrichtungen sorgt derzeit dafür, dass alte Positionen mit neuer Aggressivität vorgetragen werden: gegen die Abtreibung, gegen die Stammzellenforschung, gegen die Schwangerschaftsverhütung in Teenageralter, gegen Euthanasie und Homosexuellenrechte, gegen Aufklärungsunterricht an den Schulen und auch dagegen, dass in den Entwicklungsländern im Kampf gegen Aids Kondome zum Einsatz kommen dürfen. Die Religionsführer haben begriffen, dass viele Religiöse in Europa – wenn auch mit Unbehagen – bemühen, die verschiedenen religiösen Gemeinschaften irgendwie in die Gesamtgesellschaft zu integrieren. Der Staat gesteht den religiösen Gemeinschaften Sonderrechte zu. So will man extremistische Gläubige besänftigen und Moderate davon abhalten, ihrerseits zu Extremisten zu werden.

Unterdessen ist die extrem katholische Regierung der Gebrüder Kaczynski in Polen damit beschäftigt, ihren repressiven Einfluss auch in die Institutionen der Europäischen Union zu tragen. Im EU-Parlament erheben sich atemberaubend reaktionäre religiöse Stimmen. Zum Instrumentarium des gegenwärtigen (ebenso wie des vorigen) Papstes gehört es inzwischen, katholischen Politikern die Exkommunikation anzudrohen, sofern sie die Politik der katholischen Kirche nicht unterstützen. Das schleichende Problem demokratischer Legitimität auf Zugleich ziehen hier schleichend die Drohung einer Theokratie nach iranischem Muster herauf: Wenn ist ein katholischer

Politiker verantwortlich – seinen Wählern oder dem Vatikan? Großbritannien ist der einzige west liche Demokratie, die theokratische Elemente aufweist: Dem Oberhaus gehören 26 Bischöfe an – mit der Folge, dass die anderen Religionen inzwischen ebenfalls fordern, auf dieselbe Weise repräsentiert zu werden.

Anlässlich der ersten Zusammenkunft des neuen UN-Menschenrechtsrates wurde jüngst die Forderung erhoben, jegliche Verleumdung von Religion sofort zu verbieten. Die kuwaitische Vertretung bei den Vereinten Nationen erklärte, sie wolle Religionen kränke, sei eine Verletzung der Glaubensfreiheit – eine Auffassung, die in ihrer Verquertheit selbst kaum zu glauben ist. Die International Humanistic and Ethical Union, der als führende Mitgliedsorganisation auch die National Secular Society Großbritanniens angehört, stand in diesem Fall tapfer für die Meinungs- und Redefreiheit auf. Aber der organisierte Nichtglauben bringt nur einen schwachen Aufschrei des Protests gegen die Macht der Vertreter von Muslimen, Christen und anderen unerbittlichen Glaubensrichtungen zustande. Die Stimme der Vernunft bleibt deshalb leise, weil der Nichtglaube seinem ganzen Wesen nach moderat ist – es gibt per Definition keine Dschihadisten im Kampf für Vernunft und Wissenschaft.

Menschenrechte und Religion stehen zueinander in einem fundamentalen Konfliktverhältnis. Fast alle Religionen versuchen, die Freiheit der Frauen einzuschränken, sie über die eigene Fruchtbarkeit zu entscheiden. Sie verweigern Menschen die eigenständige Entscheidung darüber, wann sie Kinder gebären möchten und wann sie sterben wollen. Sie verweigern Menschen das Recht, ihre Sexualität nach eigenen Vorstellungen auszuleben. Und jetzt versuchen sie sogar, die Freiheit wieder abzuschaffen, in primitiven Texten enthaltene „offenbarte" religiöse Wahrheiten zu bezweifeln und zu verspotten.

Es ist höchste Zeit, dass Europäer die freiheitlichen und demokratischen Werte der Aufklärung aufs Neue verteidigen. Deren neuer Gegner ist ein finsteres Bündnis aller Glaubensrichtungen, das den Nichtgläubigen die Macht entreißen will. Geht das weltliche Europa nicht sofort zum Gegenangriff über, wird Gott in die Politik zurückkehren. Aus Angst davor, irgendwen zu beleidigen, werden wir dann zum Schweigen gezwungen sein – selbst dann, wenn Europa noch immer ein Kontinent der Nichtgläubigen ist.

Polly Toynbee ist leitende Kommentatorin beim britischen „Guardian" und lebt in London

ADDRESS OF HIS HOLINESS BENEDICT XVI
Conference Hall, Shrine of Aparecida
Sunday, 13 May 2007

(…) Yet what did the acceptance of the Christian faith mean for the nations of Latin America and the Caribbean? For them, it meant knowing and welcoming Christ, the unknown God whom their ancestors were seeking, without realizing it, in their rich religious traditions. Christ is the Saviour for whom they were silently longing. It also meant that they received, in the waters of Baptism, the divine life that made them children of God by adoption; moreover, they received the Holy Spirit who came to make their cultures fruitful, purifying them and developing the numerous seeds that the incarnate Word had planted in them, thereby guiding them along the paths of the Gospel. In effect, the proclamation of Jesus and of his Gospel did not at any point involve an alienation of the pre-Columbian cultures, nor was it the imposition of a foreign culture (…)

Spread from *Feuilleton, Die Zeit*, Nr. 23, 31 May 2007, guest-edited and designed by WT (English translation overlay used on table TSC 154, Truth Study Center installation in *The British Art Show 7*, 2010)

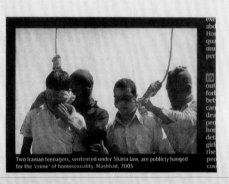

Two Iranian teenagers, sentenced under Sharia law, are publicly hanged
for the 'crime' of homosexuality. Mashhad, 2005

labour costs, increase shareholder value, and hand over public property including water, health, and public transport to the private profit-driven sector. A majority of populations in many countries now generally understand the increasing gap between rich and poor as 'absolutely unavoidable'.[27]

It is capitalism's 'truths' that Tillmans has always doubted. Tillmans first asked 'What's wrong with redistribution?' on a sheet of paper in a *truth study center* at the MCA Chicago in 2006 and as we have seen, he has answered his own question by redistributing images, ideas and information through all the platforms he has worked with. But this question must also be read for its most obvious meaning: what is wrong with the redistribution of wealth?

Abstract pictures

At the time Tillmans first presented a *truth study center* at Maureen Paley in 2005, his photographic production had mainly turned towards abstraction. Indeed in the room below the tables, he hung five large maroon prints titled *Einzelgänger*, related to his *Freischwimmer* series, and one large pink monochrome called *Impossible Colour V*. Following Tillmans's own suggestions, some have read this move as a retreat from an engagement in the representation of social and political life coinciding with the end of the 1990s and with 9/11. ('With the abstract pictures, I feel myself liberated from the obligation to represent – that compulsion to represent', he told Obrist.[28]) While there is some weight to this argument, I want to suggest instead that abstraction has run through Tillmans's work from its origins and, more importantly, that all the different bodies of abstract work reveal in different ways his worldview. In other words – Tillmans's own – it is always 'abstraction grounded in the real world.'[29]

Abstraction can mean many things in relation to photography, and it has functioned in different ways for Tillmans. It arises with his very first photographs and the way he would expose the last 'extra' frame on a roll, knowing that there would be a flare to turn half an image orange,[30] and with his first exhibited works, shown in Hamburg in 1988, created by using a laser copier to enlarge and distort photographs he had taken of builders, beaches and waterfalls. By using the photocopier, Tillmans relinquished some of his authorship to the machine, later recognising that this was an analogy for his life at the time, feeling in and out of control of his own fate. He was also interested in the way the photocopiers transformed and degraded the source images. A clear photograph became a paper surface textured by rhythmical, horizontal scan lines: the works 'were really about the dissolving of details, of zooming into pictures and information breaking down'.[31] Tillmans also liked the way 'the laser copier printed out the image in dots, so the dots were also enlarged. It was like a fractured picture: it was the dissolving of the photograph.'[32]

Tillmans's approach has some correspondence with that of Sigmar Polke. In the early 1960s, Polke was interested in magnifying and painting the dots that make up a printed image; in the 1980s, he experimented with photocopiers, enlarging printing errors in magazine images and distorting other printed pictures by moving the sheet around the photocopier glass as it was being copied (Tillmans sometimes did this,

Installation view of *Truth Study Center*, Maureen Paley, London, 2005

Paradise, War, Religion, Work, TSC 131 (detail), 2007

Einzelgänger II, III, IV and V, 2003 in *Truth Study Center*, Maureen Paley, London, 2005

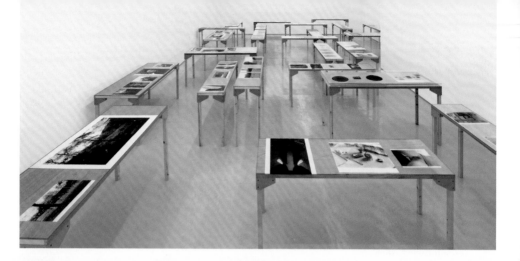

der, regularly attended by Bush administration officials. NEWSWEEK's Michael Hastings spoke to Norquist to get his thoughts on America's conservative streak. Excerpts:

HASTINGS: Europeans were shocked by George. W. Bush's re-election. What aren't they getting about America?
NORQUIST: They think the United States is Europe moved west. The United States is a distinct culture that decided to not be Europe. The Revolutionary War, the War of 1812, World War I and World War II were all wars to not be part of Europe. The cold war—not to be part of Europe. The whole country is filled with people who decided not live in Europe. We had people who wanted to live in Europe but didn't have the energy to go back. We call them Canadian

Europe seems to fear America is moving back to 19th-century capitalism.
We moved toward a European Bismarck welfare state, but not as rapidly as Europe. When the rest of Europe was going fascist

What's wrong with redistribution?

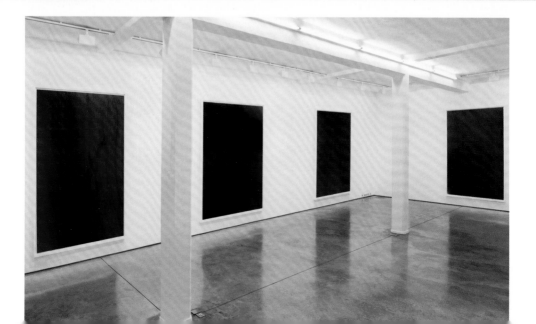

too). Abstraction always meant corruption and not purity for Polke, and this is the case for Tillmans's early photocopied works, too. But Tillmans also began to explore the idea that the mechanical distortions somehow heightened the psychological impact of the image, tweaking desire by degrading or veiling the object of vision. It wasn't just that some of these works zoomed in on the muscular bodies of builders, but that by exchanging their likenesses for series of black and white scan lines, the images became all the more intriguing. The same goes for a picture of waves composed as a series of horizontal strips as if in anticipation of the way it would be read by the copier: Tillmans learned that a viewer might have more attraction towards this scene because we feel the loss of light and colour and desire the beach all the more. This vein of Tillmans's abstraction has led to various images over the years, some of bodies – for instance, *photocopy (Barnaby)*, 1994, where Tillmans worked with a photograph he had made three years before, and created a piece where a torso may be sexier because it is overexposed on one side and crossed by lines of toner ink on the other – and some of places such as Venice, where Tillmans realised he could only make an image if he later photocopied it, scanned the copy and blew it up until much of the texture of the canal's ripples was blanked out.[33] (It should be said that Tillmans would never exhibit the 'original' photograph, and that the photocopy is not a 'version' of a pre-existing work, but a method of transforming a photograph intended from the beginning.)

The early photocopy pieces anticipate a series of works made by taking source photographs and interfering with them in the darkroom during printing or exposure. This begins with the project Tillmans made for *Parkett* in 1998, when rather than make an edition of identical objects, he chose sixty unique prints of printing mistakes and chemical interactions, which he had collected over the course of six years, instead of throwing them out as one would normally do with such rejects. By this point, some of the images seen misprinted here were already getting well known, and the *Parkett* project can be seen as another way Tillmans countered his own facility for making iconic images. At a time when so many photographers were exploiting digital manipulation programmes, Tillmans courted all kinds of analogue glitches: weird bands of colour obscuring images, mis-registrations, doubled exposures and so on. By abusing his own images, Tillmans could find new interests in them. The *Parkett Edition* seems to have given Tillmans a confidence to work on other larger prints in a related way, shining lights onto the paper during exposure. Some of these works seem (to me, at least) maybe a bit too spectacular in their 'experimental' effects (for instance, *Icestorm*, 2001, and the *Mental Pictures* from the same time), but one remains extremely affecting: *I don't want to get over you*, 2000. Tillmans took an image of dusk falling over a Californian desert floor and worked into the pale evening sky to create thick swirls of green and thinner strands of bloody brown-red. Though he took the title from the song by The Magnetic Fields, it is hard not to read the image as connected to the loss of his partner, Jochen Klein, some years before and the guilt of living on and being able to continue to make art. Maybe I am over-reading, but the 'interference' feels at once like a deliberate attempt to spoil an image of natural beauty, an act of self-punishment, and a way of extending some of the language of Klein's own paintings into photography – the way, for instance, Klein would trail a thick brush loaded with white paint over a painting of a woodland.[34]

Tillmans was now creating trails of colour by projecting light onto photographic paper while exposing and enlarg-

Previous pages:
Einzelgänger I, 2003

Opposite page:
Wellen Lacanau (Waves Lacanau), 1987

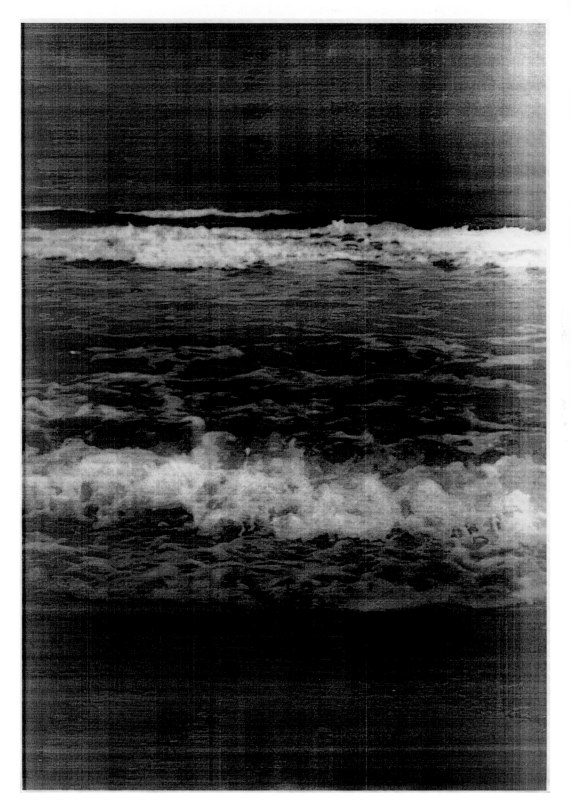

Parkett Edition, 1992–1998

Venice, 2007

Approach (Avenue of the Americas), 1987

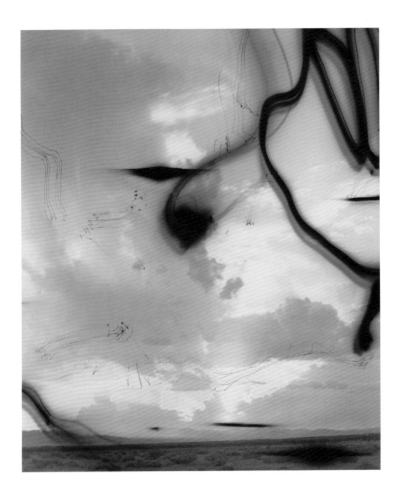

ing a negative of a source image, but why not jettison the negative? This question led to among his first cameraless photographs, an open series, most of which are called *Blushes* and *Freischwimmer*. Unabashedly beautiful, always seductive, often monumental, these works are characterised by thin strands of intense colour swirling and streaking across paler but often saturated grounds of the same colour, here super-sharp, there melting into blurs. Early schoolroom experiments showing ink dissolving in water come to mind, but Tillmans's process has actually no liquid components, and in this sense there is an important distance from Polke's near-abstract photography, which was so often characterised by pools of chemicals almost obscuring images, such as his series *Bowery*, 1973. As much as the *Freischwimmer* are the outcome of a private darkroom practice – nights when Tillmans shuts the studio and works alone without his team of assistants – the works are never hermetic formalist experiments because they are always and insistently connected to lived experience. Tillmans titled the first group of these works *Blushes*, relating the photographs to an involuntary physical reaction that seldom takes place in private, indeed that often exposes secret desire in public. He knows these works will also sometimes resemble intimate views of the body such as we see in his own photographs of armpits and testicles – for instance, *Barthaut (vignetted)*, 1992; *Circle Line*, 2000; and *Empire (men)*, 2005 – and he

I don't want to get over you, 2000

Jochen Klein, Untitled, 1996, oil and collage on canvas, 50 × 40 cm

Cover of *Conor Donlon*, 2016

Silver 131, 2013

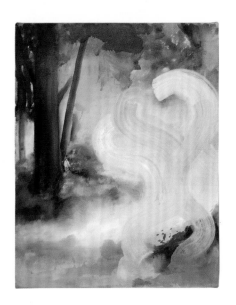

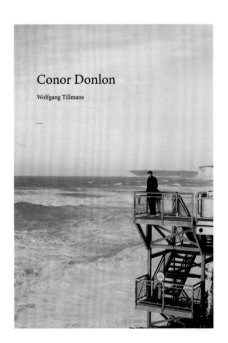

Conor Donlon

Wolfgang Tillmans

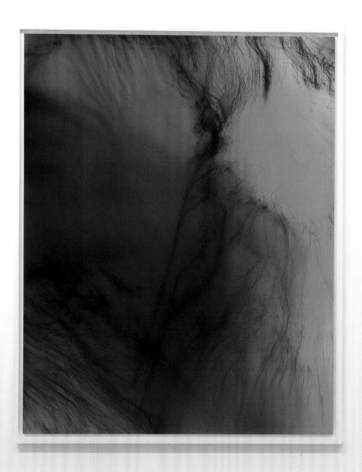

Freischwimmer 180, 2011 and Freischwimmer 177, 2011 in *Wolfgang Tillmans*, Moderna Museet, Stockholm, 2012

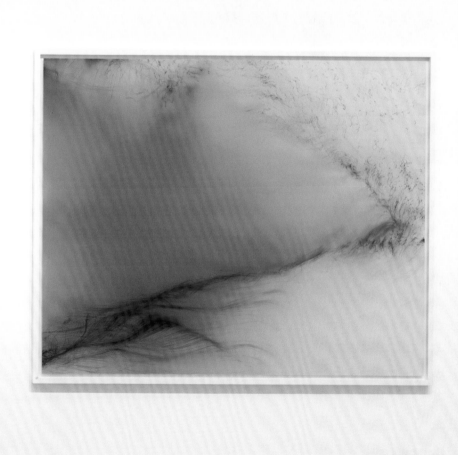

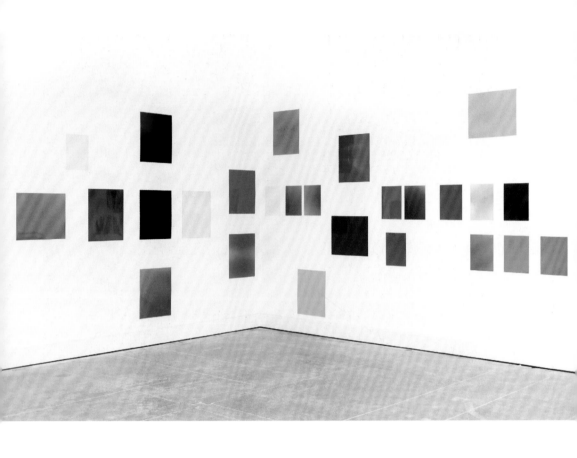

Silver installation VII, 2009 in *Fare Mondi – Making Worlds*, 53rd Venice Biennale, 2009

Ushuaia Favela, 2010

device control, 2005

Silver 170, 2013

even sometimes juxtaposes the two kinds of images in his books to draw on their related-ness.[35] This is another instance of him thinking in analogies – recognising that abstract photographs share something with images of bodies – but I wouldn't quite say that the *Freischwimmer* make us recall or long for those moments where we see another person's skin so close it fills our visual field. Rather they draw out our dreams of fluid movement. In his 2016 book *Conor Donlon*, Tillmans published a photograph of two bodies swimming underwater, and it is this sense of being free that the *Freischwimmer* (named after a German swimming certificate) connect to. Such a dream is not an escape but a response to a world of categories and constraints, a counter-movement that proposes another way of living. Tillmans says that the works are 'my resistance to feeling powerless against the falling apart of a world bent on reviving ideologies and erecting borders and barriers and fuelling hatred between people',[36] but they also *propose* an alternative.

The largest body of Tillmans's abstract works is called the *Silvers*, which date from 1992 and are the result of passing sheets of photographic paper through a colour photography processing developer so that they pick up waste material: silver-based chemicals and funguses. The sheets also carry the rhythmical traces of the rollers through which they pass – vertical and horizontal scratches and sometimes stuttering bands.[37] Passing photographic paper through a printer would normally just be a way to clean a machine but Tillmans became attracted to these textures perhaps because they recalled his 1988 photocopier works, and connected to his interests in electronic music, and so he began to find a way to expose the sheets to light during the process so that they would emerge in different colours. Initially he only showed the unique small sheets with their low reliefs of chemical encrusting; later he started to scan these sheets and print them as enlargements. Even though he sometimes intersperses them among landscapes, the *Silvers* may seem to take us furthest away from Tillmans's 'worldview' and towards a world of pure chromatic pleasure, but once again he thinks about them through analogies. He is interested in the way the unique small works and the enlarged prints offer two mutually exclusive possibilities: on the one hand, a textured surface; on the other, a smooth picture where micro-abrasions that would have been invisible in the smaller originals become apparent and even dramatic. Neither version allows us a more significant appreciation of a physical reality than the other, and Tillmans sees this as an analogy for a way of approaching the world, rejecting the idea that there are 'truths' about how to live life. This is why he populated his books on the *truth study centers* with plates showing his *Silvers* and why he also brought a group of these works together to form a *Memorial for the Victims of Organized Religions* in Washington, D.C. in 2006, where the 'certainties' of such religions were undone by the imperfections and minute tonal shifts of these C-type works.

Places

The bulk of Tillmans's abstract photographs are, as I have shown, the result of studio work rather than journeys into the world to record abstract patterns or textures.[38] But as well as making non-image works *in* the studio, as an exhibition in 2016 at Galerie Buchholz in Berlin made clear, Tillmans has always made images *of* the studio.[39] The studio is a place for printing, for laying out books and materials, for building models of exhibitions and

Silver 151, 2013

sometimes standing in them to craft visual jokes with startling scale shifts (Wolfgang in Wonderland?). After the hard work, there are parties when the studio dresses up in gold foils. Above all, the studio is a place where vision can be sharpened, where the living greens of different plants can be contrasted with the inks of green *Freischwimmer* test prints. Windowsill plants are cared for and flourish, and they can appear suddenly dramatic as, for instance, when a Madagascar dragon tree catches the light and looks like a bursting firework. It is a place to plot campaigns and a refuge where you can watch the seasons change outside. Sometimes – especially in those photographs taken the day after a party – the studio becomes like a camera, its back wall like a plate, recording window-frame shadows and the mix of light from street lamps and the falling sun.

The studio is the world Tillmans has studied the most intensely, but what of other places? In his early exhibitions and books, location mostly served as a background for images of people, as in *Corinne on Gloucester Place*, 1993. The first major photographs of places were the aerial views in the book *View from Above* that often reveal how cities grow as a result of countless unplanned decisions rather than the grand designs of planners. The images capture that moment shortly before landing or after take-off, or from a tall building, of looking out over cityscapes from a slanted distance. Tillmans's oblique camera angles made his own presence felt (these were never the downward views associated with surveillance or cartography) and, by bringing in the human perspective, these images recalled (for me, at least) a particular kind of feeling – that however one might be sorry to leave a place or excited to arrive, one's presence can't really affect the world outside the window. Very visibly, life is going on very efficiently below. Tillmans calls his viewpoints 'the unprivileged view',[40] which speaks to the ordinariness today of looking out of a plane window and his hope that all his images have this viewpoint, but they are also unprivileged since they provoke a feeling of not mattering, rather than command.

Tillmans's next major body of work about place was *Neue Welt*, a long project dating at its core from 2009 to 2012 and framed by the question of how the world appeared to him some twenty-five years after he started making photographs. Before he began, he set up some technical and organisational conditions that marked some shifts in his practice, but there were also continuities. Having always previously used analogue film, he moved to a digital camera, partly because he was confident that the apparatus could now capture the optical perspective of his analogue cameras, and also because he wanted to exploit a kind of sharpness in his images that he felt was appropriate to the changed visual conditions across the world. As before, however, he chose a non-specialist camera rather than a super-expensive model associated with special effects.[41] And, as ever, he photographed using a 50mm lens rather than wide-angle or zoom so that his images approximated a human viewpoint. In this way, however 'faraway' he travelled, he remained attentive to the world nearby. Tillmans was well aware of critiques of artists who parachute into 'exotic' locations to seize visual spoils, but as he started to travel very widely, he also determined that he would visit places quite fleetingly, feeling that 'a short period of full immersion is enough for me.'[42] He often included in his journeys famous and very frequently photographed places, realising that they were photogenic for good reason, as had Peter Fischli and David Weiss while they made their *Visible World* 1987–2000, but unlike them, he did not only seek to record the surface

studio light, 2006

Corinne on Gloucester Place, 1993

Aufsicht (yellow) (View from above [yellow]), 1999

Lampedusa, 2008

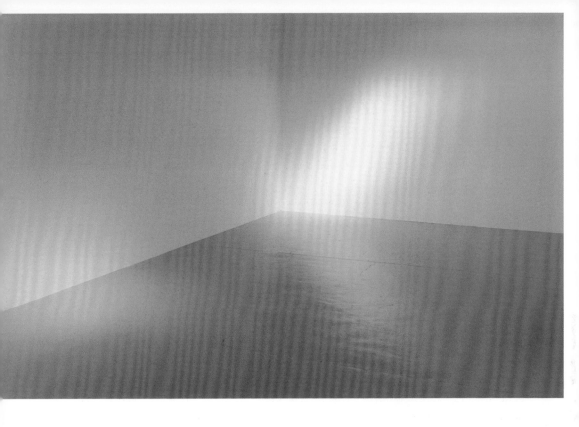

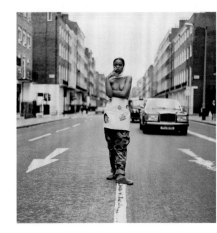

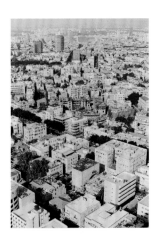

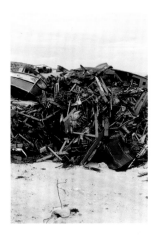

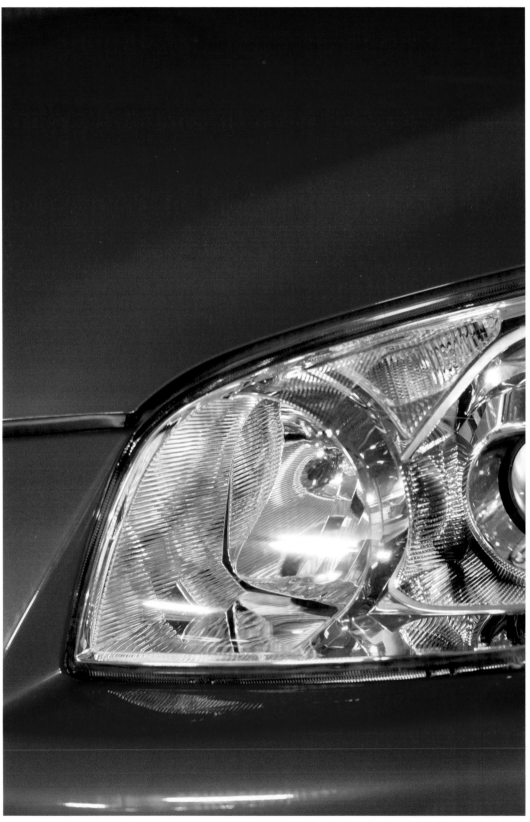

Headlight (f), 2012

Headlight (d), 2012

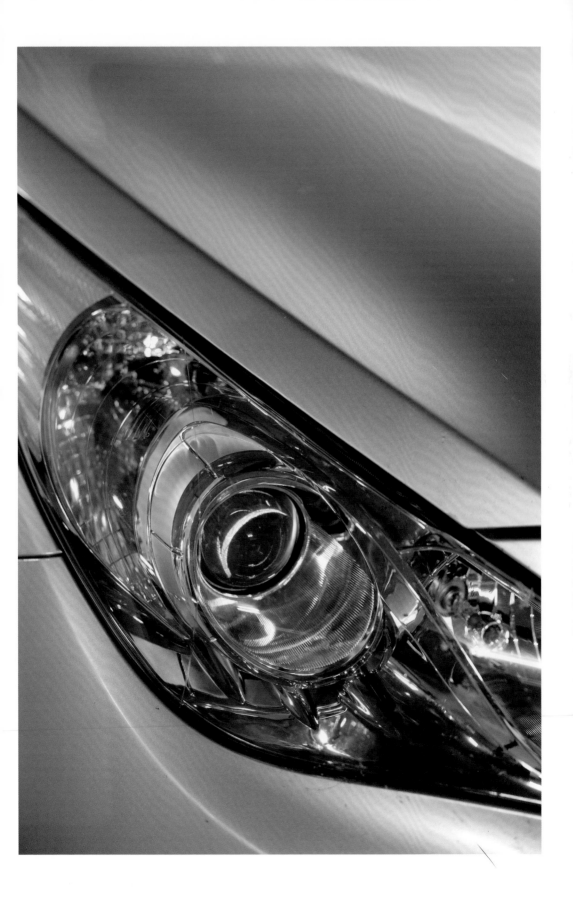

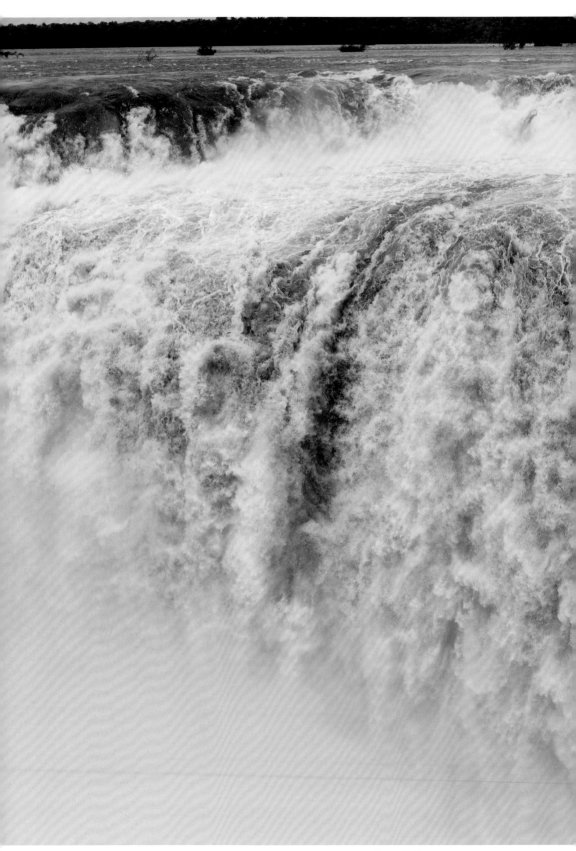

Iguazu, 2010

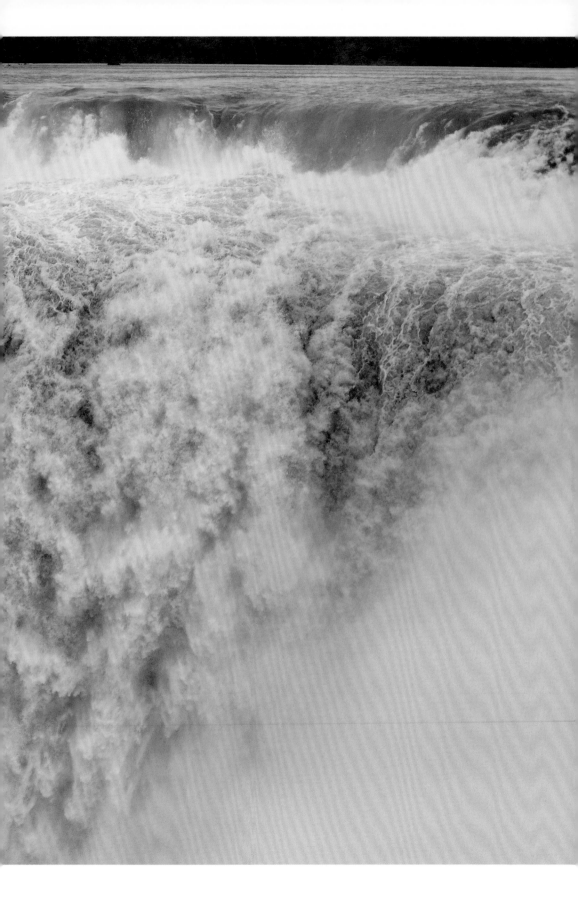

of the world he travelled through – indeed his aim was 'to have a genuinely new experience' wherever he travelled.[43] As mentioned before, these technical and organisational conditions connected to an ethical position: that it was totally acceptable to photograph strangers, even if they were unaware, since the result could be a more empathetic view of humanity.

Tillmans embarked on *Neue Welt* with questions on his mind rather than theses to prove. For all the photographs of billboards in Times Square and shopping malls in Jeddah, *Neue Welt* is not an attempt to show the homogenising forces of global consumerism, even though sometimes Tillmans hit on images that for him sum up changes in worldviews, such as pictures of 'shark-eye' car headlights (taken in a Tasmanian underground car park), which reveal how even car designers register or reward consumers' more predatory mindsets. *Neue Welt* is not a condemnation of the inequalities that capitalism causes, and the arduous journeys it motivates, even though it includes photographs of rough sleepers near the malls in Mumbai and African migrants' wooden boats destroyed by Italian authorities on the island of Lampedusa. We see the Gaza wall built to separate Israelis and Palestinians, and activists on a PETA march, but equally there are moments of leisure. There are photographs of the aftermath of natural disasters such as the earthquake in Haiti; Tillmans also rhymes an image of a claw picking up household garbage with a picture of the Iguazu Falls as if to show the production of waste is just as interminable as the waterfall, but *Neue Welt* does not seem to condemn humans for spoiling their planet. Pictures taken in laboratories and hospitals indicate welcome technological achievements, and yet overall there is no celebration of human advances; other images show a market in Ethiopia, a Masai boy walking with his hair caked in clay and a house made out of palm fronds in the Trobriand Islands – but *Neue Welt* is not a sentimental paean to 'authentic' or 'traditional' ways of life. So how *do* we understand this project?

Neue Welt was as much a book as an exhibition project. In the book, photographs like the waterfall are bled to the edges and others have white margins around them, but on many pages, when editing and designing the book, Tillmans overlaid images; this was new for him. Pictures are superimposed over others, without any significant relationship being created between the top image and the one it partially blocks. This disjunctive and disorienting arrangement on the page repeats features of actual environments that Tillmans witnessed and recorded: *envy*, 2010, which is divided into horizontal bands showing a street barrier, a line of New York taxis in traffic, a shop sign in English and Mandarin, and a Calvin Klein perfume advert featuring a woman in lingerie; or *Shanghai mall*, 2009, where columns, mirrors, partitions, shop signs, escalators and barriers divide the image into so many planes that the interior space becomes hard to read. These images as well as the arrangements of photographs through the book seem to me to express Tillmans's conclusions in *Neue Welt*, which were that the world is now impossible to organise in the way earlier photographers may have attempted. 'We might possess more absolute knowledge than ever before,' he said, 'but everything is fragmented – the same way hard drives save "fragmented" files. There is no longer a view of the totality, of the whole.'[44] Another telling image shows a young man in the middle of Old Street roundabout in London looking down at his smartphone, present 'here' and 'elsewhere' at the same time; above him is an advert for Virgin's HD television service – in other words, for another screen.[45]

Times Square LED, 2010

envy, 2010

Spreads from *Neue Welt*, 2012

Old Street, 2010

Tag/Nacht (Day/Night), 2009

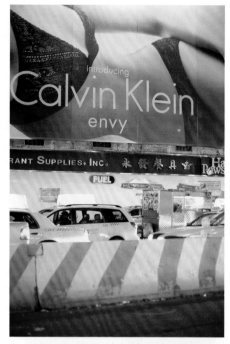
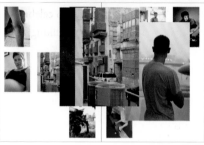
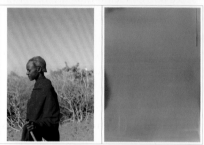
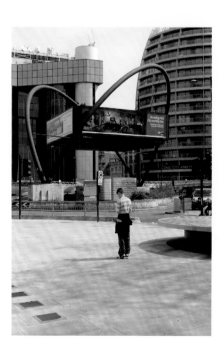

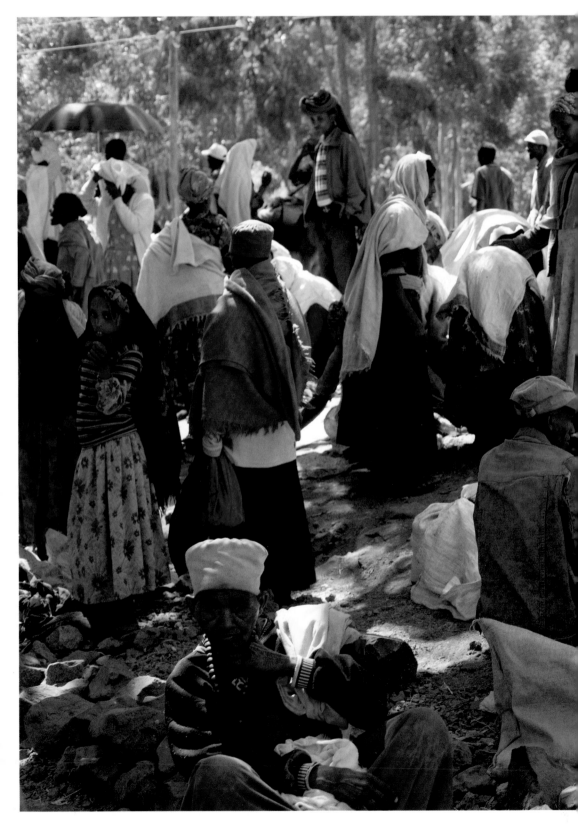

Market I, 2012

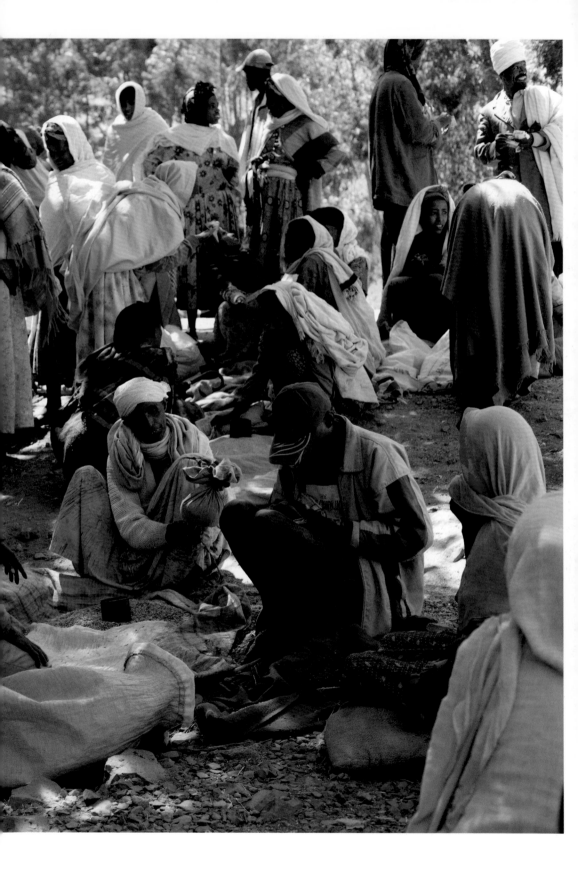

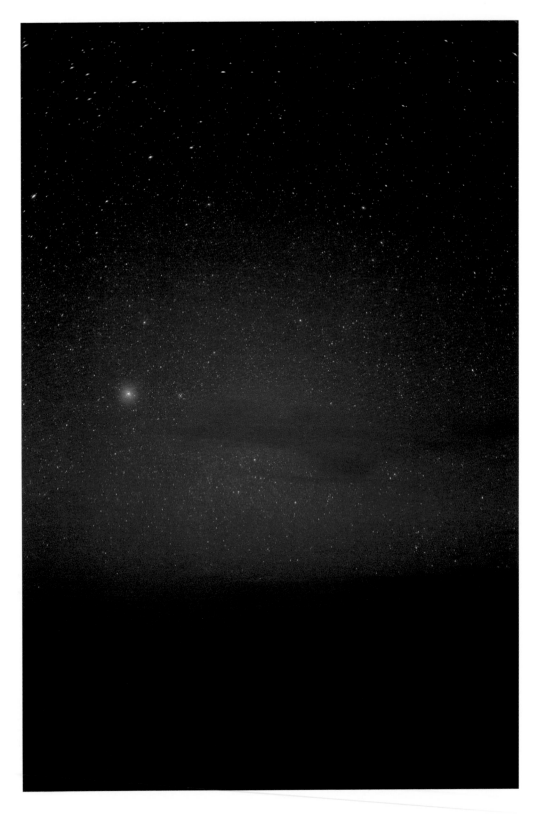

Munuwata sky, 2011
young man, Jeddah, a, 2012

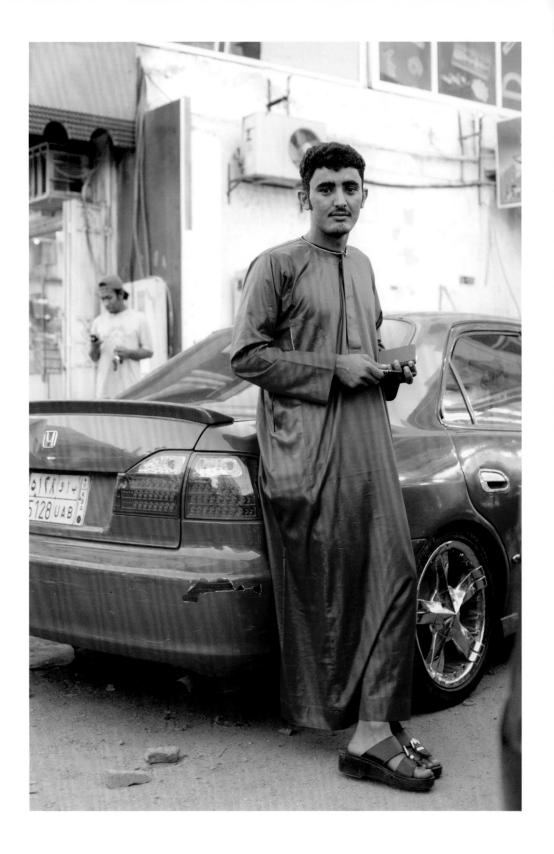

Faced with these conditions, the artist, without judgment, has to represent spatial cacophonies, dizzying simultaneities, screens upon screens, rather than imposing false and non-credible kinds of organisation upon the world.[46] If this is a conclusion Tillmans seems to have reached with *Neue Welt*, one can easily discern how it connects to another major series of photographs titled *End of Broadcast*, monumental prints showing close-ups of a first-generation flat TV screen still receiving analogue signals, taken, as the title suggests, at the end of the day when signals are scrambled. The pictures were made in a hotel room in St Petersburg, and shown later in *Manifesta* in the same city in 2014, alongside photographs of newly built Orthodox churches. One might well argue that with *End of Broadcast* Tillmans extends his conclusions from *Neue Welt* to confront a political situation characterised by regression and fear. The image of analogue TV static is a kind of allegory of political and social confusion. Far from being another abstraction, it is a representation of the world when progress is reverted, where connections between people break down, a situation Tillmans discerns not just in Putin's Russia.

But there is another dimension to *End of Broadcast*. Because he could photograph the analogue static with his digital camera using its particular settings, Tillmans was able to print it at a monumental scale so that it functions dynamically when experienced in real space. From a distance it is black and white noise, but anyone who walked up to the print found that each pixel was a unit of red, green or blue. A colour grid revealed itself, slowly. This leads to the next question I will ask: Did Tillmans's conclusions about the 'new world' leave him in a position where all he can do is reflect fragmentation and regression, or can he still assert a worldview that expresses a kind of hope, even a resistance to the conditions he represented? I think he does, and to see how we have to look at a final group of his works.

Planets, clouds and waves

Right in the middle of *Neue Welt*, Tillmans printed a ravishing and romantic cloudscape, *Lux*, 2009. A central column of purple-grey cloud is flanked by two apertures through which we see more distant clouds still illuminated by the soft pink rays of a setting sun beyond and below. It is a dreamy picture showing long distances impossible to measure. Elsewhere in the book are photographs of wondrous night skies teeming with stars above faraway islands and silhouetted trees. Photographs like these have always been in Tillmans's corpus,[47] and aware of their glaring obviousness as photographic subjects, he always asks whether such images are actually possible for him to make. But he concludes that they are, and in the years since the publication of *Neue Welt*, pictures of clouds, starry nights, sunsets, seashores and waves have become more prominent, and were the focus of his 2016 exhibition and catalogue *On the Verge of Visibility* for Museo de Arte Contemporânea de Serralves in Porto. Tillmans now makes these images with a camera that can record incredible detail even if sometimes the digital mechanism creates 'stars' instead of darkness, meaning that not every white dot we see in the final image is an astral body. He also plans ahead for these photographs, selecting specific window seats on planes, and occasionally visiting a particular beach, but of course, for all this control, he lays himself open to the unpredictability of weather systems, and he will never enhance an image by adjusting colour, cropping or digital clean-ups. The critical questions these photographs raise recall those I asked about

Lux, 2009

Spreads from *Total Solar Eclipse*, 1999

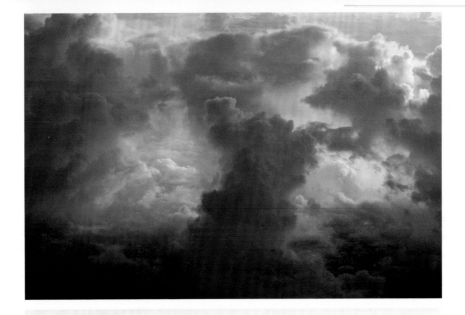

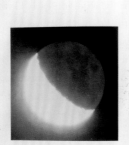

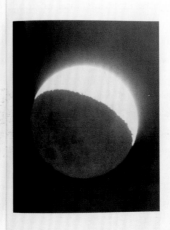

his abstractions: Are they escapist, indulgent, saccharine and even clichéd pictures, or, more than ever before, do they emanate from Tillmans's worldview?[48]

This strand of Tillmans's practice goes right back to childhood hobbies – as revealed in his 1999 book *Totale Sonnenfinsternis*, where he published teenage charts and photographs recording astral movements. Early on, Tillmans's interest in astronomy was no different from any other child's except for its obsessiveness, but soon he connected this study to a radical sense of existential humility. To look at the universe and understand one's location in relation to planetary movements was to register earth's smallness, how little we can see, and how much we do not know. To measure intervals such as the 128 years between 'pairs' of the passage of Venus (a phenomenon he photographed in 2004 and 2012) was to understand by contrast the brevity of human, historical time. His interest in eclipses also connected to this sense of vulnerability, to the idea that our source of light and warmth can disappear. And as an artist using a camera, as with many others such as Tacita Dean, his later dedication to travel to see eclipses linked to his interests in his apparatus, as he associated the blocking and revealing of the sun with the speed and aperture of the camera lens. Tillmans has also followed research into the possible life forms elsewhere in the universe, not to indulge sci-fi fantasies, but because a proof of their existence would shatter so many powerful belief systems and humans' confidence that their way of understanding the universe is the only 'truth'.

But what of the awesome beauty of these photographs? Tillmans's preparedness to make and show these images reveals his generosity and desire to connect with his audiences, knowing that the appreciation of picturesque night skies, sea and cloudscapes is widely shared, and that many of his viewers will have attempted to make similar images, even if they were not able to print them as large! Indeed, it is only thanks to his mastery of current photographic technology that he can make them at such a scale: for instance, the almost four-metre-wide print of *The State We're In, A*, 2015, which offers a visceral immersion in the physicality of the Atlantic in a way that was technically simply not possible until today, thus marking a new moment in the history of painters' and photographers' efforts to depict the inherent and daunting mutability of the sea in a still picture.

Where many recent artists have mined this subject matter to expose the clichés and conventions of advertising and amateur photography, or even as ironic appropriations of kitsch, Tillmans acknowledges that like others, he too is moved by these scenes. In this respect these photographs are closer in spirit to Bas Jan Ader's 1971 *Farewell to Faraway Islands* than to Richard Prince's sunset-backed cowboys, but in fact Tillmans's pursuit and appreciation of beauty has more in common with the situation Felix Gonzalez-Torres recounted when writing about Roni Horn's *Gold Field* in 1990. Gonzalez-Torres described how during a time living in Los Angeles with his dying boyfriend, Ross Laycock, he came across Horn's sculpture in a room in the Museum of Contemporary Art. Against a backdrop of persecution, disease and the ascendancy of reactionary political forces, Horn's work was 'A new landscape, a possible horizon, a place of rest and absolute beauty. Waiting for the right viewer willing and needing to be moved to a place of the imagination … That gesture was all we needed to rest, to think about the possibility of change. This showed the innate ability of an artist proposing to make this place a better place. How truly revolutionary.'[49] The same might be said for the

Venus transit, 2004

Installation view of *Wolfgang Tillmans*, Kunstsammlung Nordrhein-Westfalen – K21, Düsseldorf, 2013

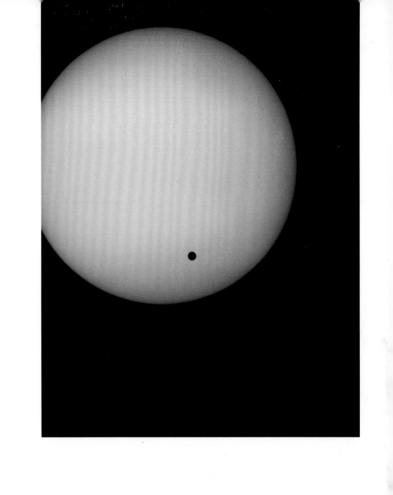

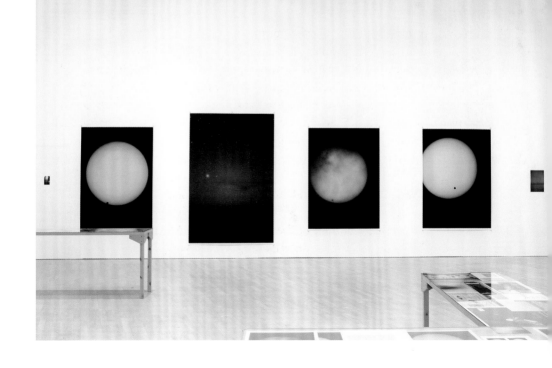

La Palma, 2014

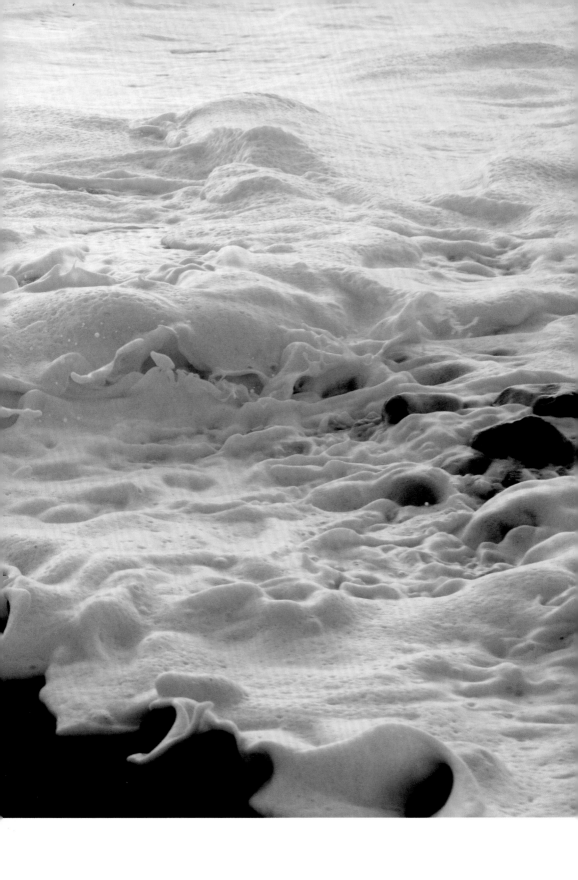

offer Tillmans makes with his images. Discussing them, Tillmans mentioned another artist living with AIDS at that time, 'David Wojnarowicz, one of the most socially engaged artists of recent history.' In Wojnarowicz's video *ITSOFOMO* (1990) he punctuates a dialogue about the AIDS crisis with the mantra 'Smell the flowers while you can.' Tillmans asks: 'How can that be a retreat?'[50]

Set against the reality of being vulnerable and a world of inequality and persecution, an appreciation of the beauty of waves, sunsets and stars is all the more urgent. Tillmans's pursuit of natural beauty cannot be separated from his engagement with society, but still the question remains as to why such images have become so prominent in the mid-2010s. In a very allegorical way, they reveal Tillmans's growing sense of what it means to be entangled with the world. Just as a drop is part of a wave, and may evaporate into a cloud, so we are entangled in our society, whether we like it or not, with all the responsibility that it brings. One of the reasons Tillmans makes these images so large is to make this entanglement *felt*. For Tillmans, entanglement is social and material. 'Everything is matter continually renewing itself and transforming from one aggregate state into another. I even find that somewhat comforting.'[51] The focus on water and light in the sea and cloudscapes also connects back to his concern with paper as the material base of photographs. In a recent installation entitled *I refuse to be your enemy*, he covered *truth study center* tables with sheets of blank paper, and there was a kind of reminder that however standardised their sizes, the sheets were the products of living trees pulped with water.

Seascapes and cloudscapes enable Tillmans to explore entanglement in a different way from *Neue Welt* with its images of compressed urban spaces and its disjunctive layouts; but they also allow him to retrieve a sense of space in which to remember that the artist does not just have to register conditions they witness. The artist can also wish for – even campaign for – something different. This is why the 'possible horizon' features so prominently in Tillmans's cloudscapes and seascapes: marking the limit of our vision, the horizon is the place we associate with hope, with the possibility of change. This brings me on to the last context for Tillmans's recent works. In clouds and waves Tillmans sees water in a system of constant redistribution, which as we know is an idea that interests him greatly. More than that, clouds and waves are bodies of matter that move across the world without the control of nation-states, that cross borders without human control. The seascapes and cloudscapes might be considered as counter-images to the photographs the artist surreptitiously (and illegally?) takes at border crossings and passport controls. Tillmans knows the sea is the graveyard of so many people trying to create better lives: with images of search patrols in the Mediterranean, he does not let viewers forget this, and he also described the 'very agitated' surface of the sea in *The State We're In, A*, a surface 'about to erupt at any spot', as 'an analogy with the state we're in right now'.[52] But at a time when nations close borders, Tillmans has confidence that his more peaceful pictures of cloudscapes and waves will also be images of another, freer way of being in the world.

Horizons and hope

When it came to creating posters to encourage people to vote 'Remain' in the 23 June 2016 referendum on the future of the UK's EU membership, for all these reasons, Tillmans

Posters designed for the pro-EU /
anti-Brexit campaign, 2016

WHO WANTS TO LEAVE WHY ?

"I ONCE ASKED RUPERT MURDOCH WHY HE WAS SO OPPOSED TO THE EUROPEAN UNION.

'THAT'S EASY' HE REPLIED.

'WHEN I GO INTO DOWNING STREET THEY DO WHAT I SAY; WHEN I GO TO BRUSSELS THEY TAKE NO NOTICE.'"

Your opinion about the EU only counts if you're going to vote on **23rd June**

Wolfgang Tillmans
Between Bridges

A POLISH FRIEND TOLD ME THE OTHER DAY:

I NOW HAVE AN E.U. FLAG AT HOME. WHEN WE DEM- ONSTRATE AGAINST OUR NEW AUTHORITARIAN GOVERNMENT, WE DO SO UNDER THIS FLAG.

I SUDDENLY REALISED, THE E.U. IS THE LAST DEFENCE AGAINST ANTI-WOMEN'S RIGHTS, ANTI-GAY RIGHTS, RACIST 'STRONGMEN' POPULISTS IN EASTERN EUROPE.

DO YOU WANT TO LEAVE THEM ALONE? NOW?

Vote Remain on **23rd June**

Wolfgang Tillmans
Between Bridges

Say you're in if you're in.

It's a question of where you feel you belong.
We are the European family.
Vote Remain on <u>23rd June.</u>

Wolfgang Tillmans
Between Bridges

It's a question of where you feel you belong.

We are the European family.

Register to vote before 7th June

MY FATHER'S ENGLISH, MY MUM'S FRENCH, I STUDIED IN VIENNA, NOW LIVE IN DENMARK.

IT'S NEVER BEEN A HASSLE TO DO SO.

AND I DONT WANT IT TO BE.

COUNT ME *IN*.

Wolfgang Tillmans
Between Bridges

used his recent cloudscapes with their horizon lines as the backdrops for his slogans. In this context, it became apparent how far Tillmans's photographs were from 'nationalist' landscapes such as those we can conjure up in our minds' eyes: proud pictures of the white cliffs of Dover, or cosy shots of English village greens. The cloudscapes show us a view of the world without emphasising landmarks associated with any single nation's identity. They point to tomorrows. Thus to find 'We are the European family' over a horizon line was quite fitting. Tillmans's campaign was a rare moment today of an artist devoting time, resources and his own images to a cause; he took everything he had learned about distribution platforms over a twenty-five-year art practice and put it to work, also mobilising editors, journalists, art-world colleagues and other artists. But as we know, a majority of British voters chose a different path.

Towards the end of his book *truth study center*, a collection published in 2005 just prior to the first installation of tables given the same name, Tillmans printed *I don't want to get over you*, 2000, an image I discussed before. Following this, eleven pages were given over to photographs of a fragile branch of a thin apple tree growing from a pot on a narrow balcony of a flat opposite a London council block. The first photograph was taken at night, so the flash almost bleaches out the pink blossoms; all the daytime shots have overcast grey London skies beyond the branches. These are pretty unremarkable scenes, but slowly one realises that the sequence charts the passage of a year, or rather a year and a bit, because in the last shot, it is spring again, and the thin branch is just a tiny bit thicker. Following from *I don't want to get over you*, which as I have argued marks a moment of loss, the sequence shows Tillmans thinking about renewal and regrowth. Some may remark that to associate blossoms with such ideas is to indulge in sentimental cliché, but what is wrong with sentiments, and don't we need images and symbols to help us heal? In any case, I am referring to this sequence because it shows how this artist has always remained hopeful. So it was that on 24 June 2016, a day after Britain voted to leave the 'European family', Tillmans published a letter of resilience and another call to arms. The vote was a huge disappointment, but the view to the horizon had to be held:

> It's now the duty of us all to defend the pillars of the free world order that was created over the last 70 years. To hold the centre ground, and not to contribute to the centrifugal energies around us. And I know that we're still the majority.[53]

Posters designed for the pro-EU / anti-Brexit campaign, 2016

**What is lost
is lost forever.**

Say you're in if you're in.
This one's important:
If the UK leaves Europe
it may spell the end of
the largest peace project
in human history. It's not
about 'same old' but
about pulling through
together.

Register to vote
before **7th June**

**For 60 years
the E.U. has
been the
foundation
of peace
between
European
neighbours.**

Say you're in if you're in. This
one's important:
If the UK leaves Europe it'll
send a strong message to
haters of European values.
It's not about 'same old' but
about pulling through
together.

Vote Remain
on 23rd June

**After
centuries of
bloodshed.**

THE EFFECTS OF *LEAVING*
THE E.U. FOR STUDENTS:

FUNDED OPPORTUNITES
FOR YOUNG PEOPLE SUCH
AS *ERASMUS* OR WORK
PLACEMENTS ABROAD ARE
AN EVERYDAY REALITY IN
E.U. MEMBER STATES. THEY
WILL DIMINISH WHEN THE
UK LEAVES THE E.U.

Your opinion about the EU only counts
if you're going to vote on **23rd June**

Democracy, peace and
human rights have
many enemies.

Brexit will make them
stronger. Only as a
united Europe can we
stand in their way.

Have your say.
Register to vote by
7th June.

**No man is
an island.**

**No country
by itself.**

Say you're in if you're in.
This one's important:
If the UK leaves Europe
it'll send a strong
message of support
to haters of European
values. The EU defends
human rights,
democracy and peace.

You have to register to
vote before **7th June**

EU referendum poster event orchestrated
by Helen Robertson, Central Saint Martins,
2016, photo: Helen Robertson

Posters designed for the pro-EU /
anti-Brexit campaign, 2016, photo:
Claire Smith

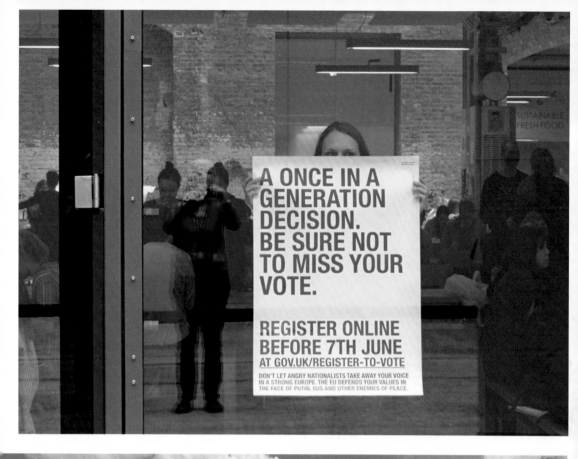

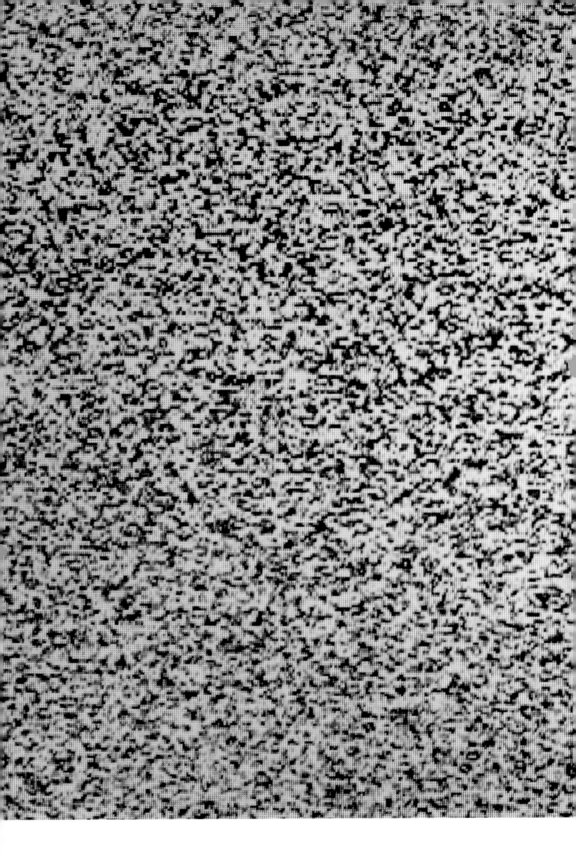

Sendeschluss / End of Broadcast I, 2014

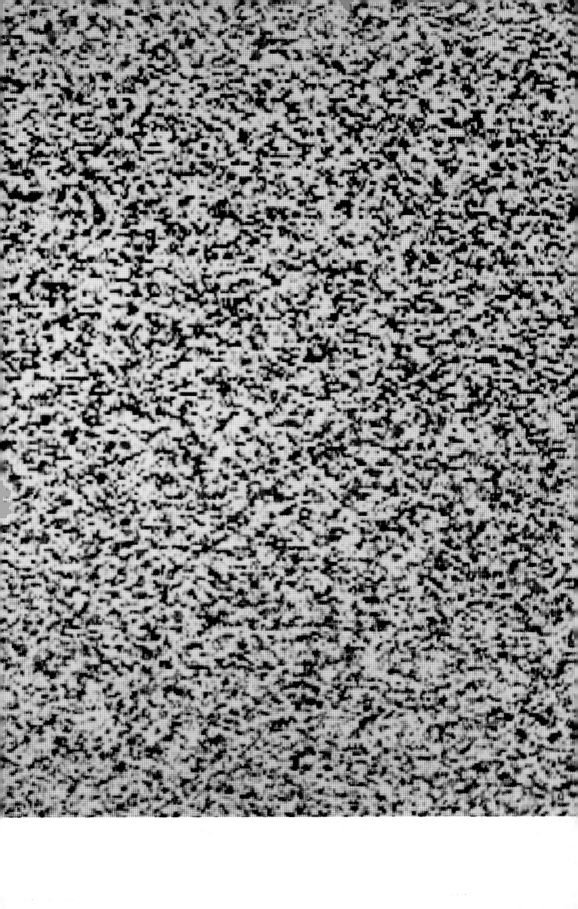

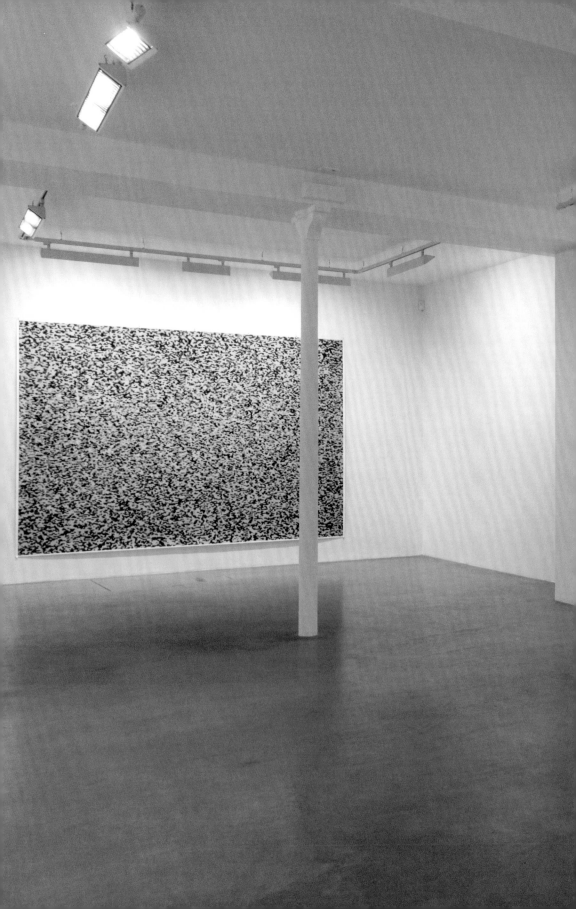

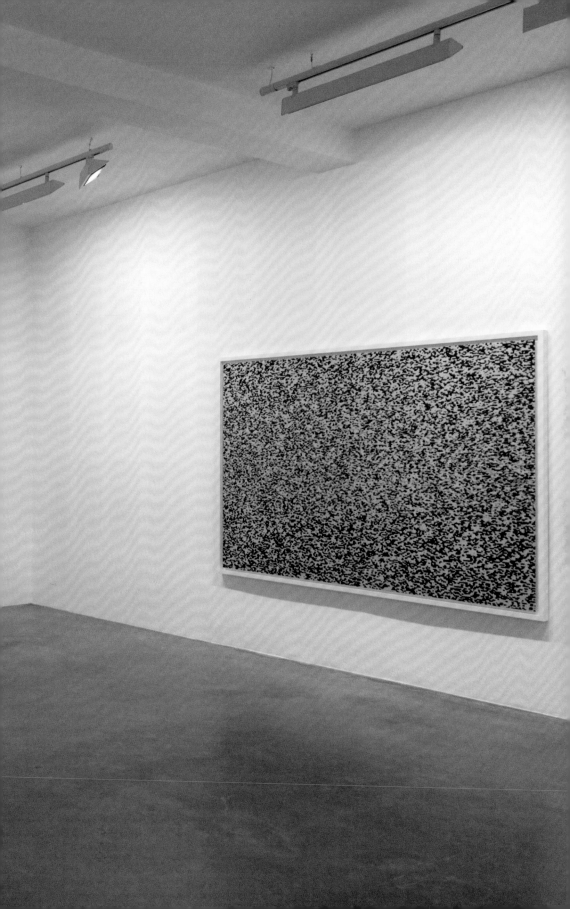

Memorial for the Victims of Organized Religions, 2006 in *Wolfgang Tillmans*, Hirshhorn Museum and Sculpture Garden, Washington, D.C., 2007

Gold (a), 2002
Gold (e), 2002
Gong, 2007, gold, 70 × 45 × 4 cm

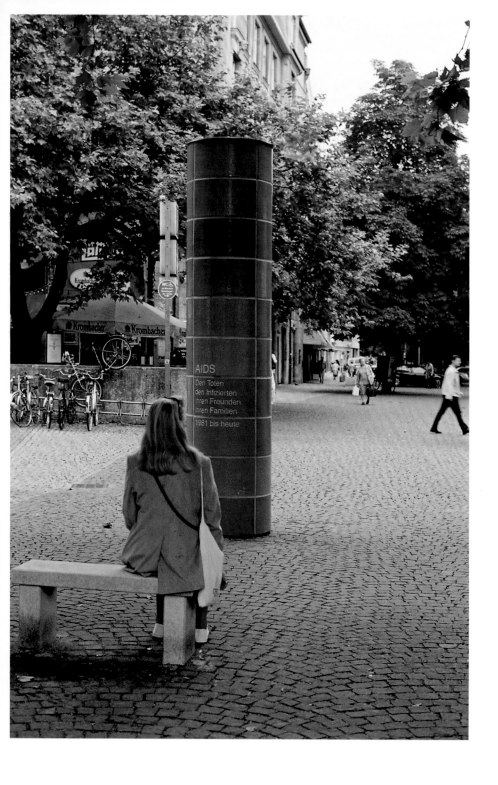

AIDS Memorial, 2002, column of ceramic tiles
with inscription, 400 × 80 cm, Sendlinger Tor,
Munich

Zeitungsjacke (Newspaper Jacket), 1985,
various fabrics and newspaper, 93 × 45 × 15 cm

Berlin Biennale Installation (Eastern
Woodlands Room), 2014, *8th Berlin
Biennale*, Museum Dahlem, Berlin, 2014

Tom Holert

Sensate Life in the Public Sphere: The Polypolitical World of Wolfgang Tillmans

Inherent/Overt

Visitors who entered the exhibitions by Wolfgang Tillmans at Galerie Buchholz in Berlin
or at Maureen Paley in London in Spring/Summer 2016 were confronted with an array of
posters that carried slogans such as 'No man is an island. No country by itself', 'Say you're in
if you're in', 'What is lost is lost forever', or 'Democracy, peace and human rights have many
enemies. Don't make them stronger. Only as a united Europe can we stand in their way.'
Written and designed by Tillmans and his assistant Paul Hutchinson, the posters
addressed the risks of a 'leave' vote on 23 June 2016, the day of the UK EU referendum,
and were a crucial element of Tillmans's multi-platform 'remain' campaign. Some were
simply typographic text posters; others were typeset on a variety of backgrounds, many of
which were drawn from Tillmans's recent series of pictures of horizons, first exhibited in
his early 2016 *On the Verge of Visibility* show at Porto's Serralves Museum. Transmitting an
immediate sense of urgency and concern about the future of the EU in a rampantly violent,
crisis-ridden geopolitical landscape of forced migration, right-wing populism, religious
extremism and environmental apocalypse, the campaign focused on specific issues such
as voter registration, the EU's origins and legacy as a peace project, the Erasmus student
programme, the role of Rupert Murdoch's media consortium in the Brexit hype or Eastern
Europe's viewpoint.

An initial impulse for Tillmans to act upon the Brexit cause was his realization that not only
was the official 'remain' campaign underwhelming and lacking in passion, but people in
the UK – particularly younger ones and those working in art and culture – seemed generally
unaware of the referendum's rubric (such as advance voter registration) and the potentially
disastrous political effects of a 'leave' vote. In his first statement, published 25 April 2016
on his own website, the artist – a UK resident since 1990 and the first non-British winner
of the Turner prize in 2000 – vividly expressed his concerns in the wake of the referendum:
'I feel that we have reached a critical moment that could prove to be a turning point for
Europe as we know and enjoy it – one that might result in a cascade of problematic
consequences and political fallout.' In close cooperation with Annett Kottek at his London
studio, Paul Hutchinson, Armin Gerold Lorenz and Evelyn Marwehe at his Berlin studio
as well as Eugen Ivan Bergmann at Tillmans's non-profit art space Between Bridges in Berlin,
the EU referendum-related activities went through different stages between February and
June 2016. In the run-up to the 7 June 2016 registration deadline and the referendum itself,
the intensity of the campaign increased significantly. Tillmans's studio, toward the end
supported by the infrastructures of his London and New York galleries, by *i-D* magazine,
Dazed Digital, impossible.com, the Boiler Room DJ site, financially helped by friends from
the architectural world such as Evelyn Stern and David Chipperfield as well as Ruth and
Richard Rogers, and frantically active on social media, produced a stream of new posters,
statements and T-shirts, downloadable from his website and targeting specific audiences,
such as Britons living abroad, the visitors to Glastonbury Festival, Ibiza tourists or LGBTQ
contexts. Coverage of the campaign was considerable, too: newspapers such as the *Guardian*

What is lost is lost forever

jevahr
De Balie ›
FOLLOW

Register to vote by
7th June
Don't let an older generation decide your future

vivriennewestwoodo... Follow

17.1k likes 11w

viviennewestwoodofficial Vivienne. Pic #juergenteller @sadiecoleshq

load more comments

lolandahcopat 🙌🏼

petit_four39 💚Love you Ma!! Your dresses look so good (on me 😂)

elemela92 Fabulous 😍 @viviennewestwoodofficial

priscilawitchqueen Unfortunately I can't vote, but yes, the fuc***** referendum has consequences for me as well too. 🇪🇺🇧🇷 Leaving my violent and trouble political country (Brazil) forever won't be possible if this shit happen UK to leave EU. God damn it! I was studying in the UAL London till final 2015 but my visa expired. Now I'm in Brazil waiting for things to happen for good and becoming Portuguese (European passaport) I hope this referendum leave the UK in Europe as normal.

♡ Add a comment... • • •

and the *Financial Times* reported on it, *Der Spiegel* printed a six-page interview and numerous online news outlets and blogs commented on it.

Although the outcome of the UK EU referendum was a huge disappointment for everyone in favour of the EU and the 'remain' option, Tillmans showed no sign of resignation after 24 June. In an open letter to artist Cornelia Parker, which he published on his website, he encouraged the readers to get involved in face-to-face activist organising, musing on how campaigning 'brings people from different backgrounds together in unexpected and friendly ways and creates friendships that hopefully will last'.[1] He also announced that he aims to continue with his political work, 'as right-wing populism and extremism will be with us for some time to come'.

As outspoken on political topics as Tillmans may have been on several occasions before – addressing issues of LGBTQ rights, HIV treatment, homelessness, the visual militarisation of media and of the militarisation of uniforms of police forces (in his *Soldiers: The Nineties* project, 1999ff.) and using the tables of his *truth study center* complex of work for all kinds of direct messaging – he rarely engaged in straightforward activist work. In a 26 May 2016 statement he thus admitted that he 'morphed in recent months from an inherently political, to an overtly political person', the 'pressing reason' for this lying in the 'observation of the larger geopolitical situation and an understanding of Western cultures, as sleepwalkers into the abyss'.[2] The differences between the inherently and the overtly political are not entirely levelled though. Stressing the freedom (and responsibility) implied in the 'uselessness' of art,[3] he draws a line between artistic and activist practices, even if this line has become increasingly porous. While considering the EU campaign posters a 'part of my work', they are 'driven by a different necessity and criteria'.[4] At the same time, Tillmans insists that the political engagement is part of his 'integrity as an artist'.[5] With the EU campaign and by running Between Bridges's 'Meeting Place' as a 'collectivised space for voices to be heard', Tillmans has forsaken 'hesitation and procrastination in favour of action', as critic Saim Demircan writes.[6] Art historian and Occupy Wall Street activist Yates McKee recently asked when the involvement of an artist in a particular kind of activity does become worthy of consideration from the vantage of contemporary art,[7] which is another way of asking how the position of the contemporary artist (and of contemporary art as such) might come to bear on the practices of political organising, consciousness raising, radical pedagogies, etc. At stake here is nothing less than a post-avant-gardist redefinition of artistic practices, of their distribution, circulation, communication and legitimisation, not to be replaced by activism but to join its project of equality, redistribution and communality.

In order to contextualise Wolfgang Tillmans's turn to political activism as an artist who has always kept a certain distance from engaging directly in politics and abstained from working in the more obvious modes of political art, such as 'social practice', the documentary, protest art or community art,[8] the following will focus on one individual work to glean from its reading a sense of what it might mean to bridge the art-and-activism divide. If activism in the best of cases 'contains the ability to form new modes of affiliation', as educator and artist Matthew Friday puts it,[9] it might be instructive to look closely at a picture that deals with sociability and togetherness and to reflect on its political implications.

Spread from and cover of *Soldiers: The Nineties*, 1999

Soldiers: The Nineties, MCA version, 1999–2006 in *Wolfgang Tillmans*, Museum of Contemporary Art, Chicago, 2006

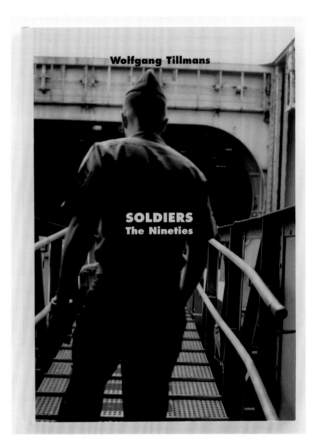

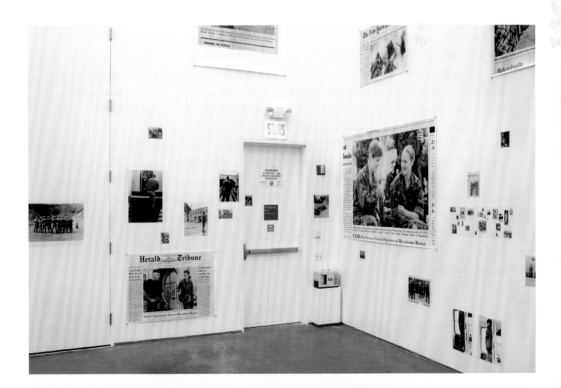

A safe space?

The glaring beam of light reflected by the large mirror in the back has a strong, yet other-worldly presence. The fact that its source, its actual place in the narrow, eagerly populated room, is hard to determine may contribute to the particular function of this luminous column as it seems to stabilise and at the same time dissolve the complicated spatiality captured by the photograph. *The Spectrum/Dagger*, 2014, shown for the first time as a large, two-metre framed inkjet print in Wolfgang Tillmans's Autumn 2015 exhibition *PCR* at David Zwirner in New York, depicts a situation involving bodies in some sort of transitory movement, of dancing maybe, of backs turned to the camera, of people smiling at each other, of hard-edged architectural structures articulating the interior. The mirrored light illuminates the scene in such a way that a discernible rendering of it becomes possible after all, even though, in order to shoot it, Tillmans has pushed to the limit the sensitivity of the system built into his digital camera. The brownish yellow tone that tinges the entire picture and is entailed by the artist's conscious decision to use, rather than neutralise, the colour temperature of the light sources in the room, emphasises a pervasive mood of intimacy and joyfulness projected into the viewer's space by the assembly of faces, bodies and shapes.

When taking the picture, Tillmans must have been standing immediately behind the back figure on the far left. What's more, in this very moment, he seems to have been witnessing a hallucinatory gyration of this socio-physical space. With the perspective awkwardly tilting to the right, the energy pulsating in the communality represented, or some other miraculous force, appears to animate the room in its entirety. Interestingly, the artist somehow managed to avoid being reflected in the mirror. One might as well say, rather than inserting a literal self-portrait in the togetherness he was witnessing when taking the picture, he has the beam of light standing in for his own mirror image.

Avoiding his own image being seen in the photograph was possibly a conscious, or even a conscientious decision. For Tillmans photographed the scene in The Spectrum, a 24/7 illegal queer club, dwelling place, performance venue, rehearsal space, yoga and self-defence centre on 59 Montrose Avenue in Williamsburg, Brooklyn, where he often went when he was in New York. The night he made the photograph, the Dagger was on: a party originally hosted 'specifically for women and those identifying as female or non-gender, with strictly female staff, performers and DJs',[10] which had since evolved into a more permissive night where familiar male guests were welcome. The subcultural politics of The Spectrum and its initiators, performer Nicholas Gorham and artist Gage of the Boone (soon joined by music booker Danny Taylor aka A Village Raid and artist/performer Raúl de Nieves), were purposefully incongruous and non-segregationist (hence the club's name, referring to the entire 'spectrum') while marked by the knowledge of the imminent vulnerability of the place itself and everyone involved. Until they were forced out of this former Puerto Rican sports bar and aerobics studio (featuring a stripper's pole) at the end of 2015 after almost five years of operation, the organisers made perfectly clear that they wanted their mirrored venue to be a protected zone where people did not have to fear harassment or hostility. Painted graffiti in the entrance hallway declared The Spectrum a 'safe queer community space', and the regulars filled this space with art, music and sheer gorgeousness, some of them actually living here, in cupboard-size spaces above the dancefloor. Not only

Installation view of *Wolfgang Tillmans*, House of Art České Budějovice, Budweis, 2015

was it a venue that hosted musicians, DJs and performers such as Le1f, Mykki Blanco, Zebra Katz, Kevin Aviance, Shannon F, Lafawndah, La'Fem Ladosha and Hood By Air, it also was a space, in the words of Gage of the Boone, that 'gave people a real opportunity to meet and connect, especially with the chill room. People could sit back and just watch, or be as much of the show as they wanted to be. It really was a home to a lot of gay orphans, and created a space that really was family. A lot of people learned a lot about themselves, as well as about queer politics, gender politics, trans rights, privilege/oppression and racial equality.'[11] The club was also meant to be off the radar, visually. From the start, Gage of the Boone and his collaborators 'decided that Spectrum was not going to allow photographers, ever. Without the fear of documentation, people felt much more comfortable about letting go.'[12]

Just a few weeks before The Spectrum closed, in a seventy-five-minute speech he gave on 1 December 2015 in Gothenburg – where he had the night before received the Hasselblad Foundation International Award in Photography – Tillmans talked about how much he was aware at that moment in The Spectrum's chill room that this was the kind of nightlife he often searches for in vain and hence treasures immensely when he finds it, a *modus vivendi* in which people are 'free, fearless, in an uncontrolled, but safe environment'.[13] Careful to distinguish between 'capturing' and 'amplifying' this – eminently vulnerable – conviviality of fearlessness and freedom photographically, in a place where party photographers feeding social-media outlets weren't tolerated, he pondered on his 'ability to preserve' such moments instead of disturbing them. Rather than using a flashlight, he thus pushed at the limits of even the most current photographic digital technology built into his compact camera, since the low-light situation required an extremely high ISO setting. However, this might be contrasted with photography theorist Ariella Azoulay's argument that such ability to preserve needs to be considered in relation to the 'camera's ability to create a commotion in an environment merely by being there'.[14] At this point where social world and visual technology meet, ethical and political concerns inevitably interfere with aesthetic objectives.

Tillmans does not deny the ethical dilemmas he is confronted with and sometimes creates. He speaks openly about how he interprets the responsibility of the artist when he uses the attention that comes with success to act in support of causes, individuals and groups he finds relevant yet maybe underrepresented; he also admits how he occasionally fails to be in control, for example regarding the distribution of his work.[15]

Another dimension of his work that can hardly be controlled is the 'event of photography', which Ariella Azoulay distinguishes from the 'photographed event'. The latter can be studied in the picture, whereas the former describes a potentiality that is all too common in a world not only saturated by images but also by image-making devices. The possibility of the 'event of photography', Azoulay claims, is 'of our being located within the range of "vision" of a camera that might potentially record a photograph of us', and it 'may well be experienced differently by the various participants as irritating, pleasurable, threatening, invasive, repressive, conciliatory or even reassuring'.[16] Through his wide-range of subjects and the variety of methodologies to arrive at pictures, Tillmans has been himself influential in shaping the 'event of photography'. By making tangible to an ever larger audience the possibility of a picture, the possibility of being photographed or acting as a photographer oneself, his work informs even the most private and enclosed situations as potential photographic subjects.

The Spectrum/Dagger, 2014 in *Wolfgang Tillmans*, Hasselblad Foundation, Gothenburg, 2015

The Spectrum/Dagger, 2014 in *PCR*, David Zwirner, New York, 2015

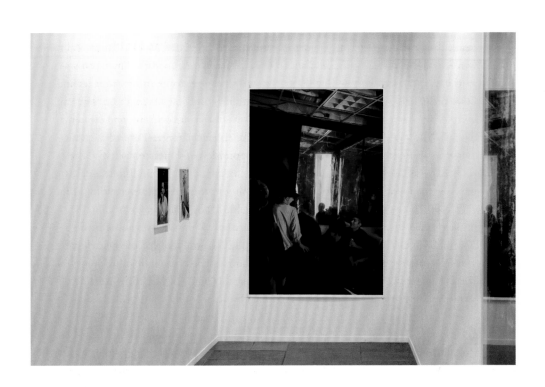

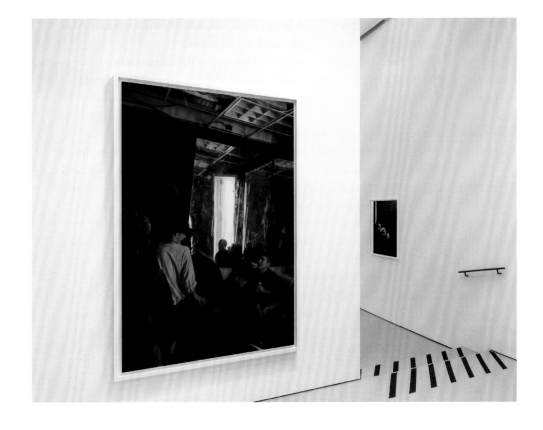

Therefore, the 'event of photography' had arguably reached the chill room of The Spectrum club before the artist entered it with his camera. In his Gothenburg speech Tillmans expressed how happy he was that this 'totally fleeting, ephemeral moment' came out as being 'compositionally so held together' in *The Spectrum/Dagger*.[17] And arguably, the togetherness of the composition corresponds with the apparently unstrained social interaction on view, that is, the quasi-utopian togetherness of the people constituting this composition in relation to the architecture of light and mirrors. *The Spectrum/Dagger*, Tillmans said, is 'a political picture for me,' and it should indeed be considered for its politicality on numerous levels. For one, every representation of nightlife and particularly non-mainstream, queer nightlife in New York, but also in many other places, is potentially a political statement in itself: inevitably, it contributes to the conflicts around the gentrification, regulation, policing and politicisation of nightlife.[18] On another level, nightlife is experienced as a permanent political practice among its various participants and constituencies who, it needs to be said, operate by following different agencies. Even a place such as The Spectrum, dedicated to the celebration of non-normative sexualities, wasn't free of conflict and problems of patriarchy and racism.

Likewise, the depiction of non-normative nightlife and subcultural empowerment, for which Tillmans became famous in the early 1990s, is always involved and engaged in struggles. These struggles may be internal; they may regard competition among performers. Much more importantly, however, these struggles concern the 'invisible presence' of 'common publics', of worlds of belonging, as queer theorist Michael Warner has put it in his memorable 2002 *Publics and Counterpublics*.[19] As Warner argues, the notion of a public, and in particular, of a counterpublic, can assume an enabling function, since it generates 'a reflexivity … among strangers who become, by virtue of their reflexively circulating discourse, a social entity'.[20] Tillmans's *The Spectrum/Dagger* could be considered the visual equivalent or translation of a counterpublic 'circulatory space, freed from heteronormative speech protocols'.[21]

However, as Warner emphasises, such a space is itself marked by the very suspension of heteronormativity. Addressing any participant as queer sooner or later will meet 'intense resistance'.[22] Orienting the world-making of a particular subculture toward protected venues or limited publications therefore doesn't make 'the risk and conflict involved' disappear. The interesting and intensely political operation that Tillmans's picture of the – quite literally – 'circulatory space' at The Spectrum is performing may be conceived as an enactment of what Warner says about counterpublic discourse, namely that even though it challenges 'modernity's social hierarchy of faculties' it does so 'by projecting the space of discursive circulation among strangers as a social entity'.[23] In other words, Tillmans not only makes available his self-confident 'ability to preserve' to the queer context at The Spectrum, he also addresses this context as a counterpublic in Warner's sense: as an underground culture of intimate relations, an 'embodied sociability'[24] that is potentially and radically transformative for everyone participating in it (rather than striving to replicate a legitimate or dominant public).

Due to its status as a work by Wolfgang Tillmans and the particular visual, social and financial economies of the art system in which it is implied, *The Spectrum/Dagger* shifts this address and the social imaginary that goes with it by transposing and extending it toward an altogether different register of attentiveness and publicness. When shown for the first time in Tillmans's 2015 solo show in the vast spaces of David Zwirner's gallery in Chelsea, the scene from the

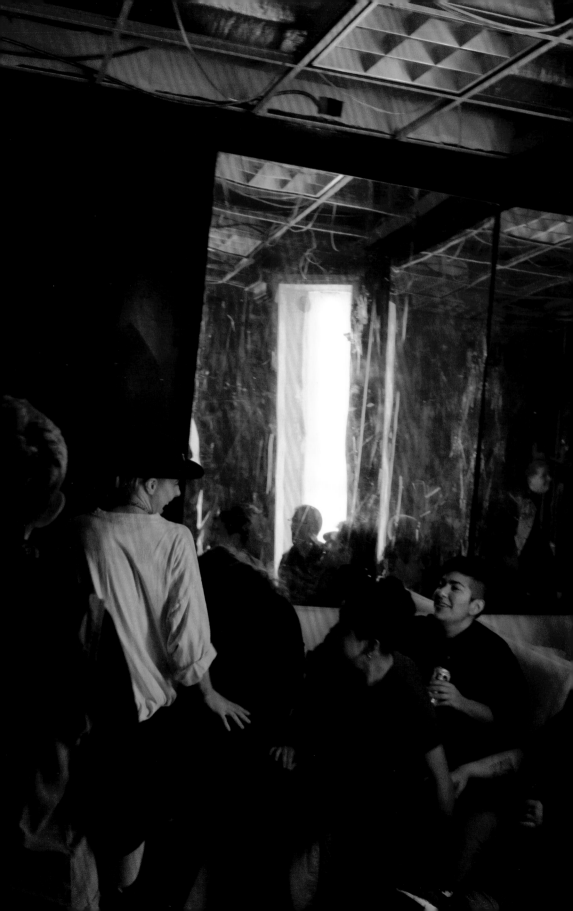

Dagger night bestowed heightened visibility on a sociality that entertains a complex and often contradictory relation to visibility. Even though going on for decades now, debates on the pros and cons of visibility in identity politics remain largely unresolved. Advocates of the empowerment through public visibility of marginalised groups and lifestyles continue to stand against those arguing for strategies of withdrawal from media presence and the control and violence it might entail.

In a telling phrase from a talk in early November 2015, the artist explains that the very act of bringing such images to a place elsewhere in the world, from the underground venue to the upscale gallery, is to 'make more of this in the world' – 'this' meaning ideas and representations of happiness in being together, playing with each other's bodies beyond the norm.[25]

If one of the reasons for a venue such as The Spectrum to exist is the safety from gazes intruding the enclosure of this queer environment, and consequentially a reduced visibility or even a complete withdrawal from the field of public vision, the inclusion of this picture in Tillmans's exhibition (and the digital dissemination this inclusion entails) may provoke criticism on the grounds of it being ethically and politically incommensurable with certain gender and queer politics. On the other hand, thinking of Michael Warner's reminder that every counterpublic is constituted by the risk and conflict inherent in its marginality, it may even be necessary to consider what fellow queer theorist John Paul Ricco has named 'the ontology of intrusion'. Stating that 'There has never not been intrusion insofar as there has been anything', Ricco claims that the sharedness of a space or a cause, but also of inequality and incommensurability, is inseparable from the 'ontological force and field' of intrusion.[26] Following up on this argument, however, the very notion of intrusion has to be qualified. For instance, accusing Tillmans of being an intruder who violates the protocols of (in)visibility of a particular social scene would not only contradict his intentions of 'amplification' and his ongoing project of contributing to an archive of alternative homosexual, queer and straight hedonism, it would also fail to account for the distinctive politics of form embodied in the large framed print that he put on the wall of the gallery, the particular methodology of filtering exposure through withdrawal, of making accessible a mode of looking at the world rather than offering what is depicted to straightforward visual consumption.[27] The Spectrum/Dagger continues the artist's strategy, already known to Tillmans aficionados from club scenes such as Easter, b, 2013 (a homage to the legendary once-a-year Snax nights at Berlin's Berghain) or those nightlife photos that originated at London clubs such as Crash and The Ghetto or at Berghain-forerunner Ostgut around 2002. In their chiaroscuro language of blur, mist and haze and their microclimate of sweat, pills and desire these photos gestured at the utopian quality of the depicted situations.[28]

In order not to evade the possible criticism of intrusion and forcible visualisation, it is necessary to insist on the notable differences that exist with regard to the subject position of an image-maker. A photographer could be everyone using a camera to take pictures. However, in ethico-political terms there are worlds between, say, a paparazzo trespassing the privacy of a celebrity (even if such intrusion might be constitutive of an ultimately symbiotic relationship) and a photographer moving as a fellow member/participating observer in a highly codified subcultural environment – and who also happens to be a world-famous artist with a track record of visual production that celebrates, rather than exposes, non-normative sexual behaviour and the communalities of the night.

arms and legs, 2014

The proto-politics of affect

To be clear, the problem of representation and the question of entitlement does not simply vanish by mentioning such achievements. Tillmans himself has always taken great care to use only images that do not show an individual or a group, human or non-human, in a compromising or unfavourable light (though the decision about what is compromising or unfavourable usually is made by him). Part of his ethical codex is to avoid publishing photos taken in hang-outs he frequented – as long as these often endangered places existed. Only after the gentrification-related demises of the Joiners' Arms, a legendary venue of the East London LGBTQ scene, or the George and Dragon, another locus of queer conviviality, had proved irreversible, Tillmans started to publish some of the photos he has made in these and other since defunct places during many years in a book that pays homage to his friend Conor Donlon.[29] The same is due for the pictures that Tillmans took of the world-making at The Spectrum. A first selection of these photos was published some months after the venue's closing, in the Spanish interior magazine *apartamento*.[30] However, exceptions from the rule, such as *The Spectrum/Dagger* or *Easter, b,* are possible, though always hinged on the condition that the underground/nightlife people featuring in the respective photo are either indistinguishable or content with being exposed. Repeatedly, Tillmans has stressed that a photograph speaks less about what has happened in front of the lens but rather about what has happened behind the camera, i.e. what has been built up prior to making (and to making *possible*) a particular picture in a particular moment.

In this sense, every picture provides evidence of the circumstantial, social, psychological factors that led to its existence. Reflecting on the consequences of the fact that his work can be read as the manifestation of a unique combination of personal experience, skill, perceptual ability, imagination, intelligence, political sensibility, etc., Tillmans once told an interviewer: 'You could say, these are just pictures of clubs, but you know thousands of people take pictures of clubs and none of them look just exactly like mine … That's a proof. I don't mean it as a proof of how brilliant I am, it's a proof of how specific photography is, how truly psychological.'[31] Hence the 'psychology' of photography, which is both a general condition and an irreducible personal fact, constitutes the artist's entitlement to carry his inconspicuous digital compact camera (which he is using in such situations) into the fleeting communality of the Dagger party at The Spectrum, a social realm that is as precarious as it is agentive.

Tillmans's emphasis on the importance of the notion of attentiveness for his aesthetic and ethical relation to others is supporting this claim. 'The way we look,' he elaborates in a 2013 interview, 'that is how we decide to act in the world, and that is then also how society as a whole acts, if you see societies always as an addition, an accumulation of individuals.'[32] Addressing this relatedness of individual and collective modes of receptibility, one may also speak of the particular instances of affect or affectedness that inform the picture and which make it resonate even beyond the world of those who were present in the situation it presumably depicts. For one, *The Spectrum/Dagger* displays gestures and facial expressions of joy and surprise. The delight and ease in the bodily movements is eminently palpable. At the same time, the picture doesn't really work as a portrait of the individual persons we see in it,

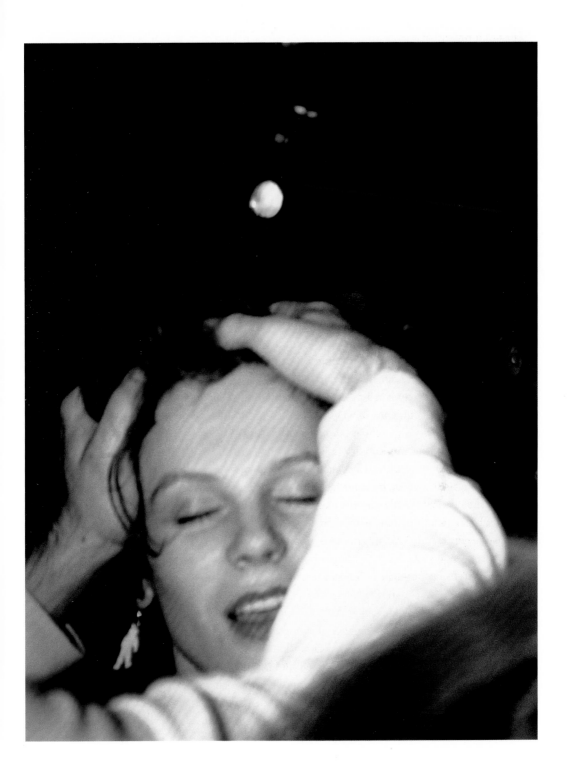

of whom only the image of the woman sitting at the bottom right side could on occasion be used for identification purposes.[33] It rather represents a certain way of being together, proposing a contemporary update of the eighteenth-century conversation piece or *fête galante*, documenting an ephemeral assembly, or rather the ephemeral of the assembly as such. It also needs mentioning that the entire upper half of the picture and more are given over to architectural elements of the room: the mirror walls, the waffle-slab ceiling, the nondescript dark space in the receding back on the left. *The Spectrum/Dagger* therefore could be called a discrete picture, a picture of discretion, withholding sociological or otherwise exploitable information about the club and its guests. Projecting a certain restraint on the part of the intruder/photographer to switch into a documentary or reportage mode, it nonetheless conveys much atmospheric data, while also providing insight into the high-frequency data-processing work being performed by the camera's sensor.

Coming back to the aforementioned notion of affect, *The Spectrum/Dagger* may be considered as rendering the affectedness of a particular space in which the photographer moved in the moment of encountering this particular arrangement of people and architecture. This affectedness is not exclusive; nobody owns it or could call it hers or his. It is shared by various communities – human and non-human. It travels inside and outside the picture and connects with other states of affectedness.

Introduced by Spinoza in the seventeenth century and further developed by philosophers such as Gilles Deleuze in the later twentieth century, the category of affect is an essentially transpersonal and processual dimension of life, encompassing, though not identical with in-dividual emotion or feeling. Affect can be helpful to determine the place where individuality and sociality intersect in the making of pictures and especially photographs. Brian Massumi, a theorist of affect writing in the vein of Deleuze, points out that '[t]he formula "to affect and be affected" is … proto-political in the sense that it includes relation in the definition. To affect and to be affected is to be open to the world, to be active in it and to be patient for its return activity.'[34] Such openness to the world's unpredictability, sometimes even its utter absurdity, is a key characteristic of Tillmans's thinking-doing as an artist and a political person. For the proto-politics of affect transgress not only the limits of the individual person but also align the various identities this person may inhabit simultaneously and over time.

Public artist

The work of Wolfgang Tillmans speaks eloquently about how the politics of affect are not a minor, negligible register of a politics of aesthetes but probably the only politics left to those who have become dissatisfied and disillusioned by any politics associated with the state and its apparatuses, not to speak of a politics entirely controlled by the imperatives of neo-liberal economy. Of course it is important to note that affects are highly malleable and can be channelled, to great effect, by populist politicians and extremist religious movements. Moreover, contemporary societies are ingrained by the contradictory 'affects of capitalism', the dangerous mix of feelings of hubris and helplessness in the face of an economic progressism that is all but indifferent to the fate of those failing on the marketplace and to the fate of the earth itself.[35] Any politics of affect that oppose such developments of polarisation and antagonism are at risk of

The Cock (Kiss), 2002

Next pages:
The Blue Oyster Bar, Saint Petersburg, 2014

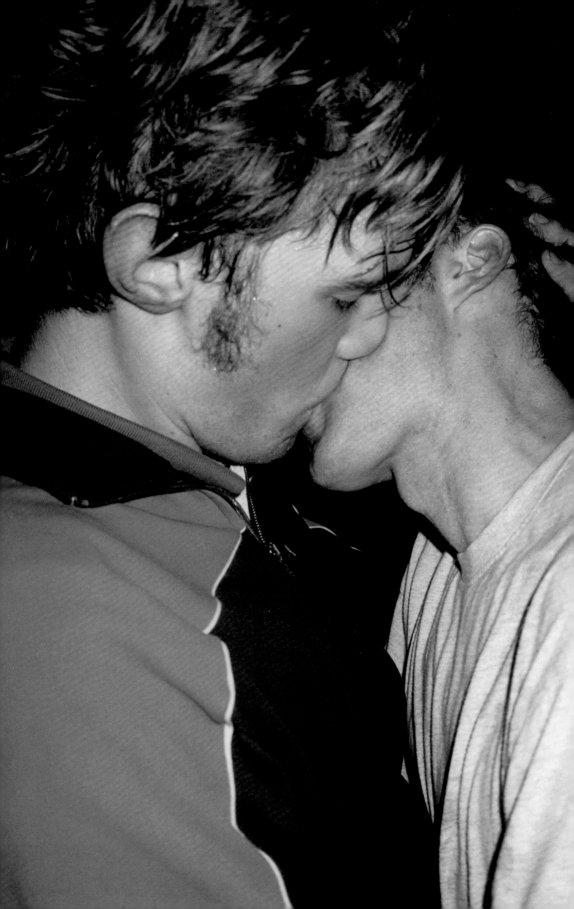

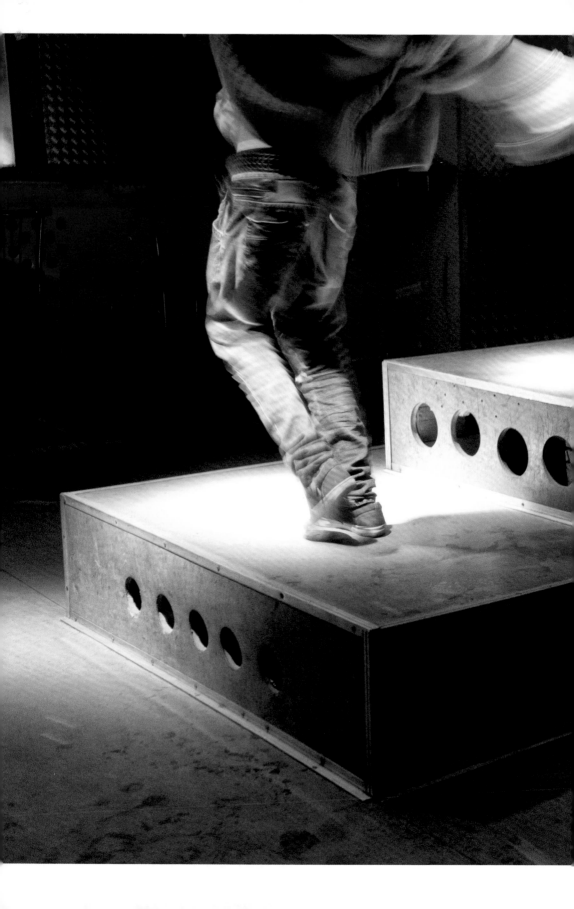

being confounded by the powers of public affect distributed, broadcast and streamed by traditional mass media and the internet. How to protect oneself and one's work from becoming enmeshed in such networked affect economy?

For Tillmans, the exhibition, the magazine, the book, the self-organised non-profit art space and, recently, recorded music – media of a scale that allows for a certain independence of aesthetic-political decisions – have become arenas to relay affect differently and with great circumspection. He uses these platforms according to his ideas and ideals of the world as a place where 'happiness' in the encounter with other bodies, ranging from a human being that may be a stranger or a lover to distant stars in the sky, to foamy water on the beach or a plant on the windowsill, actually is possible – provided it is being recognised and cherished appropriately, that is by careful observation.

Nevertheless, the decisive critical operation for Tillmans is the leap from the situatedness of the very scene depicted to the way in which the resulting individual work is situated both in the discursive realm of the artist's oeuvre and in the institutional and commercial infra-structures in which it circulates. In some respect, *The Spectrum/Dagger* is the work of an artist seeking not only a visual form but also the adequate public attention for the very fact that such a situation of people communing apparently easefully, as precarious and endangered their purported ease may be, is indeed possible in a world where hostility against minorities (or groups construed and policed as such) reigns.

Tillmans considers his exhibitions 'public experimentations, like a public laboratory situation, where I can put things next to each other and see what they do'.[36] He thus counts on a publicness of the exhibition that might (and is supposed to) exceed the confines of the art system. Moreover, his exhibitions, in their emphasis on the 'if one thing matters, everything matters'[37] logic of low-threshold accessibility and dehierarchisation, are exemplary for 'contemporary artistic or curatorial installation' in that 'the public is integrated into the context of the art ... and becomes a part of it.'[38] Such a publicness of the contemporary art exhibition/installation should not be confused with the regulatory institution of the public (or a counterpublic, for that matter) in the sense, following Jürgen Habermas, Oskar Negt and Alexander Kluge, Nancy Fraser, Michael Warner and others, of a space (or theatre) of discourses that circulate among strangers who identify as a social entity that addresses the state. Although the global art system, through its widespread and heterogeneous apparatus of private galleries, transnational museum enterprises, networked art fairs, large-scale exhibitions and biennials, as well as independent art organisations, schools and foundations, aspires to be the public sphere of the twenty-first century, it certainly lacks some of the characteristics that constitute a public as a critical counterpart to state politics and capitalist economy.

Nonetheless, the 'public' emerging from the congregations initiated by art events is to be considered seriously, even if it might not fully match the enlightenment notion of the public sphere and the subject of politics. One may even argue that the public sphere of modern democracies – the 'public space' in the terms of political philosopher Claude Lefort – resembles the laboratory publicness of Wolfgang Tillmans's exhibitions.[39] For Lefort states that the public space is a realm of political interaction without any fundament, fixity and certainty. To empty the place of power had been the aim of the revolutions that toppled the monarchies. In democracies it is the never-ending debate among social constituencies, no transcendent source, that would guarantee the groundlessness of society and politics. Moreover, it is the

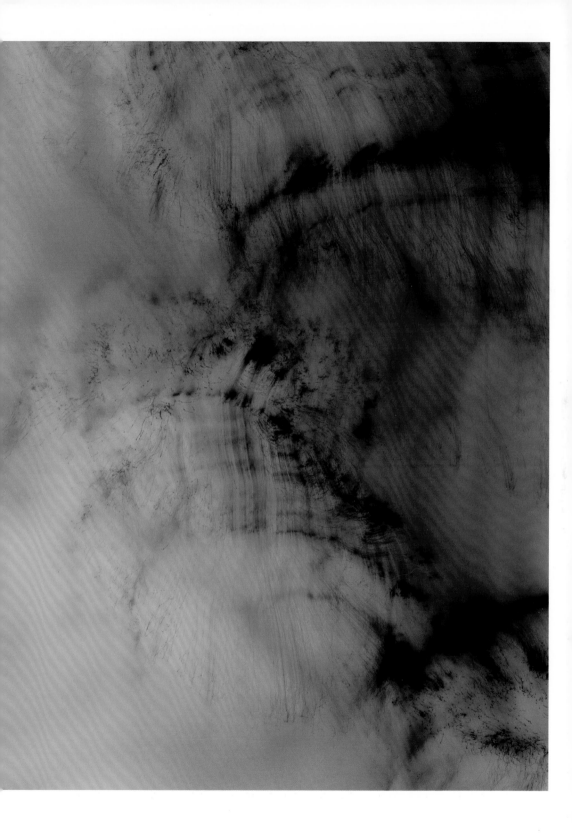

presence of the other in the public space that calls into question 'my joyous possession of the world', as philosopher Emmanuel Levinas has put it.[40] Accepting groundlessness and dispossession of knowledge as the condition, rather than as obstacle to democracy's public space, requires a willingness of each participant to constantly question the premises of her or his vision of the world.

Although the work of Wolfgang Tillmans in its impressive breadth and apparent self-sufficiency may on first sight be opposed to the humble recognition of the lack of any fundament, ontological and epistemological, it is indeed exactly such openness to self-doubt that operates at the heart of the artist's tireless fascination for the beauty of the non-normative. Paradoxically yet productively, he insists on the possibility of a publicness comprising an aesthetic vision that is both convinced of itself and self-defeating. Concerned with publicness, Tillmans's practice, increasingly over the recent years, aims at impacting the perception of political and aesthetic issues. His implicit political project as an artist eagerly redistributing the sensible[41] is constitutive of a pedagogy of perception and cognition based on aesthetic and ethical principles such as the openness for the unforeseen, the non-hierarchy of vision, the emphasis on the material objecthood of photography, the pursuit of happiness in the togetherness with people (and animals, plants, things …) against all objections of being naïve. This pedagogy has gained in programmatic edge over the years by way of Tillmans's extensive self-commentary (including interviews, lectures, teaching), but probably most effectively by way of his multi-scalar visual practice as such. The research and production preceding each exhibition or publication as well as the experimentation at the site of the gallery or museum up to the point when the local audience of a particular show is being engaged (often in informal as well as more formal talks and discussions, or in interviews that frame the event) are constitutive of Tillmans's pedagogical strategy. Not shying away from a certain didacticism (though not wishing to appear 'too didactic'[42]), he reiterates the concerns that are urgent to him, configuring his exhibitions as complex arguments in which particular pictures can gain notoriety among his followers by being presented in varying settings across different shows.[43] Thereby the artist deliberately orchestrates the effect of his art on its audience. Looking back at almost thirty years of exhibiting and publishing work, Tillmans's itinerary might be described as the evolution of a unique kind of public artisthood and intellectuality. Even though time and again Tillmans forays into immediate activism, like his 2006 cooperation with Treatment Action Campaign (TAC) in South Africa and the London-based AIDS treatment advocacy organisation HIV i-Base or the 2016 EU campaign, and even though he is very outspoken in his support and admiration for LGBTQ activisms all over the world, particularly in places such as St Petersburg or Warsaw where the gay and lesbian scene suffers from constant threatening pressure of the authorities, his major contribution to constituting a public critical of the status quo is arguably made through his art.

Returning to *The Spectrum/Dagger* and the picture's first public appearance at the 2015 *PCR* show, the modality of its presentation is of interest. Taking advantage of the great depth and detail of a large inkjet print based on data of a huge file stored on the artist's hard drive, Tillmans had the print framed and hung in a corner next to a print four times its size, a spectacular picture of a barrel turned plant tub filled with black soil, new sprouts and dead stems, photographed in close-up from above (*encounter*, 2014). Elsewhere in the gallery, *The Blue Oyster Bar, Saint*

Ostgut Freischwimmer, right, 2004 and nackt (nude), 2003 at Panorama Bar, Berghain, Berlin, 2004

Ostgut Freischwimmer, left and right, 2004 at Fondation Beyeler, Riehen/Basel, 2014

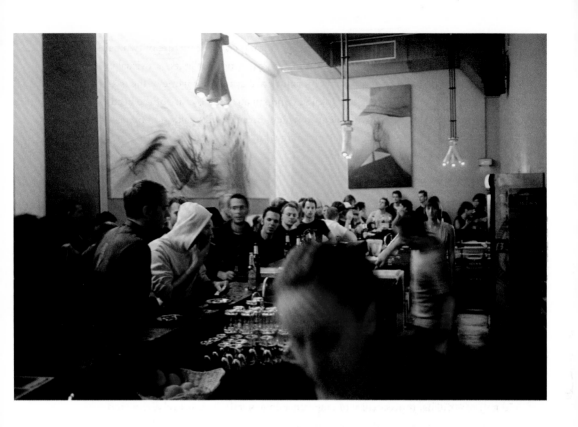

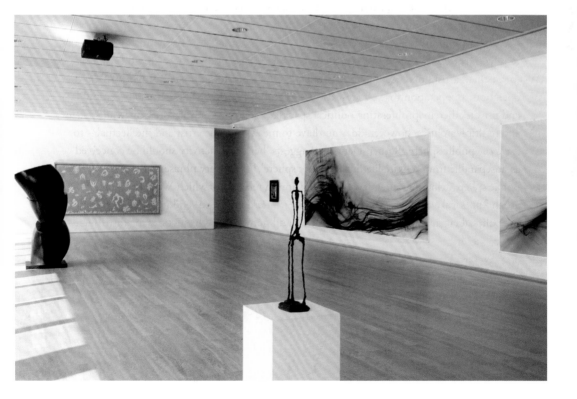

Petersburg, 2014, was shown, almost like a companion piece. The picture of two pairs of legs dancing on a small wooden stage, illuminated by strong spotlights, is a visual exercise in combining movement, light and rigid architectural structures. The name of the gay and lesbian bar and of the city where it is located contextualises the picture of the headless dancers in their ramshackle environment to which, in a different section of the exhibition, portraits of LGBTQ activists from St Petersburg who Tillmans has met during the 2014 St Petersburg Manifesta, are being added.

As with *The Spectrum/Dagger*, the title *The Blue Oyster Bar, Saint Petersburg* indicates the place where the picture originated, although the 'origin' of a particular picture authorised by the artist is actually hard to determine. The title of the exhibition, *PCR*, is telling in this regard: an abbreviation for 'polymerase chain reaction', it refers – quoting Wikipedia – to a 'technique used in molecular biology to amplify a single copy or a few copies of a piece of DNA across several orders of magnitude, generating thousands to millions of copies of a particular DNA sequence'. In fact, Tillmans conceptualises his quest for new pictures in exactly such terms. The amplification of something very tiny, the artistic process of heightening its physical size and therefore its visibility through photographic means and methodologies of installing and printing, is being related to the molecular level of genetic research. Linking the epistemological interest 'in the question of when something becomes something, and how do we know'[44] (which is another way of asking: 'where do things start, when does something become critical mass?'[45]) to the matter-of-factness of biochemistry and nature's original processuality of emergence in general, the artist relativises and aggrandises his procedure at the same time. In paralleling the way in which his pictures come into being with life sciences and, ultimately, the work of evolution, Tillmans also operates in a register that is hardly compatible with the critique of representation and institution or the direct intervention in the image spaces of contemporary politics that are usually associated with 'political art'.

In her contribution to a 2004 conference titled 'The Artist as Public Intellectual?', art historian Rosalyn Deutsche proposed to no longer look for 'some ostensibly proper location of politics' to which an artist's practice might be connected, but instead for 'the performance of an operation, an operation that undoes the proper and displaces the boundary between public and private, thereby proliferating political spaces'.[46] To unlock, displace, dissipate, dislocate and multiply politics, however, does not have to mean – for the artist and intellectual – to leave the public sphere. Rather, Deutsche suggests, her or his activity should be conceived as 'inseparable from sensate life in the public sphere'.[47] This very phrase, 'sensate life in the public sphere', eloquently renders the dimension in relation to which Wolfgang Tillmans's art and political activism can be situated in their interdependence and irreducibility. While the political engagement entails collaboration and networking, the pictures are distributed and redistributed across various platforms of publicness and degrees of accessibility. Both are matters of collective and concerted action as much as of the artist's singular vision. Though a firmly authorial discourse, the thinking-doing that precedes and succeeds these pictures' public appearance as visual form involves consideration of social affectivity, image ethics, technological experimentalism. Operating on the texture of the social and the experientiality of photography, the processes of researching, developing, publishing and disseminating the kind of visual objects that

Spread from *i-D*, no. 336, Spring 2015

Exhibition posters in Santiago de Chile for *Wolfgang Tillmans*, Museo de Artes Visuales, Santiago de Chile, 2013

Since 2006, Vladimir Putin's Russia has been slowly cracking down on the rights of LGBT people, so when Wolfgang Tillmans found himself in Russia last year for Manifesta 10, which was being held in Saint Petersburg, Russia's old, Baroque capital, he knew he had to make a statement. Saint Petersburg was traditionally one of Russia's more liberal enclaves, but it's from here that Russia's homophobic laws have begun to spiral outwards, with the city's mayor even saying, "They can do whatever they want in their homes, in the special 'garbage' places called gay night clubs. But they're not allowed to do it in the streets."

"I had to find a way to make a comment," Wolfgang explains. "I included two photographs of ugly new Orthodox churches, built by the government. I also photographed television static in my Saint Petersburg hotel room as a symbol of censorship and of potential loss of connection. These became two huge pictures in the show."

Tillmans was planning on going to the Saint Petersburg Pride festival while he was there, but this too fell victim to the Russian government. The federal law banning the "promotion of homosexuality to minors" is being used as a cloak for all kinds of homophobic behaviour, and for the police to attack protesters and to encourage vigilante style mob "justice", as well as stopping demonstrations and Pride events. "I felt bad that I didn't get this connection with the community there during Manifesta," he says, "so I got in touch with Amnesty International to arrange to do these portraits, to meet and talk with people."

"These aren't the outstanding figureheads of the movement, just the normal people, willing to be photographed," Tillmans is quick to stress. "None of them had a heroic street fighting rhetoric. In the West, activism of this sort always has a sense of something heroic and subversive about it. When I first got interested in different types of activism in Germany and the UK, there was always a style element to it, but it's interesting that in a setting where there is so much real danger, activists can't look at the aesthetics and coolness of fighting for a cause, and must instead focus on the matter at hand."

The resulting pictures, though, don't betray the fear of living a life in which you can't be openly out of the closet, in which Pride marches are continually targeted by thugs, and Saint Petersburg's activists have been shot at and even murdered. Last year there were over 300 homophobic attacks recorded by Human Rights Watch, and depressingly, only a handful of prosecutions. These are photographs that show a quiet hopefulness, a determination to make things better and a dedication to do what's right.

"I find it so admirable [that they] keep doing what they're doing, in the light of real threat, because I've never been in a situation like that," says Tillmans. "All my life I've been involved in a political and cultural context that has become ever more free. I guess I wanted to just see for myself, and speak to people myself, to really get an idea of what it feels like to live in this situation. When you meet people everything becomes less black and white. You hear all these horror stories, but there's always hope. There are terrible things, but wherever there's people, there's also hope, and that's what I like my photography to do; to amplify and give a voice to hope and solidarity."

"The situation is getting more depressing, but we are trying to do what we can. It gives us a lot of power and strength to move forward and to be equal. But at this time it's quite dangerous to fight against the government." **ELENA LEONTIEVA, SINGER, ACTRESS, LGBT VOLUNTEER**

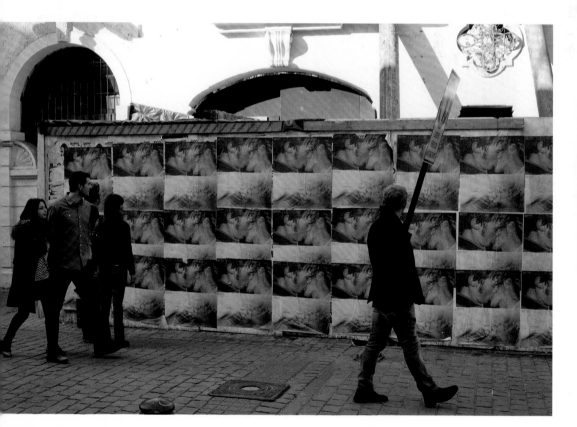

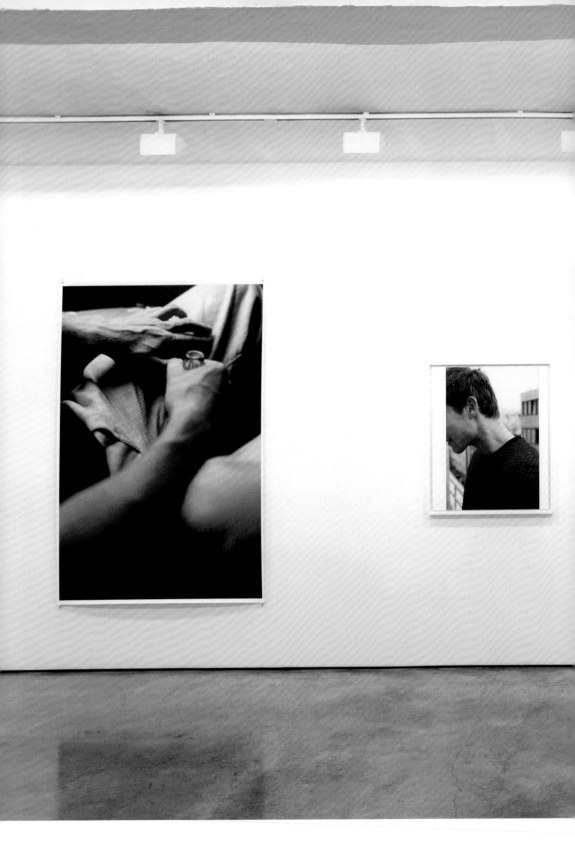

Lap, b, 2012; Central Nervous System, 2012; Karl, Behind Bars, 2008 and Karl,
Utoquai 4, 2012 in *Central Nervous System*, Maureen Paley, London, 2013

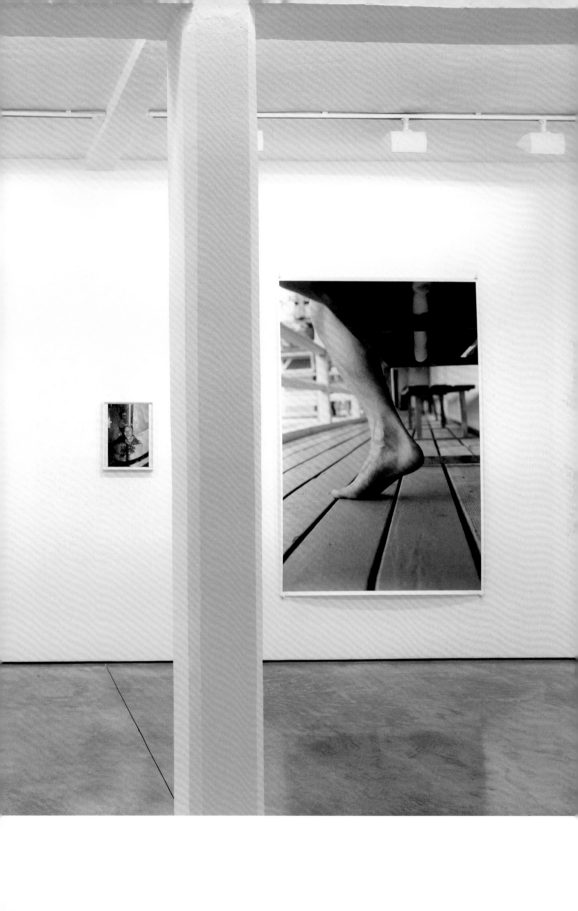

constitute the art of Wolfgang Tillmans are inherently political. Assuming the materiality of conviviality as an instance of public life within and without the parameters of contemporary art, this work has evolved into an aesthetic project that rearticulates what it means to make pictures politically.

Volume Gradient (Serralves), 2015, architectural intervention as part of *On the Verge of Visibility*, Museu de Arte Contemporânea de Serralves, Porto, 2016

Separate System, Reading Prison (self c), 2016

studio still life, c, 2014

Kunstverein, 2007

studio still life, b, 2013

Wet Room (Barnaby), 2010

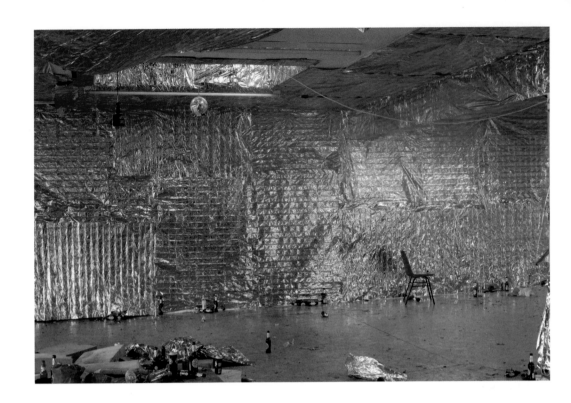

studio party (a), 2009

to know when to stop, 2005

In My Room, 1986

125

studio morning, 2011

Poster for *Neue Welt* at Kunsthalle Zürich, 2012

Tukan, 2010

Next pages:
desert (workers' accommodation), 2009

workers' accommodation, 2009

Installation view of *Neue Welt*,
Kunsthalle Zürich, 2012

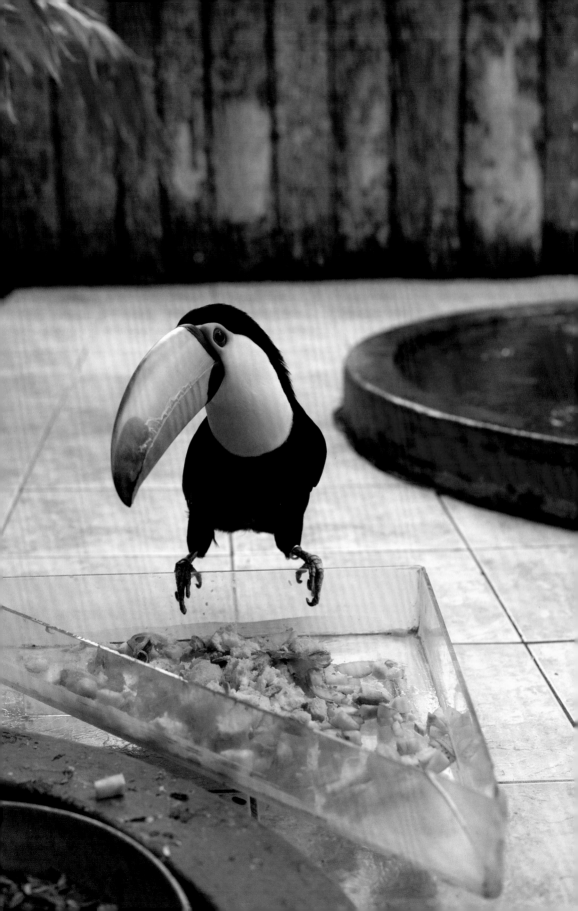

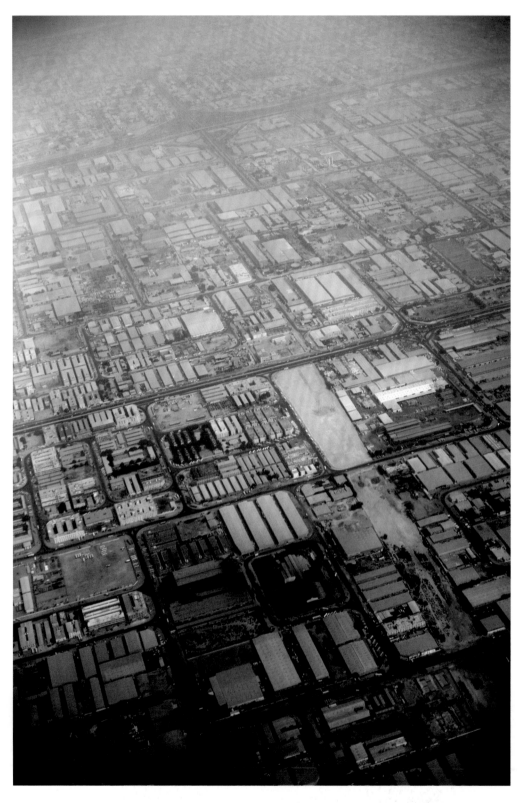

131

Previous pages:
Rest of World, 2009

spores, 2012

These pages:
Buenos Aires, 2010 and blacks, 2011 in *Wolfgang
Tillmans*, Kunstsammlung Nordrhein-Westfalen –
K21, Düsseldorf, 2013

astro crusto, a, 2012

TGV, 2010

São Paulo, 2012

Harvard Astrophysics Institute /
European Southern Observatory, 2012

Jeddah mall I, 2012

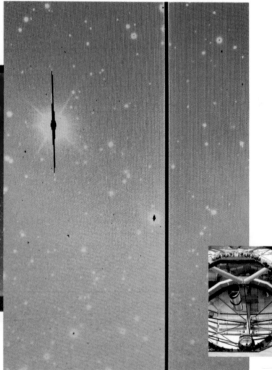

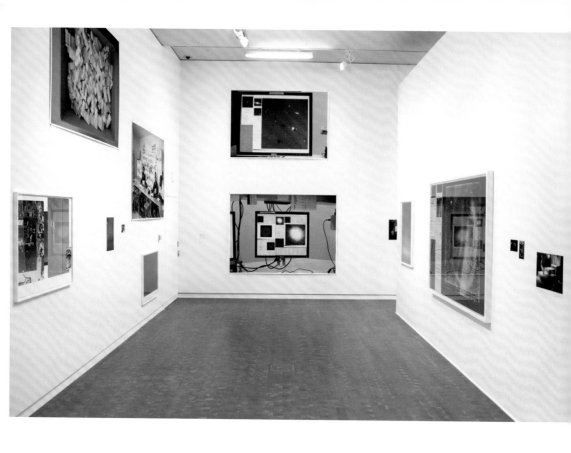

Installation view of *Your Body is Yours*,
National Museum of Art, Osaka, 2015

Lighter, green concave V, 2014 and Army,
2008 in *(Mis)Understanding Photography* at
Museum Folkwang, Essen, 2014

Next pages:
Silver 128, 2013

Silver 114, 2012

Silver 123, 2013

Next pages:
Silver 99, 2012

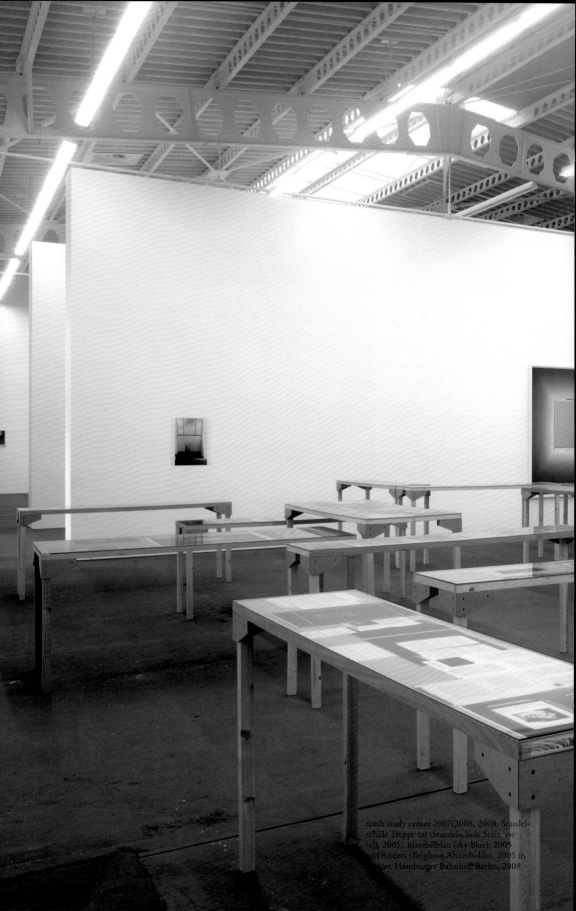

truth study centre 2007/2008, 2008; Staedel-
schule Treppe (a) (Staedelschule Staircase
(a)), 2005; himmelblau (sky-blue), 2005
nd Anders (Brighton Arcimboldo), 2005 in
ter, Hamburger Bahnhof, Berlin, 2008

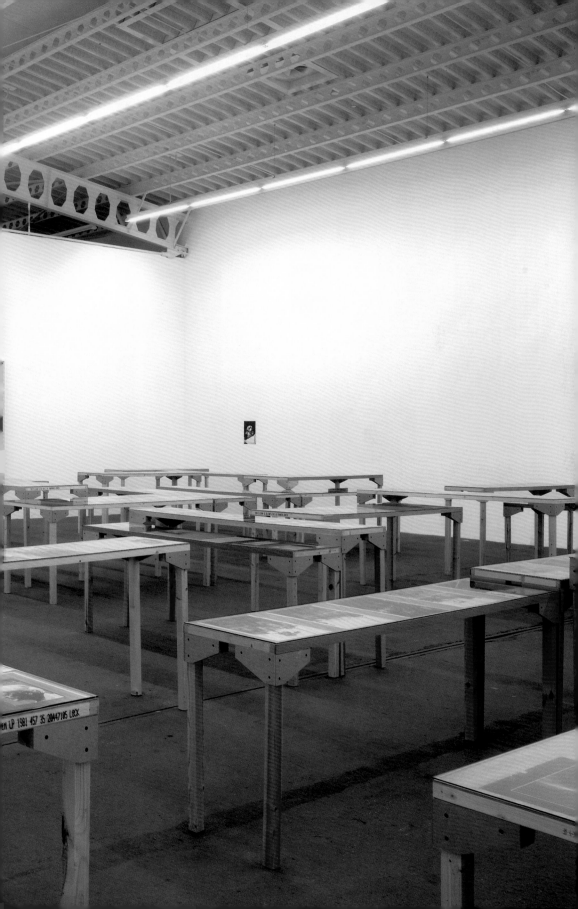

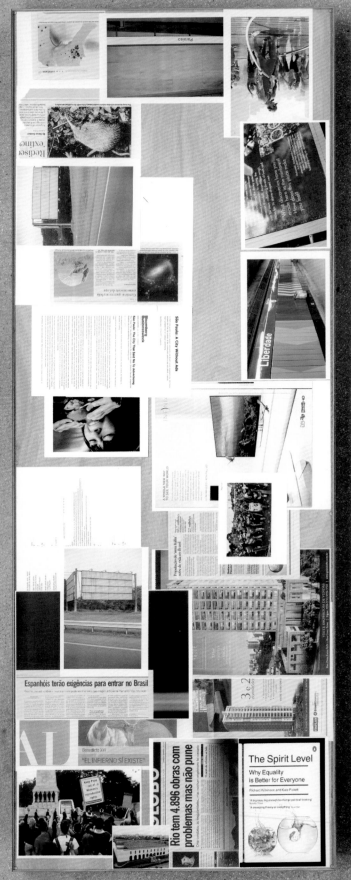

Truth Study Center,
South America Tour
(São Paulo), TSC 479,
2012

Kepler Venice table,
TSC 151, 2009

WORLDWATCH
INSTITUTE
RESEARCH LIBRARY

The
Richardson Institute for
Peace Studies and
Conflict Resolution

Earthwatch In-
stitute

Institut
für Strukturforschung
und Systemanalyse

Earthwatch Institute

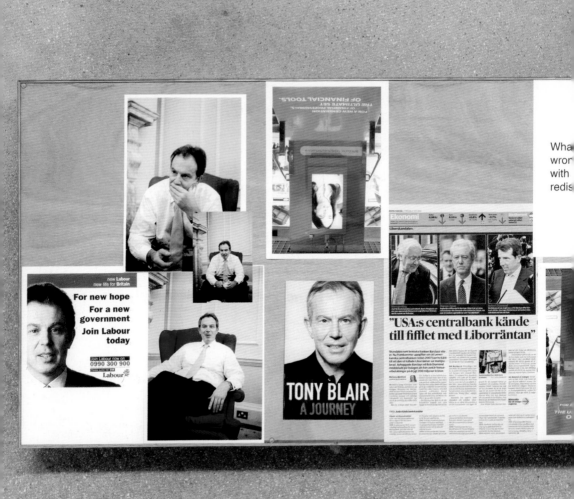

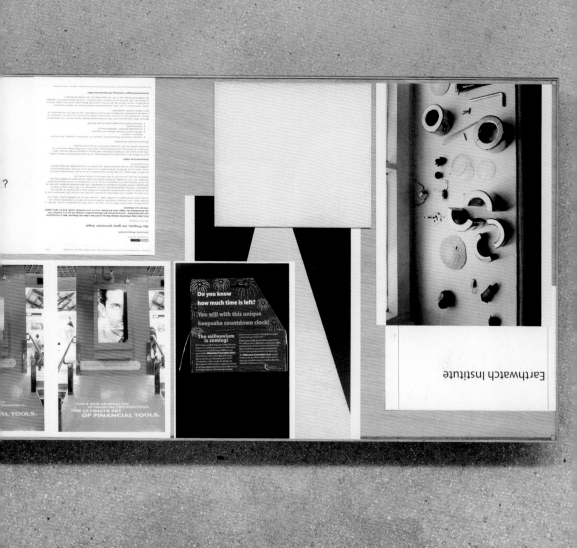

Histogram taken from image-editing software
Adobe Lightroom

United States five-dollar bills

Which European country offers the best sick leave?
www.telegraph.co.uk, screen shot, 5 September 2016

Most read articles on www.telegraph.co.uk, screen
shot, 6 September 2016

While several countries offer 100pc of your salary for each day you take off due to illness, the UK is proving to be the sick man of Europe as it fails to pay workers even an average rate for leave.

The map below shows how much a worker will earn in 33 countries across Europe if they take sick leave for a week. The figures also show what percentage of the country's average salary that represents.

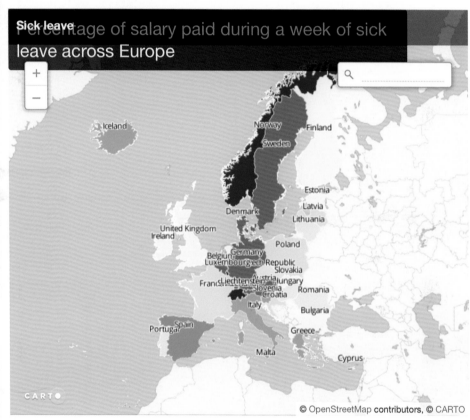

Sick leave

Percentage of salary paid during a week of sick leave across Europe

Map created by ⭐ cristinacriddle

© OpenStreetMap contributors, © CARTO

The research was carried out by Vouchercloud, which calculated SSP during a week and a month of sick leave, shows Britain is lagging behind its European counterparts in terms of how much employees earn

Most Read

1 Revolution against 'rich parasites' at utopian Burning Man Festival as 'hooligans' attack luxury camp
06 Sep 2016, 10:42am

2 Daniel Craig 'offered $150 million to return as James Bond'
05 Sep 2016, 10:33pm

3 ▶ iPhone 7 release date, price and features: What you need to

4 Philippine President calls Obama 'the son of a w****' as h

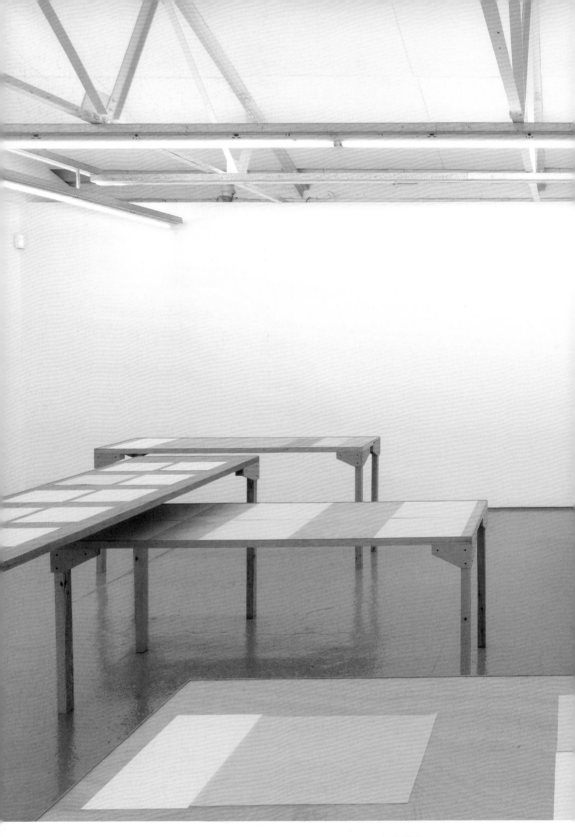

I refuse to be your enemy, 2, 2016 and
Ultrachrome, 2014 in *Wolfgang Tillmans*,
Maureen Paley, London, 2016

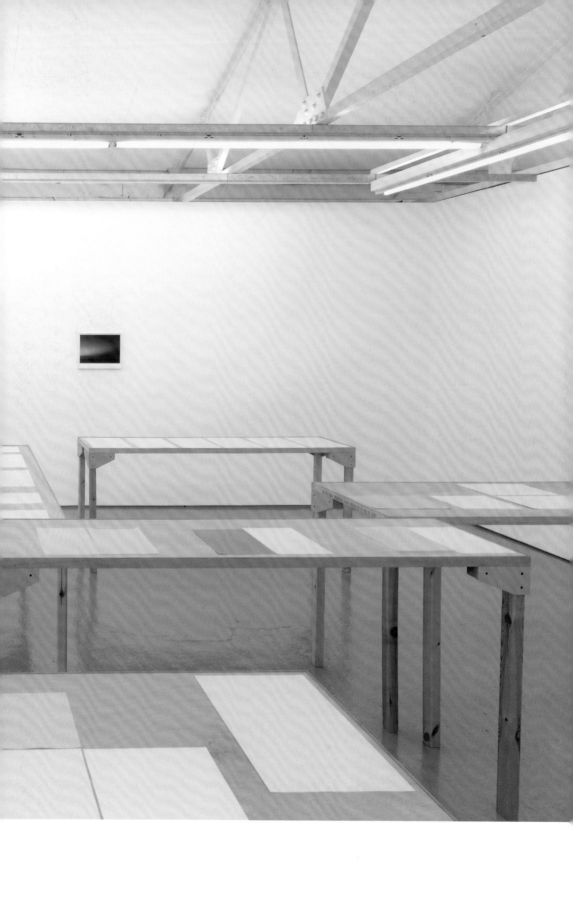

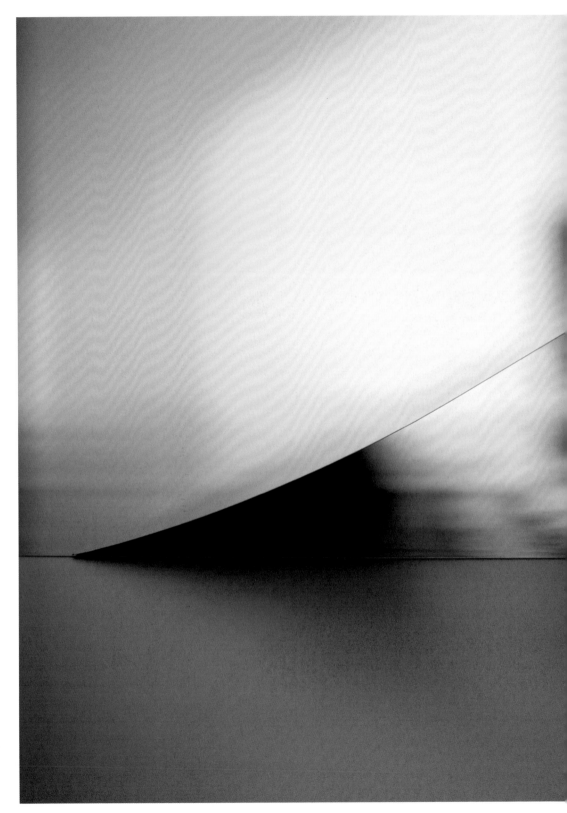

paper drop Prinzessinnenstrasse, a, 2014

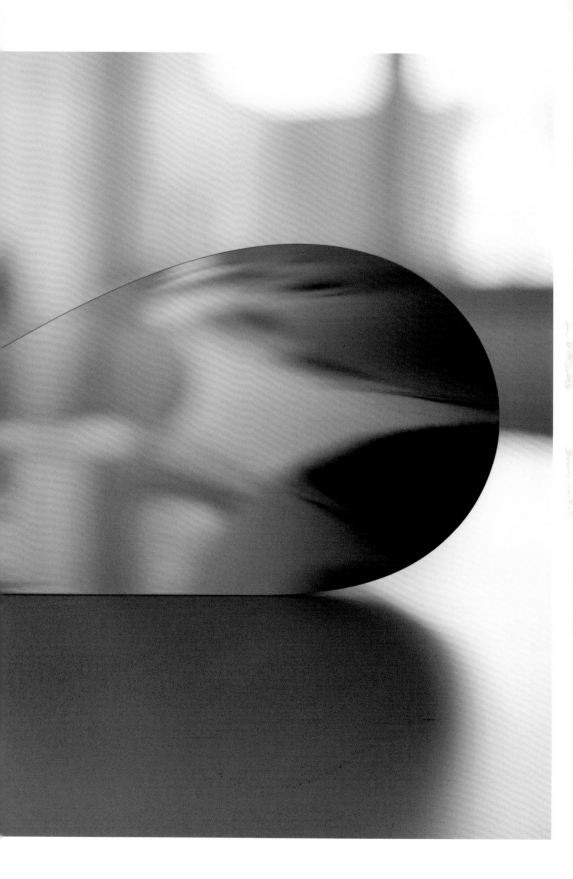

Previous pages:
Blushes 136, 2014

These pages:
Arm, 2006 and Fist, 2006 in *Wolfgang Tillmans*,
Hasselblad Foundation, Gothenburg, 2015

Shanghai night, a, 2009

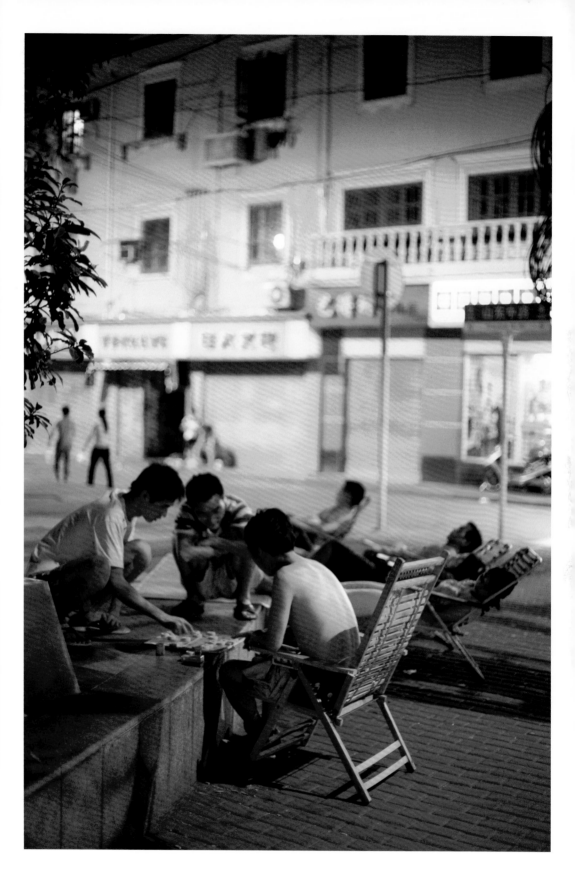

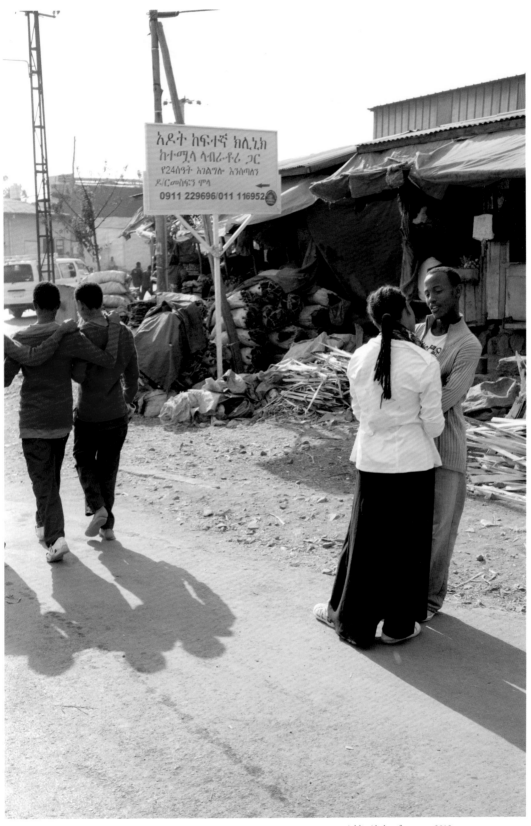

Addis Abeba afternoon, 2012

London Olympics, 2012

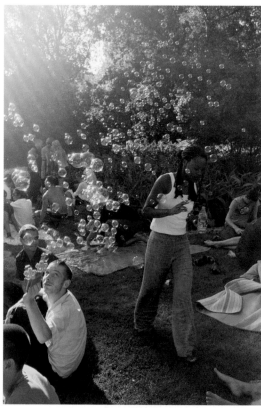

we summer, left and right, 2004

Anders pulling splinter from his foot, 2004

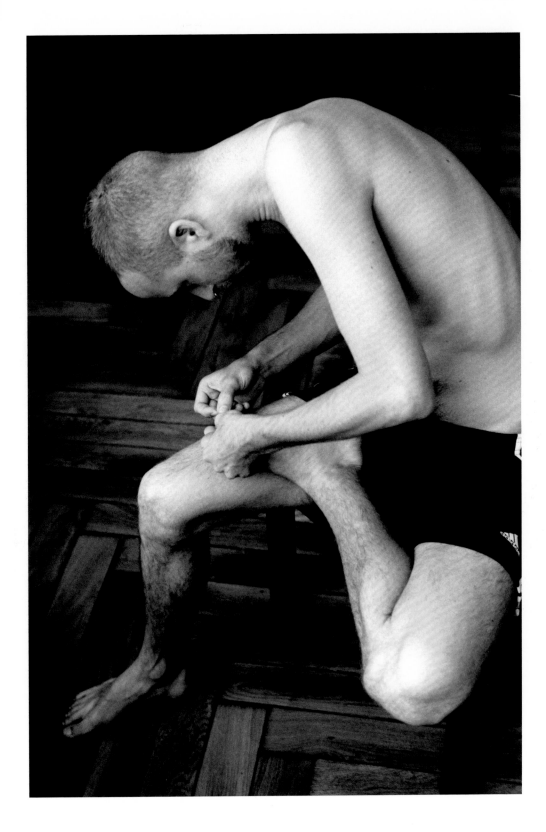

Easter, a, 2012

Between Bridges

223 Cambridge Heath Road, London, 2006–2011
Keithstraße 15, Berlin, 2013–present

Installation view of *Charlotte Posenenske – Series DW*,
Between Bridges, London, 2007

Installation view of *Wolfgang Breuer – Umbel*,
Between Bridges, London, 2006

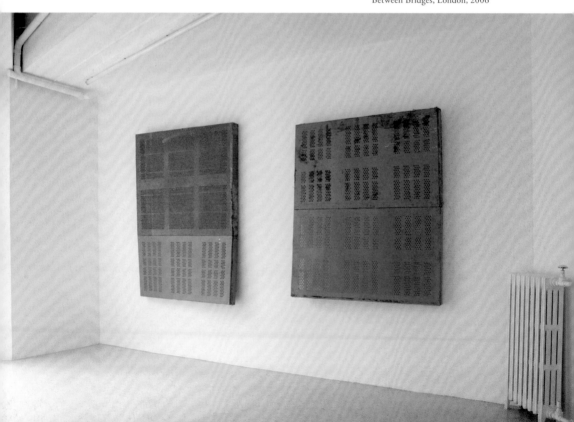

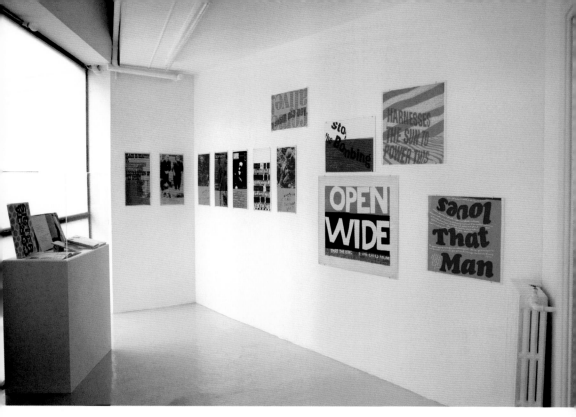

Installation view of *Sister Corita – Works from the 1960s*,
Between Bridges, London, 2006

Installation view of *Gerd Arntz (1900–1988) and Isotype*,
Between Bridges, London, 2010

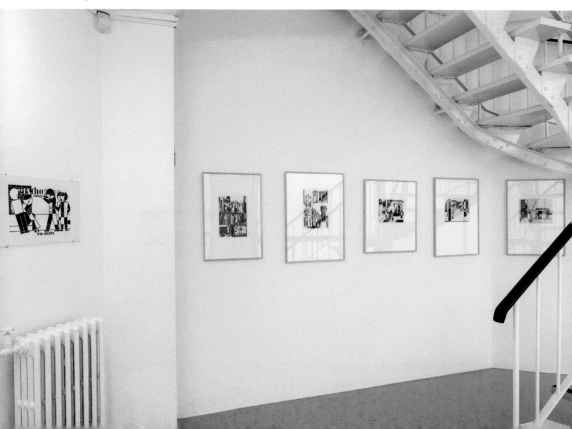

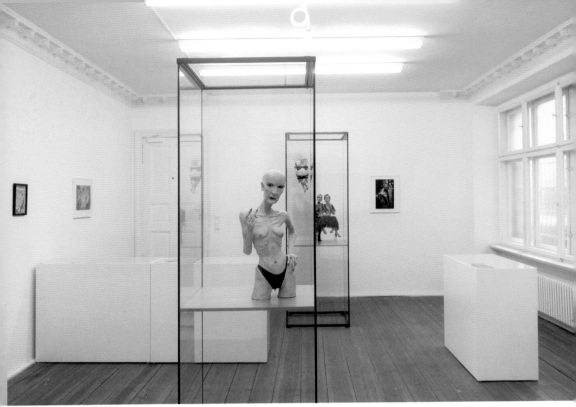

Installation view of *Greer Lankton*,
Between Bridges, Berlin, 2015

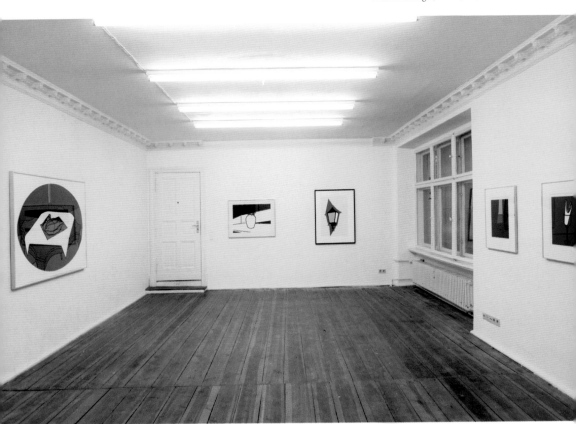

Installation view of *Patrick Caulfield*,
Between Bridges, Berlin, 2014

Anders Clausen, Untitled (feather, c), 2015, nickel
galvanized bird feather, airbrush, 35 × 5 cm, in *Anders
Clausen*, Between Bridges, Berlin, 2015

Installation view of *Meeting Place*,
Between Bridges, Berlin, 14 April–31 July 2016

Meeting Place

12 May, 7pm – The British EU referendum:
A look at the campaigns and arguments for leaving

14 July, 7pm – The Physicality And Performativity
Of Bordering Processes / Lecture

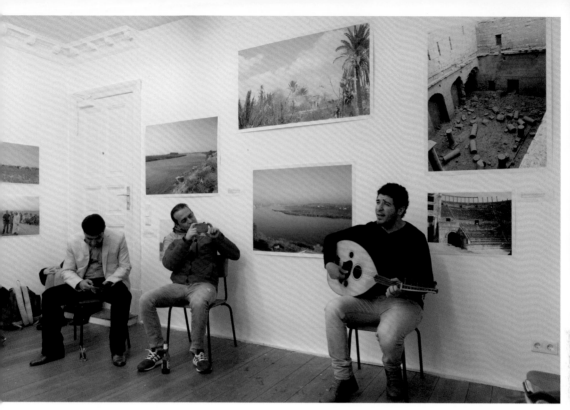

14 April, 7pm – Opening, Tour of Syria,
Bachar Al Chahin

21 April, 7pm – Gülây Akin in conversation
with Wolfgang Tillmans

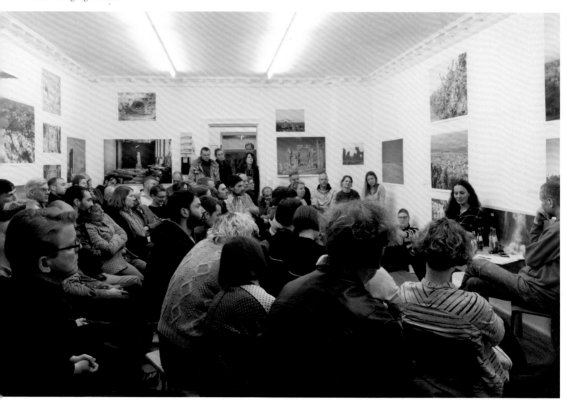

What could unite all
activist activity is the
slogan:

*Inhibit
Assholes*

Stop the arseholes
Prevent arsehole kind of guys
Hinder
to get in the way of sth. I got, got/gotten I Arsehole types

The name of the overall
campaign
should be
Inhibit Assholes

Double page insert for *Artforum*, November 2016,
incorporating installation views of WT text in
Meeting Place at Between Bridges, Berlin, 2016

Next pages:
Press release; excerpts from Samples List v1.5
(available at http://web.mit.edu/klund/www/cbox.
txt) and installation view of *Colourbox – Music of the
group (1982–1987)*, Between Bridges, Berlin, 2014

In mir ist ein Arschlochtyp.
Das Ziel ist, das nicht zu
negieren, sondern das aktiv
zu bekämpfen.
In Dir, in mir, in uns
allen; und uns alle vor
Arschlochtypen zu
schützen.

Am Ende kocht sich alles
runter auf ein Ziel:

Arschlochtypen
verhindern

In me is an asshole.
The point is not to deny
that, but to actively fight it.
In you, in me, in all of us;
and to protect us all from
assholes.

In the end, it all boils down
to one aim:

Inhibit Assholes

Playback Room

Colourbox
Music of the group (1982 – 1987)
13.09.2014 – 25.10.2014

Wednesday to Saturday 12 noon - 6 pm

This is the first in a series of exhibitions and events that aim to give a dedicated space to the playback of recorded music. It is considered normal that in order to see original works of visual art one can visit a museum. However there is no dedicated space or place where one can go to to hear the works of musicians with the studio sound quality that the original recording was made in.

Live music has dedicated spaces, whereas recorded music has none. This does not do justice to the fact that to many musicians the very essence of their work is the recorded final version of a song or album. Months of studio time have gone into creating a work with optimum sound quality. In contrast to this effort 99.9% of music playback is on commercial, domestic or portable devices not fit for perfect sound reproduction. Digital compression in recent years has caused a more and more wide-spread low sound quality in playback.

Undoubtedly music is a huge inspiration to visual artists, and many hold pieces of recorded music in the highest esteem. When attempts are made to bring music into art galleries, it is often done by using visual by-products, rarely by 'showing' the music in dedicated spaces equipped with the highest standard speaker systems. The *Between Bridges* project *Playback Room* is hoping to encourage a critical discussion of this divide.

For *Colourbox - Music of the group (1982 - 1987)* the larger space of *Between Bridges* will become a playback room equipped with a high-end hi-fi sound system. A sequence of 16 songs will be played. The actual carriers of the recordings will be on show in the entrance space of *Between Bridges*: a display of original mastering tapes, 2", 1/2" and 1/4", and the records, which were published by the independent label *4AD*, London and were designed by the much acclaimed designer Vaughan Oliver, will be available to be handled by visitors. A list of transcripts of the original sound samples used by *Colourbox* will be displayed at the entrance on the gallery walls.

The nature of *Colourbox*'s way of working lends itself to this focus on recorded music since the group refused to perform live and was generally reluctant to mediate their work in forms other than the records they put out. Brothers Martyn and Steven Young together with Ian Robbins, Lorita Grahame and Debian Curry were pioneers of experimental pop music. They created an eclectic sound drawing from reggae and soul influences, beat-box driven hip-hop rhythms, blue-eyed soul, as well as a fusion of far-ranging influences spanning from classic R&B, to dub and industrial.

Using montages of analogue magnetic tape bits and experiments with tape machines, *Colourbox* were on the fore-front of sampling, which in it's digital form would become ubiquitous in the course of the 1980's. The band worked in a seeming contrast of pure artistic research in the studio and an anti-intellectual stance towards the outside world. The sometimes soul-inspired, sometimes clashing and degraded, at times harsh, sound qualities of their tracks stood apart from *4AD* label mates *Dead Can Dance, Cocteau Twins* and *This Mortal Coil*.

The band had considerable success in the independent charts but didn't cross over into the mainstream until 1987, when they embarked on a collaboration with A.R. Kane under the name of *M.A.R.R.S.* and released the single *Pump up the Volume*, which went on to become an international No.1 hit. Almost entirely composed of unlicensed samples of other's music and sound pieces the song became the cause of long drawn legal battles and court actions. After this *Colourbox* stopped recording and never released music again. *Wolfgang Tillmans*

A 16 track CD of Colourbox songs, released by 4AD at the occasion of this exhibition, is available at the gallery. Special thanks to 4AD, Samuel Strang, Steve Webbon, Ray Conray. Hifi im Hinterhof, Kay Moldenhauer, Robert Schlundt

Shutdown, shutdown immediately!"
-- Westworld [58:28]

OIT THE DRAGON :

rom the 1985 self-titled "Colourbox" EP (MAD 509)

'Fancy a pubcrawl?'
'What, the whole of London?'
'There's only one place this pair could work.'
'Knees-up country.'
'East End'"
-- The Bullshitters, a TV movie spoof of "The Professionals"

Let's go!"

fight scene between Lee and O'Hara]
-- Enter the Dragon

fight scene underground at Han's Island]
-- Enter the Dragon

E WALK AROUND THE STREETS :

rom the 1985 self-titled "Colourbox" EP (MAD 509)

'We walk around the streets; it makes us angry. We see chimneys
elching out smoke. We see cars belching out smoke. We see
eople,'
'Belching!'
[laughter]
'And who's responsible for all this pollution?'
'We are.'"
-- British comedians Hale and Pace

UNCH :

rom the 1984 "Punch" 12EP (BAD 406)
The "Punch!" is a sample of M&S Young, the rest have to be from
ome bad porno movie.)

Ooo... so wicked and sexy.",
Ooo... ooo... I like that.",
Ooo... feels good.",
Lovely... ooo man."

HOTGUN

rom the 1983 self-titled EP "Colourbox" (MAD 315)

COLOURBOX Samples List v1.5
===========================
Songs listed in album order. Albums listed in reverse
chronological order.
This list is now kept at http://web.mit.edu/klund/www/cbox.txt
Samples listed in order, but only for the first time they are
used.
Times in brackets are the location of the sample in the source
movie.

Please print this out, take it home, and compare it to what you
hear.
If you can correct or identify any of the quotes, please send me
email.
By the way, Westworld is a pretty good movie.

HOT DOGGIE :

From the 1987 compliation "Lonely is an Eyesore" (CAD 703)

"Let's hear some music!",
"We've got us some good'uns."
--- 2000 Maniacs

"Be with me.",
"Here I go."
--- Lifeforce

"Well hot doggie!"
--- 2000 Maniacs

"This guy is crazy. Okay, you break these windows and get me
that body."
--- Dead End Kids/Bowery Boys movie

"Soon the frontier will be down.",
"Bow to their new emperor!"
--- The Last Starfighter

"Alright ... Scotty, there has to be."
--- Star Trek? (sounds like Kirk?)

"You're blind, buddy."

"Pushed to the edge.",
"Pushed to the limit."
--- Late '70s tv commerical for batteries???

"Collection time."
--- Deathwish (2? 3?)

"Now you're going to die."
--- Supergirl

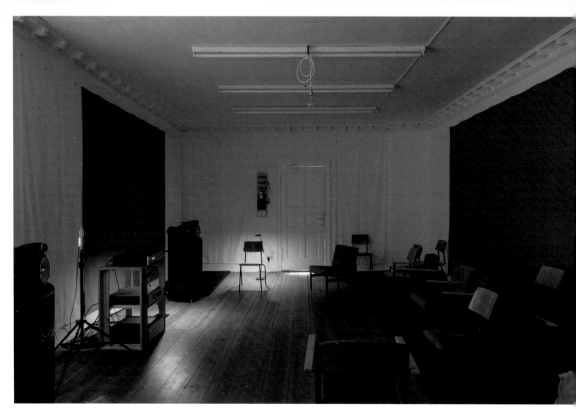

Playback Room

Part I: Colourbox – Music of the group (1982–1987)
13 September 2014 – 25 October 2014

Part III: Bring Your Own
Programmed by Yusuf Etiman
4–28 February 2015

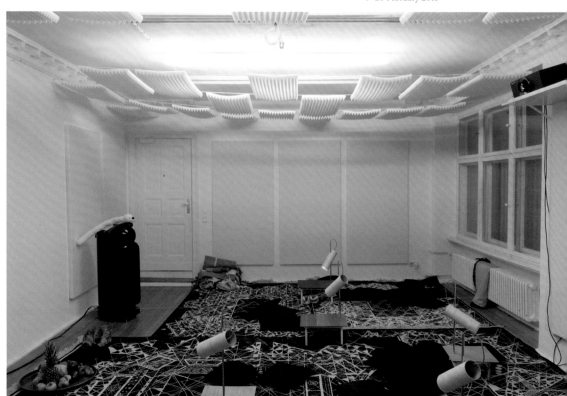

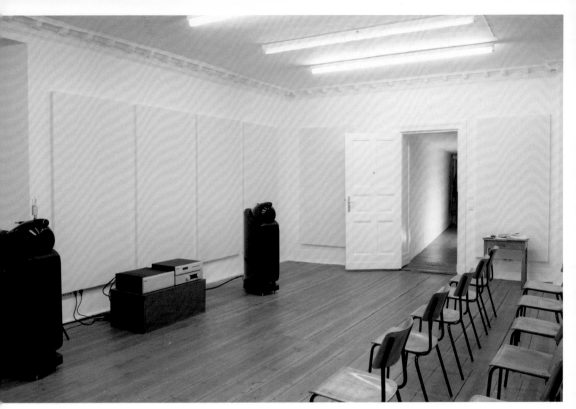

Part II: American Producers
15 November 2014 – 31 January 2015

Colourbox – Music of the group (1982–1987);
To Know When To Stop (playlist); Bring Your Own
16 February 2016 – 24 April 2016, Lenbachhaus, Munich

American Producers (Playback Room part II)

'I Am' — Tyree

Funny your email should come just as I'm just reading this book now *How Music Works* by David Byrne. He touches quite a bit on the topic of how we're listening to music today versus 20-30 years ago and centuries before. The whole history of music composition has for the most part been designed to work in the spaces it's being performed in and listened to - from drum circles in villages to cathedrals, classical music halls on to rock n' roll venues and later into dance clubs and warehouse raves, etc. The act of home listening hasn't' even reached 100 years yet! And safe to say that the built in speakers on all of our devices has certainly dumbed down the experience of listening to music as it's meant to be. If you haven't read this yet, grab a copy of the book... I've found it quite helpful at putting everything into perspective.

Your pointed out Missy and Timbaland - to be honest I think their collaborations were some of the most radical things to make it to the top of the charts here in the last 20 years. They still sound super futuristic to me even if they've been copied to death since. To be honest I can't think of anything since as ground breaking in pop culture as those productions. Dance music is having a big moment on the radio here in the States but it's really horrible EDM shit that is just so painful to listen to. Skrillex, Tiesto, etc... FUCK! Can't deal with it, I completely tune it out.

As far as your question about compression, clipping, etc...maybe pay attention to Arca's stuff. He's a really young producer who has been living here in NYC for the past few years, he just graduated NYU and is already on the fast track to being super famous - he's co-producing the new Bjork record and about to release his debut full-length on Mute records.

It's probably more satisfying to listen to something hip hop based on your computer speakers than it is to listen to techno. With hip hop it's really about the vocals and what they're saying - producers tend to mix the vocals higher at the forefront so they pop out. Listening to a Robert Hood production at home may sound OK but you're really not getting the full experience unless it's in a warehouse setting. He's a good example actually - I've played tracks of his at home and enjoyed them but when I play them in a warehouse or a club - where I have massive subwoofers at my disposal- I've heard entirely new base lines open up that weren't so apparent on my little speakers in my bedroom.
Best,
Michael

This is the second in a series of exhibitions and events that aim to give a dedicated space to the playback of recorded music. It is considered normal that in order to see original works of visual art one can visit a museum. However there is no dedicated space or place where one can go to to hear the works of musicians with the studio sound quality that the original recording was made in.

Live music has dedicated spaces, whereas recorded music has none. This does not do justice to the fact that to many musicians the very essence of their work is the recorded final version of a song or album. Months of studio time have gone into creating a work with optimum sound quality. In contrast to this effort 99.9% of music playback is on commercial, domestic or portable devices not fit for perfect sound reproduction. Digital compression in recent years has caused a more and more wide-spread low sound quality in playback.

Undoubtedly music is a huge inspiration to visual artists, and many hold pieces of recorded music in the highest esteem. When attempts are made to bring music into art galleries, it is often done by using visual by-products, rarely by 'showing' the music in dedicated spaces equipped with the highest
standard speaker systems. The Between Bridges project Playback Room is hoping to encourage a critical discussion of this divide.

Heavy Metal And Reflective (Official Music Video) - Azealia Banks

codebreaker

Michael Jackson
Nguzunguzu - "Smoke Alarm"

für hochkomprimierte MP3 Produktionen: alles von Lady Gaga
Justin Timberlake My Love
vietnameze subtitles: http://www.youtube.com/watch?v=O6cDPIN7tuc
System of a Down Toxicity

jeff mills
Beyoncé - Halo

Missy Elliott
https://www.youtube.com/watch?v=vWlMlk-cYHI
https://www.youtube.com/watch?v=zm28EEeyLek

A$AP ROCKY - WILD FOR THE NIGHT
auf Beatport: Skrillex - Bangarang (Full Album) AUDIOSURF

My question is: What did you originally record it on? was it still tape or was it recorded digitally? It would be interesting to be able to show what music is physically recorded on today.

| Heavy Metal And Reflective (Official Music Video) - Azealia Banks

codebreaker

| Michael Jackson
| Nguzunguzu - "Smoke Alarm"

| | für hochkomprimierte MP3 Produktionen: alles von Lady Gaga
| Justin Timberlake My Love
| vietnameze subtitles: http://www.youtube.com/watch?v=O6cDPIN7tuc
| System of a Down Toxicity

jeff mills
| Beyoncé - Halo

| Missy Elliott
| https://www.youtube.com/watch?v=vWlMlk-cYHI
| https://www.youtube.com/watch?v=zm28EEeyLek

A$AP ROCKY - WILD FOR THE NIGHT

auf Beatport: Skrillex - Bangarang (Full Album) AUDIOSURF

My question is: What did you originally record it on? was it still tape or was it recorded digitally? It would be interesting to be able to show what music is physically recorded on today.

| Salem King Knight
That sounds nice, I love listening to music loud but not many places besides the car to do it. (Strip clubs to sometimes have amazing sound systems but theres alot going on)

We put it all into a computer to work with it but its guitars, keyboards, samples...sometimes record on a 4track then put that into a program sometimes its all digital....just depends.

Jack
| | große fragen, großes drama:

| | UR – Transition
| | https://www.youtube.com/watch?v=9Kd4AKKSn4w

John Maus

| | Fade To Mind label
| artists:
| Kelela
| Kingdom

| und was den US Techno Bereich angeht

| -Carl Craigs Album "More Songs About Food And Revolutionary Art" ... wurde / wird auch gerade remasterd neu veröffentlicht
| http://www.discogs.com/Carl-Craig-More-Songs-About-Food-And-Revolutionary-Art/master/9228

| -Robert Hood / Floorplan

| in footsteps of missy elliot, but all new and a step ahead:
| azelia banks

69 love songs edit

The-Dream finds ich übrigens ganz großartig. Diese Yamaha-Nicky-Abyss Trilogie ist auf jeden Fall ein guter Kandidat.

act: The Dream
song: Abyss (Explicit)
| X-101 Sonic Destroyer

| Rave New World

Michael Jackson They Don't Care About Us

und
tracks 8 and 13 von
Death Grips
'The Moneystore' CD

| Green Velvet CD finden
...
Hier noch n paar tips:

Spotify:
crystal castels - (III)
var - no one dance quite like my brother
doldrums - lesser evil
...
| Katy Perry : Teenage Dream
| http://www.slate.com/articles/arts/culturebox/2014/03/katy_perry_s_teenage_dream_explaining_the_hit_using_music_theory.html
| Lady Gaga - Bad Romance (& other Songs)
| http://www.slate.com/articles/arts/culturebox/2014/03/lady_gaga_s_bad_romance_owen_pallett_explains_the_pop_diva_s_genius_using.html

Rocket To Your Heart LISA
Another Life KANO
Wishing A FLOCK OF SEAGULLS
Love Will Tear Us Apart JOY DIVISION
Do You Believe In The Westworld THEATRE OF HATE
The Klan THEATRE OF HATE
Mantra To A State Of Mind S'EXPRESS
Smalltown Boy BRONSKI BEAT
Confusion NEW ORDER
Why? BRONSKI BEAT
Renee TALK TALK
Tainted Dub SOFT CELL
Blood (LP) THIS MORTAL COIL
Bewahre Uns Gott EV. KIRCHENTAG 91
Im Jubel Ernten Die Mit Traenen Saeen EV. KIRCHENTAG 9 |
I've Been Waiting For Tomorrow All Of My Life THE THE
This Is The Day THE THE
Fast Dump COLOURBOX
Here Comes The Rain Again THE EURYTHMICS
My Time THE PSYCHEDELIC FURS
It's My Life DR. ALBAN
Do You Really Need Me K.B. CAPS
Highwire Days THE PSYCHEDELIC FURS
My Candle Still Burns MARC ALMOND
Ford Tracks (LP) BABY FORD
I've Got An Angel THE EURYTHMICS
Sweet Dreams THE EURYTHMICS
Too Late NEW ORDER
If You Go Away MARC ALMOND
Like A Hurricane NEIL YOUNG
Technique (LP) NEW ORDER
Walking In Space HAIR SOUNDTRACK
I Ain't Nightclubbing T-COY
Annette DREAM 17
Talking With Myself ELECTRIBE 101
Acid Over TYREE
I'll Be Your Shelter THE HOUSEMARTINS
True Faith NEW ORDER
Secret Land SANDRA
Dr. Mabuse PROPAGANDA
Am I Right ERASURE
Moments In Love (Versions) THE ART OF NOISE
Good Beat DEE-LITE
Power, Corruption & Lies NEW ORDER
Frozen Faces PROPAGANDA
Happiness (LP) THE BELOVED
The Lion And The Cobra SINEAD O'CONNOR (LP)
In My Room MARC ALMOND
Catch A Fallen Star MARC ALMOND
First Time MARC ALMOND
All recordings by COLOURBOX
I Am TYREE
Promised Land JOE SMOOTH
Bow Down THE HOUSEMARTINS
Flag Day THE HOUSEMARTINS
I Like Chopin GAZEBO
You Can Win If You Want MODERN TALKING
Strings Of Life RHYTHIM IS RHYTHIM
Blue Monday NEW ORDER
The Beach NEW ORDER
This Last Night In Sodom (LP) SOFT CELL
Der Computer Nummer Drei FRANCE GALL
Glory To God (The Messiah) HAENDEL
All I Need Is MOBY
I Want You ROFO
Einsam Bist Du Klein FRITZ BALLTRUWEIT
Young Offender PET SHOP BOYS
Top Of The World THE CARPENTERS
Losing My Religion R.E.M.
Lonely Man In The Corner GENESIS
Hey Hey Guy ?
Slice Me Nice FANCY
Colour My Love FUN FUN
The Days Of Pearly Spencer MARC ALMOND
My Hand Over My Heart MARC ALMOND
Misty Circles DEAD OR ALIVE

KanLaslo

The End Of The World PET SHOP BOYS
Kissing To Be Clever (LP) CULTURE CLUB
Glaspalast SPLIFF
Time After Time THE BELOVED
This City Never Sleeps THE EURYTHMICS
HAIR ORIGINAL MOVIE SOUNDTRACK
This Charming Man THE SMITHS
What Difference Does It Make THE SMITHS
Just Be Good To Me S.O.S. BAND
Holding Out For A Hero BONNIE TAYLOR
Living On Video TRANS-X
The Eagle ABBA
Strange Angels (LP) LAURIE ANDERSON
Big Science (LP) LAURIE ANDERSON
Instant Karma JOHN LENNON
For One Moment MARC ALMOND
Black Lullabye MARC ALMOND
Non Stop Erotic Cabaret (LP) SOFT CELL
Soul Inside SOFT CELL
Violence PET SHOP BOYS
Torch SOFT CELL
The Art Of Falling Apart (LP) Soft Cell
My Death MARC ALMOND
The Girl With The Patent Leather Face SOFT CELL
A Soap Opera SUPERTRAMP
Crisis What Crisis ? (LP) SUPERTRAMP
Wish You Were Here (LP) PINK FLOYD
Diamonds And Rust JOAN BAEZ
Passion THE FLIRTS
Bizarre Love Triangle NEW ORDER
When Tomorrow Comes THE EURYTHMICS
Do You Really Want To Hurt Me? CULTURE CLUB
Colour By Numbers (LP) CULTURE CLUB
Das Weiche Wasser Bricht Den Stein BOTTS
Time (Clock Of The Heart) CULTURE CLUB
Wicked Game CHRIS ISAAK
Acid Thunder FAST EDDIE
Can U Feel It FINGERS INC. FEAT. CHUCK ROBERTS
IN THE KEY OF E (SAMPLER)
Song To The Siren THIS MORTAL COIL
Devotion TEN CITY
Fade To Grey VISAGE
Als Waer's Das Letzte Mal DAF
Brothers DAF
Luxus IDEAL
Wonderful Life BLACK
Chill Out (LP) THE KLF
Native Love DIVINE
Shoot Your Shot DIVINE
Love Reaction DIVINE
Shake It Up DIVINE
Being Boring PET SHOP BOYS
Do I Have To PET SHOP BOYS
You Know Where You Went Wrong PET SHOP BOYS
Let's Get Brutal NITRO DELUXE
Make My Body Rock JOMANDA
In Yer Face 808 STATE
All That Heaven Allows FEHLFARBEN
Better Not In England FEHLFARBEN
Monarchie Und Alltag (LP) FEHLFARBEN
I'm The Boy CULTURE CLUB
Hallelujah (remix) INNER CITY
Dieu Est Tendresse TAIZE
En Tous, La Paix Du Coeur TAIZE
O Superman LAURIE ANDERSON
UVA FUSE
Mantrax FUSE
Nitedrive FUSE
Into The Space FUSE
Bambina DAVID LYME
The Ultimate Go (in dub mix) MOBY
Love LOVE CORPORATION
Wave Goodbye ERASURE My heart sobbie
Dreiklangsdimensionen RHEINGOLD

Sonic Destroyer X-101
Rave New World X-101
Touched By The Hand Of God NEW ORDER
Times Change NEW ORDER
Special NEW ORDER
Animal Nitrate SUEDE
Ruined In A Day NEW ORDER
Hartrance Acperience HARDFLOOR
Subculture NEW ORDER
The Perfect Kiss NEW ORDER
Sugarmountain NEIL YOUNG
Jesus le Christ TAIZE
Adoramus Te Christe TAIZE
Ubi Caritas TAIZE
Toi, Tu Nous Aimes TAIZE
Tui Amoris Ignem TAIZE
Da Pacem, In Diebus TAIZE
In Te Confido TAIZE
What Is Love HADDAWAY
Give In To Me MICHAEL JACKSON
We're Not Going Back THE HOUSEMARTINS
Live 'n Direct (LP) ADAMSKI
My Candle Still Burns MARC ALMOND
The Boy Who Came Back MARC ALMOND
The Moon Is Blue COLOURBOX
We Walk Around The Streets COLOURBOX
People Are People DEPECHE MODE
For One Moment MARC ALMOND
Procession JOY DIVISION
Decades JOY DIVISION
Breakdown COLOURBOX
Looking For Love ANNE PIGALLE
Omaha Beach GOUTS DE LUXE
Quand Tu Pars ROSE LAURENS
Tout Premier Fois JEANNE MAS
Only Love Can Break Your Heart ST. ETIENNE
Mon Ame Se Repose TAIZE
Where's Your Child BAM BAM
Lack Of Love IN THE KEY OF E (Sampler)
10. Juni BAP
I Love You Like A Ball And Chain THE EURYTHMICS
1984 (LP) THE EURYTHMICS
Higher Than The Sun PRIMAL SCREAM
You Spin Me Round DEAD OR ALIVE
Sophisticated Boom Boom (LP) DEAD OR ALIVE
Echo Beach MARTHA AND THE MUFFINS
I Dream Of You ADAMSKI
Hothead DIY
Electronic (LP) ELECTRONIC
Never Take Me Alive SPEAR OF DESTINY
King's Cross PET SHOP BOYS
Heart Of Gold NEIL YOUNG
Over The River LAURIE ANDERSON
Around The World NEIL YOUNG
She's Lost Control JOY DIVISION
The Passenger IGGY POP
They Walked In Line JOY DIVISION
1963 NEW ORDER
Shadowplay JOY DIVISION
Enjoy The Silence DEPECHE MODE
The Age Of Love (Jam & Spoon mix) THE AGE OF LOVE
Visitors KOTO
The World Is You MIKO MISSION
Disco Band SCOTCH
Two For Love MIKO MISSION
Come Back JIMMY & SUSY
Moonlight Affair CLIFF TURNER

Previous pages:
Email excerpts used as press release for
American Producers (Playback Room part II),
Between Bridges, Berlin, 2015

These pages:
Salle Techno, 1994

Spread from *Wolfgang Tillmans* (exh. cat.),
Kunsthalle Zürich, 1995

Salle Techno, 1994 (sound installation) in
L'hiver de l'amour, Musée d'Art Moderne de la
Ville de Paris, 1994

Playlist for *L'hiver de l'amour*, Musée d'Art
Moderne de la Ville de Paris, 1994

Wolfgang Tillmans
Salle Techno, 1994
installation sonore

musique techno-house des Etats-Unis, d'Allemagne et
d'Angleterre des années 1991 - 93

liste de tracks:
Come Into My Life - Abfahrt
Harttrance Acperience - Hardfloor
Sonic Destroyer - X-101
Rave New World - X-101
All I Want Is To Be Loved - Moby
UVA - Fuse
Mantrax - Fuse
Nightdrive - Fuse
Into The Space - Fuse

Move - Moby
Wake Up !
Texas Cowboys - The Grid
The Age Of Love (Jam & Spoon remix) - The Age Of Love
Polygon Window - The Dice Man
Sonic Destroyer - X-101
Rave New World - X-101
Punisher - Underground Resistance
The Ultimate Go (Jam & Spoon remix) - Moby
All I Want Is To Be Loved - Moby

Artist Pages / Printed Matter

Spreads from *Abstract Pictures* (Artist Edition),
2011

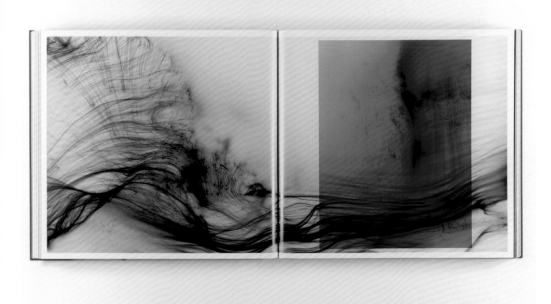

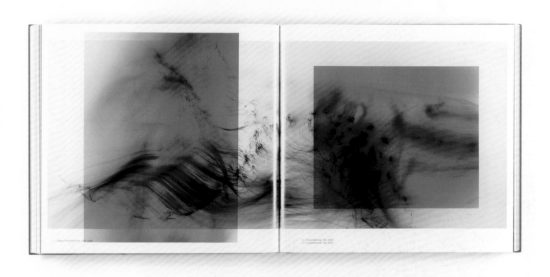

193

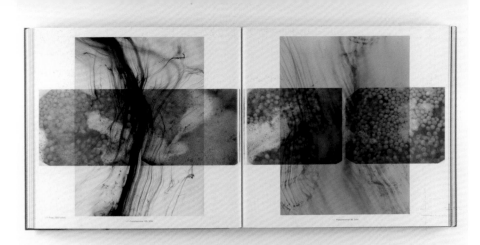

Wolfgang Tillmans Abstract Pictures

HATJE
CANTZ

170
paper drop (London), 2008
C-type print, 30.5 x 40.6 cm, edition of 10 + 1 AP
C-type print, 50.8 x 61 cm, edition of 3 + 1 AP
C-type print mounted on Forex in artist's frame,
145 x 213 x 6 cm, edition of 1 + 1 AP
Unframed archival ink jet print on paper, 138 x 208 cm,
edition of 1 + 1 AP

171
paper drop (star), 2006
C-type print, 30.5 x 40.6 cm, edition of 10 + 1 AP
C-type print, 50.8 x 61 cm, edition of 3 + 1 AP
C-type print mounted on Forex in artist's frame,
145 x 211 x 6 cm, edition of 1 + 1 AP
Unframed archival ink jet print on paper, 138 x 206 cm,
edition of 1 + 1 AP

172
paper drop (sphere), 2006
C-type print, 30.5 x 40.6 cm, edition of 10 + 1 AP
C-type print, 50.8 x 61 cm, edition of 3 + 1 AP
C-type print mounted on Forex in artist's frame,
145 x 211 x 6 cm, edition of 1 + 1 AP
Unframed archival ink jet print on paper, 138 x 206 cm,
edition of 1 + 1 AP

173
paper drop (New York) I, 2008
C-type print, 30.5 x 40.6 cm, edition of 10 + 1 AP
C-type print, 50.8 x 61 cm, edition of 3 + 1 AP
C-type print mounted on Forex in artist's frame,
145 x 212 x 6 cm, edition of 1 + 1 AP
Unframed archival ink jet print on paper, 137 x 205 cm,
edition of 1 + 1 AP

174
paper drop (dark), 2006
C-type print...
C-type print...
C-type print mounted on Forex...
145 cm...
Unframed...
edition of...

175
paper drop...
C-type print...
C-type print...
C-type print mounted on Forex...
145 x 2...
Unframed...
edition of 1 + 1 AP

176
paper drop...
C-type print, 30.5 x 40.6 cm, edition of 10 + 1 AP
C-type print, 50.8 x 61 cm, edition of 3 + 1 AP
C-type print mounted on Forex in artist's frame,
145 x 214 x 6 cm, edition of 1 + 1 AP
Unframed archival ink jet print on paper, 138 x 209 cm,
edition of 1 + 1 AP

177
paper drop (x), 2007
C-type print, 30.5 x 40.6 cm, edition of 10 + 1 AP
C-type print, 50.8 x 61 cm, edition of 3 + 1 AP
C-type print mounted on Forex in artist's frame,
145 x 213 x 6 cm, edition of 1 + 1 AP
Unframed archival ink jet print on paper, 138 x 208 cm,
edition of 1 + 1 AP

178
paper drop (fan), 2006
C-type print, 30.5 x 40.6 cm, edition of 10 + 1 AP
C-type print, 50.8 x 61 cm, edition of 3 + 1 AP
C-type print mounted on Forex in artist's frame,
145 x 211 x 6 cm, edition of 1 + 1 AP
Unframed archival ink jet print on paper, 138 x 206 cm,
edition of 1 + 1 AP

179
paper drop fused I, 2006
C-type print, 40.6 x 30.5 cm, edition of 10 + 1 AP
C-type print, 61 x 50.8 cm, edition of 3 + 1 AP
C-type print mounted on Forex in artist's frame,
211 x 145 x 6 cm, edition of 1 + 1 AP
Unframed archival ink jet print on paper, 206 x 138 cm,
edition of 1 + 1 AP

180
paper drop fused II, 2006
C-type print, 40.6 x 30.5 cm, edition of 10 + 1 AP
C-type print, 61 x 50.8 cm, edition of 3 + 1 AP
C-type print mounted on Forex in artist's frame,
211 x 145 x 6 cm, edition of 1 + 1 AP
Unframed archival ink jet print on paper, 206 x 138 cm,
edition of 1 + 1 AP

181
paper drop (space), 2006
C-type print, 30.5 x 40.6 cm, edition of 10 + 1 AP
C-type print, 50.8 x 61 cm, edition of 3 + 1 AP
C-type print mounted on Forex in artist's frame,
145 x 213 x 6 cm, edition of 1 + 1 AP
Unframed archival ink jet print on paper, 137 x 205 cm,
edition of 1 + 1 AP

182
paper drop (glass), 2007
C-type print, 30.5 x 40.6 cm, edition of 10 + 1 AP
C-type print, 50.8 x 61 cm, edition of 3 + 1 AP
C-type print mounted on Forex in artist's frame,
145 x 212 x 6 cm, edition of 1 + 1 AP
Unframed archival ink jet print on paper, 138 x 207 cm,
edition of 1 + 1 AP

183
paper drop (window), 2006
C-type print, 30.5 x 40.6 cm, edition of 10 + 1 AP
C-type print, 50.8 x 61 cm, edition of 3 + 1 AP
C-type print mounted on Forex in artist's frame,
145 x 212 x 6 cm, edition of 1 + 1 AP
Unframed archival ink jet print on paper, 137 x 205 cm,
edition of 1 + 1 AP

184
Installation view *Lighter*, Hamburger Bahnhof—Museum
für Gegenwart, Berlin, 2008

Urgency II, 2006
Unframed archival ink jet print on paper,
296 x 395 cm, edition of 1 + 1 AP

Ikis praying (faded tax), 2005
photocopy,
29.7 x 42 cm, edition of 25 + 2 AP

entrance Opera, 2008
C-type print,
40.6 x 30.5 cm, edition of 10 + 1 AP

185
Urgency XIV, 2006
C-type print mounted on Forex in artist's frame,
238 x 181 x 6 cm, edition of 1 + 1 AP

185
Urgency I, 2006
Unframed archival ink jet print on paper,
296 x 395 cm, edition of 1 + 1 AP

186
Installation view Wolfgang Tillmans, Museum of
Contemporary Art, Chicago, 2006

Urgency III, 2006
Unframed archival ink jet print on paper,
303 x 403 cm, edition of 1 + 1 AP

187
Urgency XIV, 2006
C-type print mounted on Forex...
238 x 181 x 6 cm, edition of...

188
Urgency XVI, 2006
C-type print mounted on Forex...
181 x 238 x 6 cm, edition of 1 + 1 AP

189
Urgency XXI, 2006
C-type print mounted on Forex in artist's frame
238 x 181 x 6 cm, edition of 1 + 1 AP

190
Urgency VIII, 2006
C-type print mounted on Forex in artist's frame,
238 x 181 x 6 cm, edition of 1 + 1 AP

191
Urgency XXII, 2006
C-type print mounted on Forex in artist's frame,
238 x 181 x 6 cm, edition of 1 + 1 AP

192
Das Problem mit den Löchern, 2005
C-type print mounted on Forex in artist's frame,
181 x 298 x 6 cm, edition of 1 + 1 AP

193
Empire (The problem with holes), 2005
C-type print mounted on Forex in artist's frame,
258 x 181 x 6 cm, edition of 1 + 1 AP

194
Empire (paper thin), 2005
C-type print mounted on Forex in artist's frame,
267 x 181 x 6 cm, edition of 1 + 1 AP

195
they are like this why, 2005
C-type print mounted on Forex in artist's frame,
181 x 238 x 6 cm, edition of 1 + 1 AP

196
Zuversicht, 2003
C-type print mounted on Forex in artist's frame,
181 x 204 x 6 cm, edition of 1 + 1 AP

197
Silver 3, 1998
C-type print mounted on Forex in artist's frame,
238 x 181 x 6 cm, edition of 1 + 1 AP

198
this is perceived, 2005
C-type print mounted on Forex in artist's frame,
145 x 212 x 6 cm, edition of 1 + 1 AP

199
Gotes Tier, 2005
C-type print mounted on Forex in artist's frame,
181 x 238 x 6 cm, edition of 1 + 1 AP

200
high school, 1996
photocopy,
42 cm x 29.7 cm, unique

201
it's only love give it away, 2005
C-type print mounted on Forex in...
238 x 181 x 6 cm, edition of 1 + 1...

202
Detail of
it's only love give it away, 2005

203
Time, Action and Fear, 2005
C-type print mounted on Forex in artist's frame,
308 x 181 x 6 cm, edition of 1 + 1 AP

204
Installation view *Lighter*, Hamburger Bahnhof—Museum
für Gegenwart, Berlin, 2008

photocopy (Barnaby), 1994
C-type print, 181 x 145 x 6 cm, edition of 1 + 1 AP

Teufelspool, left, 2004
C-type print,
40.6 x 30.5 cm, edition of 10 + 1 AP

Teufelspool, right, 2004
C-type print,
40.6 x 30.5 cm, edition of 10 + 1 AP

Time, Action and Fear, 2005
C-type print mounted on Forex in artist's frame,
308 x 181 x 6 cm, edition of 1 + 1 AP

205
impossible colour V, 2005
C-type print mounted on Forex in artist's frame,
238 x 181 x 6 cm, edition of 1 + 1 AP

206
this is neutral, 2005
C-type print mounted on Forex in artist's frame,
241 x 181 x 6 cm, edition of 1 + 1 AP

207
Installation view Wolfgang Tillmans, Museum of
Contemporary Art, Chicago, 2006

Venus transit, passage, 2004
C-type print,
61 x 50.8 cm, edition of 3 + 1 AP

Venus transit, second contact, 2004
C-type print,
61 x 50.8 cm, edition of 3 + 1 AP

Venus transit, drop, 2004
C-type print,
61 x 50.8 cm, edition of 3 + 1 AP

Venus transit, 2004
C-type print,
61 x 50.8 cm, edition of 3 + 1 AP

Venus transit, clouds, 2004
C-type print,
61 x 50.8 cm, edition of 3 + 1 AP

Venus transit, edge, 2004
C-type print,
61 x 50.8 cm, edition of 3 + 1 AP

avec ciorut, 2005
C-type print mounted on Forex in artist's frame,
238 x 181 x 6 cm, edition of 1 + 1 AP

208
Empire (man), 2005
C-type print mounted on Forex in artist's frame,
252 x 181 x 6 cm, edition of 1 + 1 AP

209
Empire (US/Mexico border), 2005
C-type print mounted on Forex in artist's frame,
256 x 181 x 6 cm, edition of 1 + 1 AP

210
impossible colour VII, 2005
C-type print,
40.6 x 30.5 cm, unique

211
slate, 2005
C-type print mounted on Forex in artist's frame,
181 x 238 x 6 cm, edition of 1 + 1 AP

212
Daddy has an Execution, 2004
photocopy,
42 x 29.7 cm, unique

213
Empire (Punk), 2005
C-type print mounted on Forex in artist's frame,
243 x 181 cm x 6 cm, edition of 1 + 1 AP

214
Detail of
Empire (Punk), 2005
C-type print in plexiglass frame,
65 x 54 x 10 cm, unique

215
Installation view *Fare Mondi*, La Biennale di Venezia,
Venice, 2008

Lighter, black V, 2009
C-type print in plexiglass frame,
65 x 54 x 12.5 cm, unique

Lighter, black concave III, 2009
C-type print in plexiglass frame,
65 x 54 x 10 cm, unique

Lighter 76, 2008
C-type print in plexiglass frame,
65 x 54 x 6 cm, unique

Lighter, white convex I, 2009
C-type print in plexiglass frame,
65 x 54 x 6 cm, unique

216
Lighter, beige I, 2007
C-type print in plexiglass frame,
65 x 54 x 5.6 cm, unique

217
Lighter, white concave I, 2010
C-type print in plexiglass frame,
65 x 54 x 10 cm, unique

218
Lighter, white III, 2010
C-type print in plexiglass frame,
65 x 54 x 10 cm, unique

219
Lighter, white IV, 2010
C-type print in plexiglass frame,
54 x 65 x 7 cm, unique

220
Lighter, AC3, 2009
C-type print in plexiglass frame,
65 x 54 x 12.5 cm, unique

221
Lighter, black II, 2008
C-type print in plexiglass frame,
65 x 54 x 9.2 cm, unique

222
Lighter 43, 2008
C-type print in plexiglass frame,
54 x 65 x 4 cm, unique

223
Lighter 9, 2008
C-type print in plexiglass frame,
65 x 54 x 4 cm, unique

224
Installation view *Atair*, Andrea Rosen Gallery, 2007

Lighter I, 2006
C-type print in plexiglass frame,
65 x 54 x 4 cm, unique

208
Lighter II, 2006
C-type print in plexiglass frame,
65 x 54 x 4 cm, unique

Lighter III, 2006
C-type print in plexiglass frame,
65 x 54 x 4 cm, unique

Lighter IV, 2006
C-type print in plexiglass frame,
65 x 54 x 4 cm, unique

Lighter V, 2006
C-type print in plexiglass frame,
65 x 54 x 8 cm, unique

225
Lighter 26, 2007
C-type print in plexiglass frame,
65 x 54 x 13 cm, unique

226
Lighter, blue convex III, 2010
C-type print in plexiglass frame,
65 x 54 x 10 cm, unique

227
Lighter, green concave IV, 2010
C-type print in plexiglass frame,
65 x 54 x 12.5 cm, unique

228
Lighter, green VI, 2010
C-type print in plexiglass frame,
65 x 54 x 12.5 cm, unique

228
Lighter, white blue-black I, 2010
C-type print in plexiglass frame,
54 x 65 x 8 cm, unique

220
Lighter, orange I, 2008
C-type print in plexiglass frame,
65 x 54 x 12.5 cm, unique

231
Lighter, orange II, 2008
C-type print in plexiglass frame,
65 x 54 x 8 cm, unique

232
Lighter 57, 2008
C-type print in plexiglass frame,
65 x 54 x 4 cm, unique

233
Lighter, purple-blue I, 2008
C-type print in plexiglass frame,
65 x 54 x 10 cm, unique

234
Lighter, black yellow I, 2008
C-type print in plexiglass frame,
65 x 54 x 10 cm, unique

Lighter, yellow convex I, 2008
C-type print in plexiglass frame,
65 x 54 x 6.5 cm, unique

235
Installation view Wolfgang Tillmans, Serpentine Gallery,
London, 2010

Kuh, 2008
photocopy,
29.7 x 21 cm, edition of 10 + 2 AP

Lighter, black VII, 2010
C-type print in plexiglass frame,
65 x 54 x 12 cm, unique

Gecko!, 2004
C-type print,
40.6 x 30.5 cm, edition of 10 + 1 AP

236
Installation view, Walker Art Gallery, Liverpool, 2010

Lighter, red II, 2008
C-type print in plexiglass frame,
65 x 54 x 4 cm, unique

Lighter, AC3, 2009
C-type print in plexiglass frame,
65 x 54 x 12.5 cm, unique

237
Lighter, unprocessed supra I, 2010
C-type print in plexiglass frame,
65 x 54 x 10 cm, unique

238
Installation view Strings, Galerie Chantal Crousel, Paris,
2008

Lighter 37, 2008
C-type print in plexiglass frame,
65 x 54 x 4 cm, unique

Lighter 38, 2008
C-type print in plexiglass frame,
65 x 54 x 4 cm, unique

Lighter 39, 2008
C-type print in plexiglass frame,
65 x 54 x 6 cm, unique

239
C-type print in plexiglass frame,
65 x 54 x 6 cm, unique

Lighter 85, 2010
C-type print in plexiglass frame,
65 x 54 x 6 cm, unique

240
Installation view Wolfgang Tillmans, Serpentine Gallery,
London, 2010

Lighter, white IV, 2010
C-type print in plexiglass frame,
54 x 65 x 7 cm, unique

Lighter, blue concave I, 2008
C-type print in plexiglass frame,
65 x 54 x 12.5 cm, unique

241
Lighter, red concave I, 2010
C-type print in plexiglass frame,
65 x 54 x 10 cm, unique

242
Lighter, yellow/green III, 2009
C-type print in plexiglass frame,
65 x 54 x 5.5 cm, unique

243
Lighter, green/red IV, 2009
C-type print in plexiglass frame,
65 x 54 x 4 cm, unique

244
Lighter, red/purple I, 2010
C-type print in plexiglass frame,
54 x 65 x 6 cm, unique

245
Lighter, blue up II, 2008
C-type print in plexiglass frame,
65 x 54 x 7 cm, unique

246
Lighter, blue up V, 2009
C-type print in plexiglass frame,
65 x 54 x 7 cm, unique

247
Lighter, blue up VI, 2009
C-type print in plexiglass frame,
65 x 54 x 7 cm, unique

248
Lighter, blue concave I, 2008
C-type print in plexiglass frame,
65 x 54 x 12.5 cm, unique

249
Lighter 32, 2007
C-type print in plexiglass frame,
65 x 54 x 12.5 cm, unique

250
Kopierer, 2010
Single channel video projection, video, 10 minutes, size
variable, edition of 5 + 2 AP

251
Detail of
Memorial for the Victims of Organized Religions, 2006
48 C-prints, each 61 x 50.8 cm
205 x 1196 cm, unique

252
Kopierer, 2010
single channel video projection, video, 10 minutes,
size variable,
edition of 5 + 2 AP

253
Farbwerk, 2010
single channel video projection, video, 2 minutes 51
seconds, size variable,
edition of 5 + 2 AP

254
Silver I, 1998
C-type print mounted on Forex in artist's frame,
238 x 181 x 6 cm, edition of 1 + 1 AP

255
Installation view Wolfgang Tillmans, Serpentine Gallery,
London, 2010

growth, 2006
C-type print,
40.6 x 30.5 cm, edition of 10 + 1 AP

Silver I, 1998
C-type print mounted on Forex in artist's frame,
edition of 1 + 1 AP

print from his foot, 2004
edition of 3 + 1 AP

edition of 10 + 1 AP

256
photocopy, (Barnaby), 1994
C-type print, 40.6 x 30.5 cm, edition of 10 + 1 AP
C-type print, 61 x 50.8 cm, edition of 3 + 1 AP
C-type print mounted on Forex in artist's frame,
213 x 143 x 6 cm, edition of 1 + 1 AP
Unframed archival ink jet print on paper, 208 x 138 cm,
edition of 1 + 1 AP

257
Silver 78, 2010
C-type print,
61 x 50.8 cm, unique

258
Silver 51, 2006
C-type print mounted on Forex in artist's frame,
228 x 181 x 6 cm, edition of 1 + 1 AP

259
Silver 57, 2006
C-type print mounted on Forex in artist's frame,
228 x 181 x 6 cm, edition of 1 + 1 AP

260
Silver 79, 2011
C-type print mounted on Forex in artist's frame,
181 x 238 x 6 cm, edition of 1 + 1 AP

261
Silver 2, 1998
C-type print,
30.5 x 40.6 cm, unique

262
Silver 73, 2008
C-type print mounted on Forex in artist's frame,
181 x 238 x 6 cm, edition of 1 + 1 AP

Silver 69, 2000
C-type print mounted on Forex in artist's frame,
181 x 238 x 6 cm, edition of 1 + 1 AP

264
Detail of
Silver 69, 2000

265
Silver 71, 2008
C-type print mounted on Forex in artist's frame,
238 x 181 x 6 cm, edition of 1 + 1 AP

266
Silver 81, 2011
C-type print mounted on Forex in artist's frame,
238 x 181 x 6 cm, edition of 1 + 1 AP

267
8407-30, 2007
C-type print mounted on Forex in artist's frame,
237 x 181 x 6 cm, edition of 1 + 1 AP

268
Silver 70, 2008
C-type print mounted on Forex in artist's frame,
238 x 181 x 6 cm, edition of 1 + 1 AP

269
Silver 74, 2008
C-type print mounted on Forex in artist's frame,
181 x 238 x 6 cm, edition of 1 + 1 AP

270
Silver 72, 2008
C-type print mounted on Forex in artist's frame,
181 x 228 x 6 cm, edition of 1 + 1 AP

271
Installation view Lighter, Hamburger Bahnhof-Museum
für Gegenwart, Berlin, 2008

at center:
Silver 65, 2008
C-type print,
61 x 50.8 cm, unique

272
Silver 50, 2006
C-type print mounted on Forex in artist's frame,
228 x 181 x 6 cm, edition of 1 + 1 AP

273
Silver 84, 2003
C-type print,
61 x 50.8 cm, unique
part of Silver Installation VI, 2008

274
Silver 80, 2011
C-type print mounted on Forex in artist's frame,
239 x 181 x 6 cm, edition of 1 + 1 AP

275
8407-3, 2007
C-type print,
40.6 x 30.5 cm, unique

276
edition of 1 + 1 AP

277
edition of 1 + 1 AP

278
8407-4, 2007
C-type print,
40.6 x 30.5 cm, unique

279
8407-8, 2007
C-type print,
40.6 x 30.5 cm, unique

280
8407-19, 2007
C-type print,
40.6 x 30.5 cm, unique

281
Installation view paper drop, Galerie Daniel Buchholz,
Cologne, 2007

Lighter XVIII, 2007
C-type print,
61 x 50.8 cm, unique

263
Lighter XIX, 2007
C-type print,
61 x 50.8 cm, unique

282
Installation view Lighter, Hamburger Bahnhof – Museum
für Gegenwart, Berlin, 2008

Silver Washington (1994/2005), 2007
4 C-type prints,
40.6 x 205 cm, unique

C-type print mounted on Forex in artist's frame,
214 x 145 x 6 cm, edition of 1 + 1 AP

283
Installation view, Wolfgang Tillmans, Hirshhorn Museum
and Sculpture Garden, Washington D.C., 2007

Memorial for the Victims of Organized Religions, 2006
48 C-prints each 61 x 50.8 cm
205 x 1196 cm, unique

284
Detail of
Memorial for the Victims of Organized Religions, 2006

285
Silver Installation (detail), 2006
C-type print, 30.5 x 40.6 cm, edition of 10 + 1 AP
C-type print, 50.8 x 61 cm, edition of 3 + 1 AP
C-type print mounted on Forex in artist's frame,
145 x 213 x 6 cm, edition of 1 + 1 AP
Unframed archive ink jet print on paper, 138 x 208 cm,
edition of 1 + 1 AP

286
Installation view paper drop, Galerie Daniel Buchholz,
Cologne, 2007

untitled (Concorde Installation), 2007
12 C-type prints,
129 x 463 cm, unique

287
Silver Installation VI, 2009
8 C-type prints,
231 x 963 cm, unique

288
Installation view Fare Mondi, La Biennale di Venezia,
Venice, 2009

Silver Installation VII, 2009
26 C-type prints,
306 x 843 cm, unique

289
edition of 1 + 1 AP

Neutral Density (B), 2009
archival ink on print
edition of 1 + 1 AP

Neutral Density (G), 2009
archival ink on print on paper,
edition of 1 + 1 AP

293
Neutral Density (z), 2009
C-type print,
30.5 x 40.6 cm, unique

294
Neutral Density (d), 2009
C-type print,
40.6 x 30.5 cm, unique

295
Installation view Fare Mondi, La Biennale di Venezia,
Venice, 2009

Lighter, blue II, 2006
C-type print in plexiglass frame,
65 x 54 x 10 cm, unique

Wald (Briol I), 2008
C-type print mounted on Forex in artist's frame,
261 x 181 x 6 cm, edition of 1 + 1 AP

296
Kuh, 2008
photocopy,
29.7 x 21 cm, edition of 10 + 2 AP

297
Wald (Briol I), 2008
C-type print mounted on Forex in artist's frame,
261 x 181 x 6 cm, edition of 1 + 1 AP

298
Wald (Re/snagel), 2008
C-type print mounted on Forex in artist's frame,
265 x 181 x 6 cm, edition of 1 + 1 AP

299
Wald (flex I), 2010
C-type print mounted on Forex in artist's frame,
254 x 172 x 6 cm, edition of 1 + 1 AP

300
Wald (Berlin), 2010
C-type print mounted on Forex in artist's frame,
251 x 172 x 6 cm, edition of 1 + 1 AP

301
Wald (Tierra del Fuego) I, 2010
C-type print mounted on Forex in artist's frame,
251 x 172 x 6 cm, edition of 1 + 1 AP

302
City, 2006
C-type print mounted on Forex in artist's frame,
250 x 181 x 6 cm, edition of 1 + 1 AP

303
Clouds I, 2006
C-type print mounted on Forex in artist's frame,
241 x 172 x 6 cm, edition of 1 + 1 AP

304
Clouds II, 2008
C-type print mounted on Forex in artist's frame,
242 x 172 x 6 cm, edition of 1 + 1 AP

305
Garden, 2007
C-type print mounted on Forex in artist's frame,
252 x 181 x 6 cm, edition of 1 + 1 AP

306
Venice, 2007
C-type print mounted on Forex in artist's frame,
181 x 252 x 6 cm, edition of 1 + 1 AP

307
City (Sao Paulo) I, 2010
C-type print mounted on Forex in artist's frame,
251 x 181 x 6 cm, edition of 1 + 1 AP

308
like praying (faced fax), 2005
photocopy,
29.7 x 42 cm, edition of 25 + 2 AP

309
City (Sao Paulo) II, 2010
C-type print mounted on Forex in artist's frame,
257 x 181 x 6 cm, edition of 1 + 1 AP

310
Abney Park, 2008
C-type print mounted on Forex in artist's frame,
181 x 260 x 6 cm, edition of 1 + 1 AP

311
An der Isar, I, 2008
C-type print mounted on Forex in artist's frame,
260 x 181 x 6 cm, edition of 1 + 1 AP

312
in flight astro (II), 2010
archival ink jet print on paper, 48.3 x 30.5 cm,
edition of 120 + 50 AP
C-type print mounted on Forex in artist's frame,
213 x 145 x 6 cm, edition of 1 + 1 AP
Unframed archival ink jet print on paper, 208 x 138 cm,
edition of 1 + 1 AP

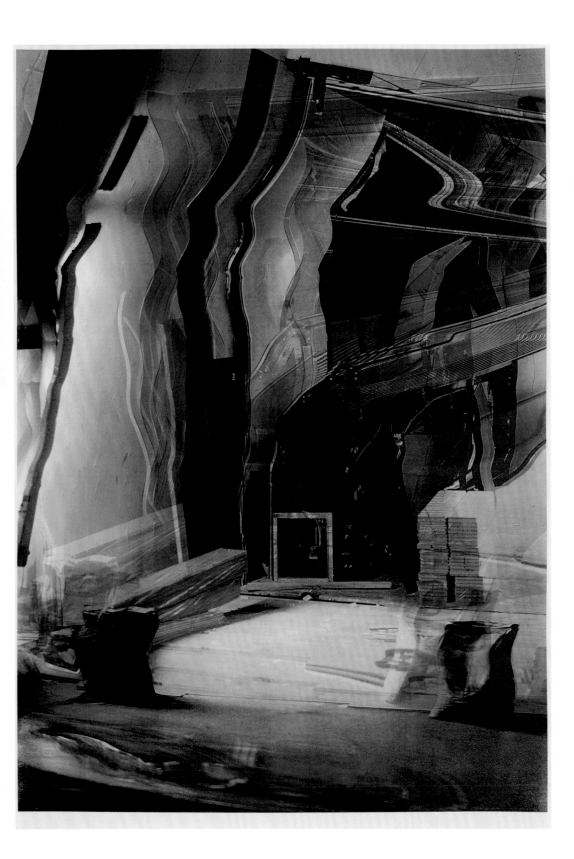

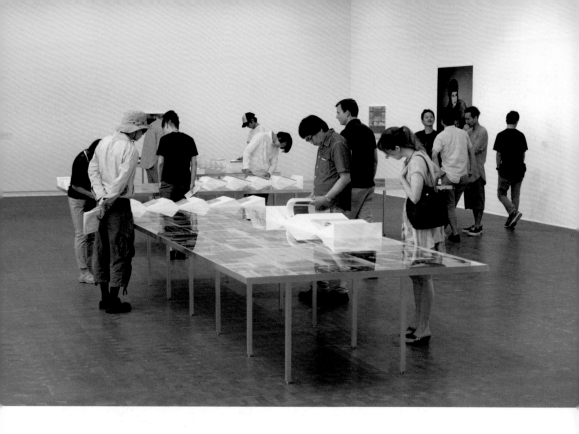

Tate Modern Edition, no. 18, 2016

Installation view of *Your Body is Yours*,
National Museum of Art, Osaka, 2015

Spread from *The Plant*, 2013

I'm fucking angry and I don't want this to
kill me and I don't want it to make me go
insane. I want to survive and I want to be
happy.

I'm fucking angry and I don't want this to
kill me and I don't want it to terrorize
me, I want to survive and I want to be
happy.

Spread from *Wolfgang Tillmans* (exh. cat.),
Kunsthalle Zürich, 1995

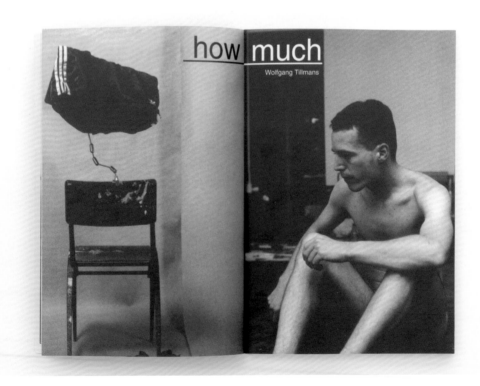

Spread from *Purple Prose*,
1995

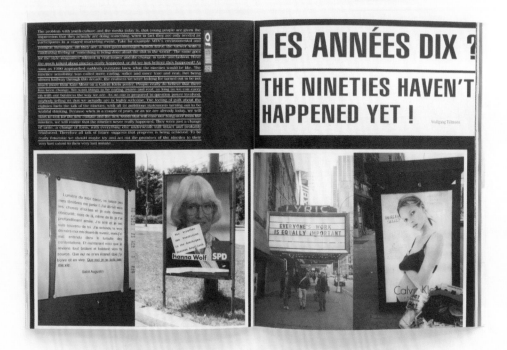

Wolfgang Tillmans
Les années dix ? The Nineties Haven't Happened Yet !
Published in: *Purple Prose*, 6, Summer 1994, pp.60–1.

The problem with youth-culture and the media today is that young people are given the impression that they actually are doing something, when in fact they are only needed as participants in a staged marketing event. Take, for example, MTV's environmental and political messages, all they are is feel-good-messages which leave the viewer with a comforting feeling of 'something is being done about the shit in the world'. The same goes for the style-magazines' interest in 'real issues' and the change in taste and fashion. Have the much-talked-about nineties really happened, or did we just believe they happened? As soon as 1990 approached suddenly everyone knew what the nineties would be like. The nineties sensibility was called more caring, softer and more true and real. But being almost halfway through this decade, the realness we were looking for turned out to be not much more than Kate Moss on a Calvin Klein poster. People really do believe that there has been change. We want things to be caring, aware and real, as long as we can carry on with our business the way we are. As no one is prepared to question power involved, anybody telling us that we actually are is highly welcome. The feeling of guilt about the eighties fuels the talk of the nineties, with all its ambitious statements turning out to be wishful thinking. Because when in a couple of years, or as we are already today, we will start to look for the new climate and the new words that will ease our hang-over from the nineties, we will realize that the nineties never really happened. They were just a change of taste, a change of form, with everything else underneath still intact and probably reinforced. Therefore all talk of future suggests that progress is being achieved. To be really futuristic we should maybe try and act out the promises of the nineties to their very last extent to their very last minute.

Lord Marshall of Knightsbridge
Chairman

BRITISH AIRWAYS

Waterside (HBB3)
PO Box 365 Harmondsworth UB7 0GB
United Kingdom Tel 0845 77 999 77
Outside United Kingdom Tel +44 (0)191 490 7901

Mr Wolfgang Tillmans
223 Cambridge Heath Road
London
E2 0EL

tillmans.doc

17 December 2002

Dear Mr Tillmans

Thank you for your letter of 20 November regarding our newspaper policy for
economy class passengers.

I am sorry that you feel concerned about our circulation of the Daily Mail but I am
sure you are aware that this is just one of the selection of newspapers that we offer
our customers including the Daily Telegraph, Evening Standard, Observer on Sunday
and Mail on Sunday.

Despite your concerns the Daily Mail remains one of the most popular papers in the
UK circulating some 2.5 million copies a day and indeed is particularly popular
amongst our customer base.

Whilst I respect you have views on this particular newspaper and given the fact that
newspapers are regulated in terms of their editorial content extremely strictly, we feel
well justified in circulating both the Mail on Sunday and the Daily Mail to our
customers.

I realise that this response is not necessarily the one you were hoping for but given
the broad appeal of these publications it is entirely appropriate that we circulate them
to our customers.

Yours sincerely

Directors: Lord Marshall of Knightsbridge (Chairman), R I Eddington (Chief Executive), J F Rishton (Chief Financial Officer)
M A Street (Director of Customer Service & Operations), M A van den Bergh, M F Broughton, Dr A S Ganguly
Capt M D Jeffery, Baroness O'Cathain OBE, Dr M P Read, Lord Renwick of Clifton

British Airways Plc
Registered Office: Waterside PO Box 365 Harmondsworth UB7 0GB
Registered in England No. 1777777
www.britishairways.com

oneworld member

BA Letter, 2002, spread from
Wako Book 3, 2004

Wolfgang Tillmans 223 Cambridge Heath Road London E2 0EL
tel 020 7729 85 9 fax 020 7729 85 4 tillmans@d on.co.uk

Lord Marshall, Chairman
British Airways plc
Waterside
P.O. Box 365
Harmondsworth, UB7 0GB

London, 14.11.2002

Dear Lord Marshall,

I'm writing to you in regards to a matter that has been of repeated concern to me
over the past few years. As a frequent traveller on British Airways flights and as a
gay German living in Britain I feel offended by your airline's policy of handing out
a copy of The Daily Mail or the The Mail on Sunday to every passenger in
Economy Class. There is no choice of newspaper offered and I am usually
actively asked by the flight crew if I would like a copy of the Daily Mail or Mail on
Sunday. At every such occasion I feel angered and wonder why an airline,
claiming to be the world's favourite, chooses to distribute such a divisive
newspaper, an organ that is proven to be homophobic, racist and xenophobic.
Please do not get me wrong I do not complain about a political bias, right-leaning
or left-leaning, I am complaining to you about the deliberately hateful writing
against parts of the British population and foreigners, Europeans and asylum
seekers in particular. I am sure the inflammatory and hateful nature of a lot of
reporting and commentary in the paper you distribute to your passengers has not
escaped you.
As you can imagine I actively try to avoid being offended by a homophobic or
xenophobic article by not picking up a copy of The Daily Mail on BA flights and
bringing my own reading matter. However passive exposure to offensive bold
headlines is unavoidable by fellow passengers who approvingly or un-
approvingly read the paper distributed to them en masse and without alternative
in the seats around me.

Your airline, even though privatised, is by it's name and nature an ambassador of
Britain to the world. Why do you welcome passengers boarding your planes in
foreign countries with a newspaper that promotes some of the most un-British
values: pettiness, narrow-mindedness and hate? As a foreign passenger one
assumes that the one and only newspaper handed out on a flight does reflect to
some extent the country it is coming from. That assumption is largely misguided
on British Airways flights. Would it not be a more fair service to all passengers
and to Great Britain to offer a choice of newspapers, like most other European

quality airlines do, or to not hand out any newspapers, like the budget airlines
do?
As a gay and foreign-born member of the British Airways Executive Club I first
would like to know why British Airways chooses this divisive practice
(i.e. does BA believe in the values promoted in The Daily Mail? are you given
the papers for free, whilst you would have to pay for alternative ones? are you
being paid for distribution as part of a marketing deal?) and second I would like to
find out if you intend to change your policy on this matter in the future?
I feel strongly about this issue and therefore look forward to hear back from you,
before I consider taking this matter to a public forum.

Yours sincerely,

Wolfgang Tillmans

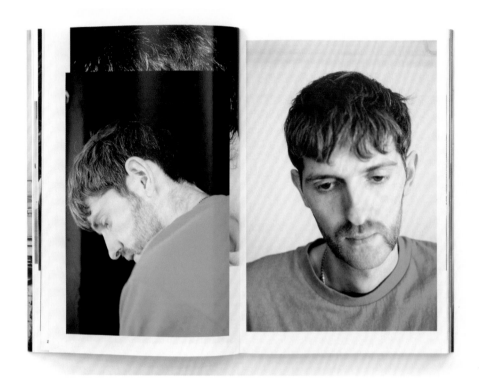

Spread from *Conor Donlon*, 2016

Spread from *Document Journal*,
Fall/Winter 2015

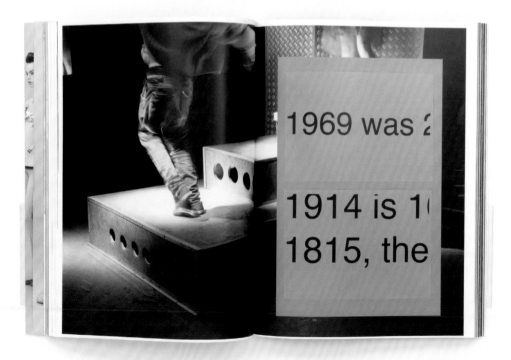

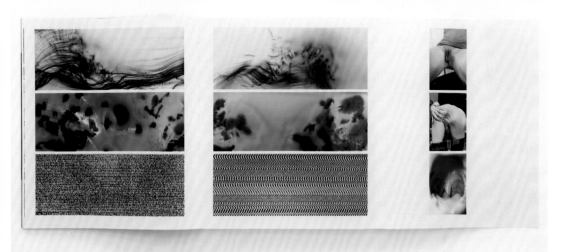

Spread from *Berghain: Kunst im Klub / Art in the Club*,
2015

Spread from *The Journal*,
XVI, Summer 2006

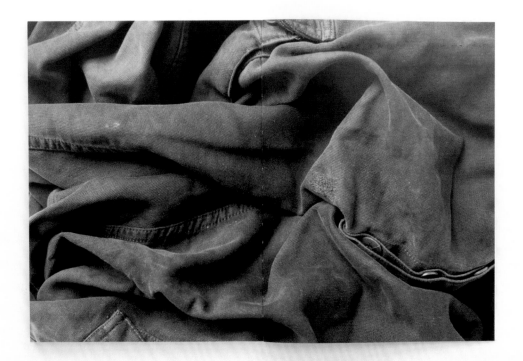

Spread from *Your Body is Yours*
(exh. cat.), The National Museum of
Art, Osaka, 2015

Spread from *Fantastic Man*,
no. 23, 2016

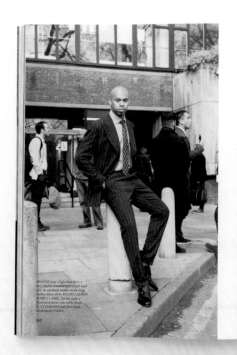

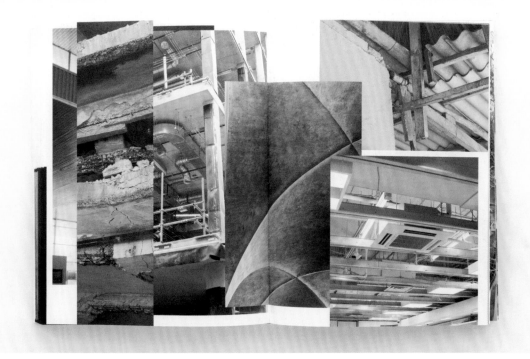

Spread from *Fundamentals* (exh. cat.), La Biennale di
Venezia – 14th International Architecture Exhibition,
Venice, 2014

Spread from *Your Body is Yours* (exh. cat.),
The National Museum of Art, Osaka, 2015

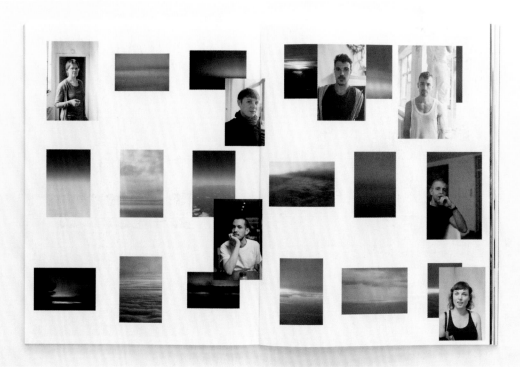

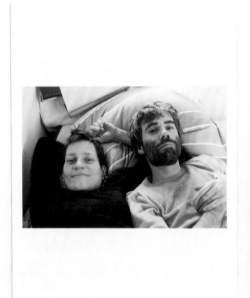

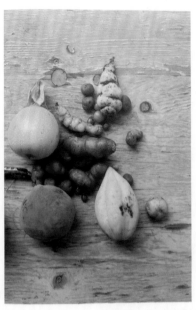

Spread from *Your Body is Yours*
(exh. cat.), The National Museum of
Art, Osaka, 2015

Spread from *Document Journal*,
Fall/Winter 2015

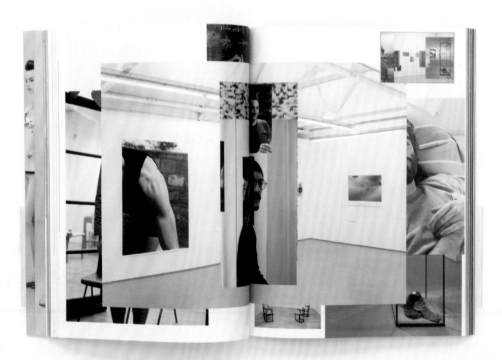

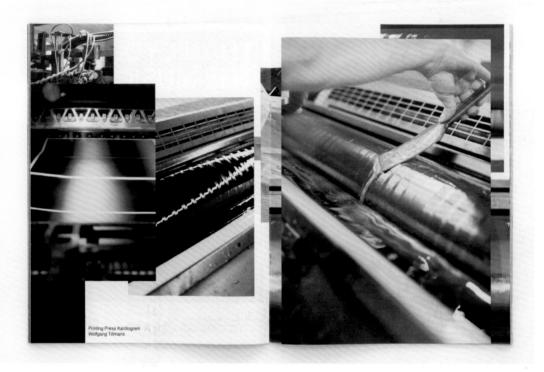

Spread from *DE:BUG*, no. 181, 2014

Spread from *Document Journal*,
Fall/Winter 2015

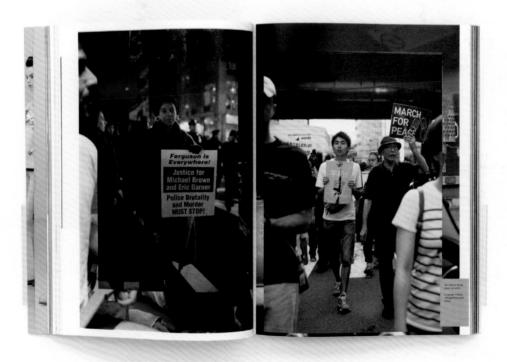

Double Exposure (Fespa Digital/Fruit Logictica)
V and III, 2012 in *Your Body is Yours*, National
Museum of Art, Osaka, 2015

Extended Practice

I Exhibitions and events curated by Wolfgang Tillmans

2016
Playback Room – Ein Raum für Studiomusik, Städtische Galerie im Lenbachhaus
und Kunstbau, Munich

2014
Fondation Beyeler, Riehen/Basel (works from the permanent collection)

2010
Park Nights: John Maus, Serpentine Pavilion, London
Park Nights: Wolfgang Tillmans and Dimitar Sasselov. The Edge of Visibility: A Night of
Astronomy, Serpentine Pavilion, London

2009
The Perpetual Dialogue, Andrea Rosen Gallery, New York (curatorial contributor)

2008
Tegenwoordigheid van Geest – Presence of Mind (works from the permanent collection),
Stedelijk Museum, Amsterdam
Jochen Klein (curated together with Bernhart Schwenk), Pinakothek der Moderne,
Munich

2004
Inventory – Scott King, Donald Urquhart, Portikus, Frankfurt am Main

Between Bridges, Berlin

2016
Peter Knoch
Meeting Place (weekly events; 14 April – 31 July)

2015
Jochen Lempert
Anders Clausen
Fashion Stories
Greer Lankton
Bring Your Own (Playback Room pt. III)

2014

American Producers (Playback Room pt. II)
Edgewise: A Picture of Cookie Mueller by Chloé Griffin (book launch event)
Colourbox – Music of the group (1982–1987), (Playback Room pt. I)
Scott King: Totem Motiv
And Life Goes On… (curated by Karl Holmqvist)
Patrick Caulfield

Between Bridges, London

2011

Marte Eknæs: Escalate
Len Lye: Free Radicals

2010

Gerd Arntz (1900–1988) and Isotype

2009

Jenny Holzer: Truisms (1977–79) and Essays (1979–82)
Ull Hohn

2008

25/34 Photographies (Ralf Marsault / Heino Muller): Fin de Siècle.
Wilhelm Leibl (1844–1900)
The Center for Land Use Interpretation
Isa Genzken: Ground Zero (2)

2007

Art Club 2000, Selected Works 1992–1994
Charles Henri Ford: The Garden of Disorder
(curated by Daniel Buchholz and Christopher Müller)
Charlotte Posenenske: Series DW (corrugated cardboard) 1967
Josef Kramhöller

2006

Sister Corita: works from the 1960s
Wolfgang Breuer: Umbel
David Wojnarowicz
Jochen Klein

II Books edited and/or designed by Wolfgang Tillmans
Artist books, catalogues and monographs

(m) monographs
(ab) artist books, edited and designed by WT
(abc) publications in which all color plates were edited and designed by WT

2017 exh. cat. Tate Modern, London 2017 (ab)

On the Verge of Visibility exh. cat. Museu Serralves, Porto 2016 (ab)

Conor Donlon Verlag der Buchhandlung Walther König, Cologne 2016 (ab)

What's wrong with redistribution? Verlag der Buchhandlung Walther König, Cologne 2015 (ab)

Your Body is Yours exh. cat. The National Museum of Art, Osaka 2015 (abc)

The Cars Verlag der Buchhandlung Walther König, Cologne 2015 (ab)

Wolfgang Tillmans Phaidon Press, London 2014 (m)

Wolfgang Tillmans BT Books, Tokyo 2014 (m)

Wako Book 5 Wako Works of Art, Tokyo 2014 (ab)

Utoquai TBW Books, Oakland 2013 (ab)

Wolfgang Tillmans exh. cat. Moderna Museet Stockholm, Kunstsammlung Nordrhein-Westfalen – K21, Düsseldorf 2012 (ab)

Neue Welt Taschen, Cologne 2012 (ab)

FESPA Digital / FRUIT LOGISTICA Verlag der Buchhandlung Walther König, Cologne 2012 (ab)

Zachęta Ermutigung exh. cat. Zachęta Narodowa Galería Sztuki, Kunstsammlung Nordrhein-Westfalen – K21, Düsseldorf 2011 (abc)

Abstract Pictures Hatje Cantz, Ostfildern 2011 (reissued 2015) (ab)

Wolfgang Tillmans exh. cat. Serpentine Gallery, London 2010 (abc)

Wolfgang Tillmans: Interviews Wako Works of Art, Tokyo 2010 (ab)

Lighter exh. cat. Hamburger Bahnhof – Museum für Gegenwart, Berlin, Hatje Cantz, Ostfildern 2008 (ab)

Wako Book 4 Wako Works of Art, Tokyo 2008 (ab)

manual Verlag der Buchhandlung Walther König, Cologne 2007 (ab)

Why we must provide HIV treatment information HIV i-base, London 2006 (abc)

Freedom From The Known exh. cat. MoMA PS1, New York, Steidl, Göttingen 2006 (abc)

truth study center Taschen, Cologne 2005, reissued 2011 (with 'Wolfgang Tillmans' and 'Burg') (abc)

Freischwimmer exh. cat. Tokyo Opera City Gallery, Tokyo 2004 (ab)

Wako Book 3 Wako Works of Art, Tokyo 2004 (ab)

If one thing matters, everything matters exh. cat. Tate Britain, London 2003 (ab)

Wolfgang Tillmans Phaidon Press, London 2002 (m)

AC: Isa Genzken / Wolfgang Tillmans exh. cat. Museum Ludwig, Cologne 2001 (abc)

Aufsicht / View from Above exh. cat. Deichtorhallen Hamburg / Castello di Rivoli – Museo d'Arte Contemporanea, Rivoli–Turin / Palais de Tokyo, Paris / Louisiana Museum of Modern Art, Humlebæk, Hatje Cantz, Ostfildern 2001 (abc)

Portraits Verlag der Buchhandlung Walther König, Cologne 2001 (ab)

Wako Book 2 Wako Works of Art, Tokyo 2001 (ab)

Soldiers – The Nineties Verlag der Buchhandlung Walther König, Cologne 1999 (ab)

Wako Book 1999 Wako Works of Art, Tokyo 1999 (ab)

Totale Sonnenfinsternis / Total Solar Eclipse Galerie Daniel Buchholz, Cologne 1999 (ab)

Burg Taschen, Cologne 1998, reissued 2002 (with 'Wolfgang Tillmans') and 2011 (with 'Wolfgang Tillmans' and 'truth study center') (ab)

Concorde Verlag der Buchhandlung Walther König, Cologne 1997 (ab)

Wer Liebe wagt lebt morgen / For when I'm weak I'm strong exh. cat. Kunstmuseum Wolfsburg, Cantz Verlag, Ostfildern 1996 (abc)

Wolfgang Tillmans exh. cat. Portikus, Frankfurt am Main 1995 (abc)

Wolfgang Tillmans exh. cat. Kunsthalle Zürich, Zürich 1995, reissued by Ringier, Zürich 2008 (ab)

Wolfgang Tillmans Taschen, Cologne 1995, reissued 2002 (with 'Burg') and 2011 (with 'Burg' and 'truth study center') (abc)

Catalogues that were edited and designed by an institution are not included in this bibliography.

III Artist pages

Magazine and book layouts photographed, edited and designed by WT

2016

'Arschlochtypen verhindern', *Artforum*, November 2016, pp.236–7.

'EU Campaign', *Spex*, 369, July/August 2016, p.114.

'EU Campaign', *032c*, 30, Summer 2016, p.264.

'Fragile Fiction', *ARENA Homme+*, Winter 2016/Spring 2017, pp.206–317.

'Gays Against Guns', *Starship*, 15, October 2016, pp.66–72.

'I'm a morning person', in Frank Ocean (ed.), *Boys Don't Cry – Issue 1 / Album 3*, 2016, cover and pp.194–9.

'Lutz – Lutz Huelle, Paris', *POP*, 35, Autumn/Winter 2016, pp.382–429.

'Münchner Kammerspiele', *Münchner Kammerspiele*, Spielzeit 2016/17, unpag.

'Spectrum Montrose Ave', *apartamento*, 17, Spring/Summer 2016, pp.129–37.

'Switch craft', *Wallpaper*, July 2016, pp.96–9.

'We've Got The Right', *Man About Town*, Winter/Spring 2016/2017, pp.320–35.

'Wolfgang Tillmans', in *Mit anderen Augen – Das Porträt in der zeitgenössischen Fotografie*, exh. cat. Kunstmuseum Bonn, Cologne 2016, pp.325–9.

2015

'(title ?) FRAGILE 1983 - 1989', *ARENA Homme+*, 44, Winter 2015/Spring 2016, pp.250–315.

'Abbild der Weltfrucht', *taz. zeozwei*, 3, pp.20–3, 28–31.

'Full Fragile Range Recordings', *Document*, 7, pp.152–67.

'Isa Genzken – Presentation of 'Hemden'', *ARENA Homme+*, 44, Winter 2015/Spring 2016, pp.368–93.

'Wolfgang Tillmans', *Free*, Autumn/Winter 2015, pp.46–59.

'Münchner Kammerspiele', *Münchner Kammerspiele*, Spielzeit 2015/16, unpag.

'Quel âge as-tu?', *ARENA Homme+*, 44, Winter 2015/Spring 2016, pp.332–53.

'Visual Essay – Fespa Digital / Fruit Logistica', *Purple Fashion*, 3, Spring/Summer 2015, pp.493–504.

'Wolfgang Tillmans. A multi-vectored practice', *Wired Japan*, 17, July 2015, pp.24–31.

2014

'Artistic contribution', in *Excursus*, exh. cat. 8th Berlin Biennale for Contemporary Art, KW Institute for Contemporary Art, Berlin 2014, pp.2–5.

'From Book for Architects', in *Fundamentals*, exh. cat. La Biennale di Venezia – 14th International Architecture Exhibition, Venice 2014, pp.312–45.

'Neue Welt', *Noon*, 1, Spring/Summer 2014, pp.152–66.

'Printing Press Kardiogram', *DE:BUG*, 181, April 2014, pp.42–9.

2013

'AnOther Hemisphere', *South*, Spring/Summer 2013, unpag.

'Club Donny. Grande Finale #10', *Club Donny*, 10, pp.1, 5–8, 109–12, 116.

'São Paulo by Wolfgang Tillmans', *Pin-Up*, 14, Spring/Summer 2013, unpag.
'Insert', *Camera Austria*, 122, 2013, pp.23–30.
'The Plant Life', *The Plant*, 4, pp.1–13.
'The Freedoms of Photography', *Camera Austria*, 122, pp.23–32.

2012
Das Magazin der Kulturstiftung des Bundes, Spring/Summer 2013, entire issue.

2011
'Tillmans – Mazhar', *ARENA Homme+*, 35, Spring/Summer 2011, pp.254–63.
'Untitled (Warsaw)', *Dik Fagazine*, 8, September 2011, pp.6–11.
'Ushuaia, Tierra Del Fuego / Febrero 2010', *Correspondencia*, 1, pp.129–53.
'What's wrong with redistribution?', *BBC History Magazine*, July 2011, p.20.
'What's wrong with redistribution?', *frieze*, 142, October 2011, pp.140–1.

2010
'Necks', *Fantastic Man*, 11, Spring/Summer 2010, pp.101–6.
'Neue Bilder aus Berlin', *Monopol*, October 2010, pp.62–75.

2009
'Der Unterwäschekatalog', *BUTT*, 26, April 2009, pp.39–52.
'Die Party ist vorbei', *Süddeutsche Zeitung Magazin*, 3 December 2009, pp.10–25.
'Evidence', *Modern Weekly International*, cover and pp.5, 8, 52–63.
'Pictured in America and Pictures of America', *Coyote*, March 2009, pp.105–53.
'Portfolio', *First Person no. 3*, Fall 2009, cover and pp. 32–45.
'Silver Installation VI', in *Fare Mondi – Making Worlds*, exh. cat. La Biennale di Venezia 53 – 53rd Venice Biennale, Venice 2009, pp.154–5.
'Wolfgang Tillmans', in *Against Exclusion*, exh. cat. 3rd Moscow Biennale of Contemporary Art, Moscow 2009, pp.166–7.

2008
'Look, again', *frieze*, 118, October 2008, cover and pp.236–44.

2007
'Insert Wolfgang Tillmans', in Heike Belzer and Daniel Birnbaum (eds.), *kunst lehren – teaching art*, Städelschule Frankfurt am Main, Cologne 2007, pp.153–84.
'Tillmans-Feuilleton – Fundstücke der Wirklichkeit' (artist pages and editorial), *Die Zeit*, 23, 31 May 2007, pp.49–57.
'Wolfgang Tillmans – Lighter / Manual', *foam*, 13, Winter 2007, pp.55–70.
'Wolfgang Tillmans', *Polar*, 2, Spring 2007, pp.65–72.

2006
'Blind Spot', *Blind Spot*, 33, Summer 2006, unpag.
'Panbladet', *Panbladet*, 6, August 2006, entire issue and cover.

'Soldiers: The Nineties', in Eugen Blume, Joachim Jäger and Gabriele Knapstein (eds.), *Friedrich Christian Flick Collection im Hamburger Bahnhof*, exh. cat. Hamburger Bahnhof – Museum für Gegenwart, Berlin 2004, pp.463–71.

2005

'Bottoms', *BUTT*, 3, Summer 2005, pp.6–9.

'Gold', *Volume 0. 'The sky is thin as paper here'*, Galerie Daniel Buchholz, Cologne 2005, unpag.

'Leaving Japan 18 Oct. 2004', *Esquire Magazine Japan*, 2, February 2005, pp.68–77.

'Make Poverty History', *i-D*, 255, June 2005, pp.160–61.

'Soldiers. The Nineties, V, 2005', in *Covering the Real. Kunst- und Pressebild von Warhol bis Tillmans*, exh. cat. Kunstmuseum Basel, Cologne 2005, pp.198–203.

'Surface is All We Have', *EXIT*, 18, May/June/July 2005, pp.71–9.

'Untitled', in *Welt-Bilder / World Images*, exh. cat. Helmhaus Zürich, Zürich 2005, pp.173–89.

2004

'21st Century Radical Chic', *Purple Fashion*, 1, Spring 2004, pp.336–43.

'Ost-West', *Freier*, 3, July 2004, pp.71–2.

'Page 3 stunnas!', *G2, Guardian*, 19 April 2004, pp.2–3; reprinted in *Newspaper Jan Mot*, 42, May 2004, pp.2–4; *Der Standard*, 1 May 2004, p.Album B3; *Courier International*, 711, June 2004, p.16.

'Self/Sweat', *Chroma*, 1, Summer 2004, cover.

2003

'A True Encounter in a Hotel Room in the Middle East', *BUTT*, 6, Spring 2003, pp.44–8.

'Normal Utilpassethed', *Panbladet*, 1, February 2003, cover and pp.20–5.

'Wolfgang Tillmans', *Studio Voice Fashion Extra*, 2003, pp.52–5.

2002

'Blushes #13', *Pop*, Spring/Summer 2002, unpag.

'Der Blautopf in Blaubeuren 2001', *NºB Magazine*, February 2002, pp.132–7.

'No shock, no scandal. Just a gay couple on holiday', *BUTT*, 5, Fall 2002, pp.48–57.

2001

'A Project for Artforum', *Artforum*, February 2001, pp.130–3.

'Heimatfilm', in *Zero Gravity*, exh. cat. Kunstverein der Rheinlande und Westfalen, Kunsthalle Düsseldorf, Cologne 2001, unpag.

'Science Fiction. Hier und Jetzt zufrieden sein' (with Isa Genzken), *Stadtrevue*, November 2001, unpag.

'Studiomaus', *i-D*, 213, September 2001, p.293.

2000

'Portfolio', *Männer aktuell*, 1, January 2000, pp.37–46.

'Rats', *Tate Etc.*, 23, Winter 2000, pp.48–9.

'The View From Here', *The Big Issue*, 401, 28 August 2000, cover and pp.3–24. (guest editor)

'Wolfgang Tillmans', in *Dire AIDS. Art in the Age of AIDS*, exh. cat. Promotrice delle Belle Arti, Milano 2000, pp.94–7.

1999
'Soldiers: The Nineties', *art*, 11, November 1999, pp.86–95.
'Strings of Life by Rhythim is Rhythim', *i-D: Beyond Price* (limited edition), p.238.
'Wolfgang Tillmans', in *Visions of the Body: Fashion or Invisible Corset*, exh. cat. National Museum of Modern Art, Kyoto 1999, pp.133–5.
'Zwölf Uhr mittags', *Süddeutsche Zeitung Magazin*, 29, 23 July 1999, pp.26–33.

1998
'Blumentopf nach Hause tragen', in *Kunstbuch*, Cologne 1998, p.163.
'Daniel, Jochen and Christopher', *i-D: family. Future Postive* (limited edition), p.146.
'Edition for Parkett. Wolfgang Tillmans', *Parkett*, 53, cover and pp.138–41.
'K78' and 'das Titel von die Portfolio ist Nestbeschmutzung', in *Berlin / Berlin*, exh. cat. Berlin Biennale für zeitgenössische Kunst, Ostfildern 1998, pp.339–40 and 377–80.
'Uniformity. Men at war', *Big*, 9, 1998, unpag.
'Gala 1997', *Vogue Italia*, 570, February 1998, pp.328–9.

1997
'Portfolio', *Studio Voice Fashion Extra. Skool of Edge*, 2, 1997, pp.52–5.
'Wolkenkratzer', *Süddeutsche Zeitung Magazin*, 26, 26 June 1997, pp.32–41.
'Wolfgang Tillmans. Mouse Walk with Me Portfolio', *Landscapes*, 1, 1997, pp.2–13.

1996
'Chateau Portfolio', *Purple Prose*, 10, Winter 1996, pp.84–91.
'faulheit & arbeit', *Junge Welt*, 71, 23/24 March 1996, cover and pp.2–5.
'L'univers de Wolfgang', *East-West Avenue*, 5, July/August 1996, pp.46–53.
'Manifesta 1 Portfolio Project', *Blvd. Amsterdam*, June 1996, pp.39, 46.
'Portfolio', *Zine*, 2, 1996, pp.34–40.
'Rats', in *Family, Nation, Tribe Community SHIFT*, exh. cat. Haus der Kulturen der Welt, Berlin 1996, pp.145–52.
'traffic', *Switch*, 13, April 1996, cover, pp.9 and 26–39.
'Visual Diary #5', *Switch*, 1, pp.154–5.
'Visual Diary #6', *Switch*, 2, pp.138–9.
'Visual Diary #7', *Switch*, 3, pp.136–7.
'Visual Diary #8', *Switch*, 4, pp.122–3.
'Visual Diary #9', *Switch*, 5, pp.124–5.
'Visual Diary #10', *Switch*, 6, pp.156–7.
'Wolfgang Tillmans', in *Prospect 96 – Photographie in der Gegenwartskunst*, Frankfurter Kunstverein and Schirn Kunsthalle, Frankfurt am Main 1996, pp.320–3.

1995
'Fake New York Diary', *Max*, June 1995, p.170.

'Photo Story', *Switch*, 7, pp.131–6.
'Visual Diary #2', *Switch*, 8, pp.146–7.
'Visual Diary #3', *Switch*, 9, pp.148–9.
'Visual Diary #4', *Switch*, 10, pp.154–5.
'Wolfgang Tillmans', *Kunstpreis der Böttcherstraße in Bremen*, exh. cat. Kunsthalle Bremen, Bremen 1995, pp.56–61.
'Wolfgang Tillmans – Because quality counts', *Switch*, 7, pp.131–9.

1994
'Kai Althoff and Justus Köhncke', *i-D*, 132, September 1994, p.40.
'Party', in *Rien à signaler*, exh. cat. Galerie Analix – B & L Polla, Geneva 1994, pp.90–1.
'Wolfgang Tillmans', in *Soggetto Soggetto*, Castello di Rivoli – Museo d'arte contemporanea, Torino/Milano 1994, pp.106–9.

IV Texts written by Wolfgang Tillmans

2016
'Foreword', in *Astronomy Photographer of the Year*, Glasgow 2016, p.13.
'Tate Modern and me', *The New Tate Modern*, June 2016, pp.4–5.
'Unerhört. Zwischen Entsetzen und Triumph: Stimmen von Literaten, Künstlern und Wissenschaftlern aus Großbritannien', *Süddeutsche Zeitung*, 25/26 June 2016, p.15.
'We're living in dangerous times', *Time Out London*, 21 June 2016, pp.78–9.

2015
'Introduction', in *The Cars*, Cologne 2015, unpag.

2014
'Museum of the Year 2014: what makes a winner? Wolfgang Tillmans on Tate Britain', *The Guardian*, 4 July 2014, https://www.theguardian.com/culture/2014/jul/04/museum-year-what-makes-winner, accessed 15 November 2016.
'Of Chance and Control', in Jan Verwoert et al. (eds.), *Wolfgang Tillmans*, London 2014, pp.148–62.
'Study Of Man', in Jop van Bennekom and Gert Jonkers (eds.), *Forever Butt*, Cologne 2014, pp.8–11.

2013
'Framing the view: six artists reveal how they choose landscapes. Wolfgang Tillmans: Concorde Grid', *The Guardian*, 2 February 2013, pp.16–7.

2012
'Introduction', in *FESPA Digital / FRUIT LOGISTICA*, Cologne 2012, unpag.
'Wolfgang Tillmans', in Lizzie Carey-Thomas (ed.), *Migrations: Journeys into British Art*, exh. cat. Tate Britain, London 2012, p.113.

'Wolfgang Tillmans. Lecture, Royal Academy of Arts, London 2011', *Cine Qua Non*, 5, Winter 2012, pp.16–25.

2011

'Best of 2011', *Artforum*, December 2011, pp.192–3.

'Es lebe London', *Die Zeit*, 34, 18 August 2011, p.41.

'Excerpts from Interviews, Lectures, and Notes' / 'Auszüge aus Interviews, Vorträgen und Notizen', in *Abstract Pictures*, Ostfildern 2011, pp.23–5 / pp.27–9.

'Foreword' in *Zachęta Ermutigung*, exh. cat. Zachęta Narodowa Galería Sztuki, Kunstsammlung Nordrhein-Westfalen – K21, Düsseldorf 2011, unpag.

'Marte Eknaes', *frieze*, 144, September 2011, p.126.

'Summer Solstice – Lady Gaga', *i-D*, 313, Summer 2011, pp.148–53.

'Wolfgang Tillmans: Dunkelkammer / Darkroom', *frieze d/e*, 3, Winter 2011, pp.30–1.

'Wolfgang Tillmans's best shot', *The Guardian*, 19 September 2011, p.23.

2010

'My London', *Time Out London*, 24 June 2010, pp.6–10.

2007

'Introduction', in *manual*, Cologne 2007, text on sleeve and pp.428–31.

2006

'Wolfgang Tillmans. Suspense, 2005', *Fanzine137*, March 2006, pp.39–40.

2005

'Foreword', in *truth study center*, Cologne 2005, pp.2–3.

'Mein Plattenschrank', *Groove*, 97, November/December 2005, p.46.

'Surface is All We Have', *EXIT*, 18, May/June/July 2005, p.71.

2004

'Corrective Lens – letter to the editor', *Artforum*, January 2004, p.18.

'Page 3 stunnas!', *G2, Guardian*, 19 April 2004, pp.2–3; reprinted in *Newspaper Jan Mot*, 42, May 2004, pp.2–4; *Der Standard*, 1 May 2004, p.Album B3 (reprinted in German as: 'Nackt ist nicht gleich nackt'); *Courier International*, 711, June 2004, p.16.

'Soldiers: The Nineties', in Eugen Blume, Joachim Jäger and Gabriele Knapstein (eds.), *Friedrich Christian Flick Collection im Hamburger Bahnhof*, exh. cat. Hamburger Bahnhof – Museum für Gegenwart, Berlin 2004, pp.462 (German), 557 (English).

'Tony Maestri', *Purple*, 16, Fall/Winter 2004, p.71.

'Wolfgang Tillmans on Donald Urquhart', *Artforum*, January 2004, p.139.

2003

'Farewell', *G2, The Guardian*, 17 October 2003, pp.2–3.

'Peter Saville', *Purple*, 14, Fall/Winter 2003, pp.64–5.

2002

'Isa Genzken', *Purple*, 13, Fall 2002, pp.64–5.

'Lights (Body), 2000–02', in Jan Verwoert et al. (eds.), *Wolfgang Tillmans*, London 2002, p.142.

'Marilyn', *Purple*, 10, Winter 2002, pp.62–3.

'Miss Kittin', *Purple*, 11, Spring 2002, pp.80–1.

'Ryan McGinley', *Purple*, 12, Summer 2002, pp.62–3.

2001

'Cerith Wyn Evans', *Purple*, 9, Fall 2001, pp.76–7.

'Foreword', in *Portraits,* Cologne 2001, unpag.

'Neil Tennant', *Purple*, 8, Summer 2001, pp.62–3.

'Ruth Wyner and John Brock', *Purple*, 7, Spring 2001, pp.78–9.

2000

'10x10. Die zehn besten Ausstellungen der letzten zehn Jahre', *Texte zur Kunst*, 40, December 2000, pp.28–30.

1999

'Sonnenflecken / Sunspots', in *Totale Sonnenfinsternis. Total Solar Eclipse*, Cologne 1999, unpag.

1998

'Foreword', in Wolfgang Tillmans (ed.), *Jochen Klein*, Cologne 1998, pp.5–6.

'Uniformity. Men at war', *Big*, 9, 1998, unpag.

1997

'Concorde', in *Concorde*, Cologne 1997, unpag.

'Nan Goldin', *Zeit Magazin*, 6, 31 January 1997, cover and pp.11–9.

1996

'Nan Goldin', *Spin*, November 1996, p.82.

1995

'Im Hamburger Polizeiskandal: Ermittlungen gegen sieben Polizisten', in *ars viva 95/96. Photographie*, exh. cat. Kulturkreis der deutschen Wirtschaft im Bundesverband der deutschen Industrie e.V., Köln 1995, p.42.

1994

'Kai Althoff and Justus Köhncke', *i-D*, 132, September 1994, p.40.

'Les Anneés Dix? The Nineties Haven't Happened Yet!', *Purple Prose*, 6, Summer 1994, pp.60–1.

'Techno Soul', in *L'Hiver de l'amour*, exh. cat. Musée d'Art Moderne de la Ville de Paris, Paris 1994, pp.8–9.

1992

'Gay Pride London', *i-D Japan*, 15, December 1992, pp.86–9.

'Gay Pride London', *i-D*, 108, September 1992, pp.86–90.

'positive!', *i-D*, 100, January 1992, p.50.

1990

'Berlin', *The Face*, 17, January 1990, p.109.

V Interviews conducted by Wolfgang Tillmans

2015

'Arca', *BUTT*, 27 March 2015, http://www.buttmagazine.com/magazine/interviews/arca/, accessed 16 November 2016.

'Great things never come from comfort zones' (interviews with members of the LGBT community in Saint Petersburg), *i-D*, 336, Spring 2015, pp.242–7.

2014

'Two people on stage doesn't always mean a relationship' (interview with Michael Clark), *Magazin im August. 26. Internationales Festival*, August 2014, pp.6–11.

2012

'Neue Welt: Elysium. A conversation between Wolfgang Tillmans and Neil Tennant', *032c*, 23, Winter 2012, pp.100–9.

'Wolfgang Tillmans & Loreen', *BON*, 62, pp.156–67.

'Wolfgang Tillmans & Neil Tennant', *Interview*, September 2012, pp.124–33.

2010

'The Edge of Visibility. Wolfgang Tillmans and Dimitar Sasselov' (excerpts from Serpentine Galleries' 'Park Nights', composed and translated by Nakahara Sayoko), *Coyote*, December 2010, pp.95–112.

2005

'John Waters: Baron of Bad Taste from Baltimore is obsessed by Michael Jackson's Polka Dot Penis', *BUTT*, 13, June 2005, pp.11–24.

'Slavoj Zizek', *index*, 5, June/July 2005, pp.32–9.

2004

'Designer: Lutz', *index*, September/October 2004, pp.96–8.

'Michael Stipe', *BUTT*, 9, Spring 2004, cover and pp.10–9.

2003

'Pet Shop Boys: Two divided by zero. Long-term friend, collaborator and Turner Prize-winning artist Wolfgang Tillmans talks Pop Art with the disco duo', *i-D*, 238, December 2003, pp.94–9.

2000

'James Turrell', *Vogue Hommes*, Spring/Summer 2000, pp.74–8.

1999

'Tom Ford and Ann Hamilton', *index*, 20, September/October 1999, pp.66–78.

VI Lectures, talks and screenings (selection)

2016

'Brexit Remain Campaign', In Our Time: A Year of Architecture in a Day, The Metropolitan Museum of Art, New York, 12 November 2016.

Artist Talk with Thomas McDonough, Canadian Art Encounters Series, Canadian Arts Foundation, University of Toronto, 11 November 2016; Simon Fraser University, Vancouver, 26 October 2016.

'Upstarts: New '90s Art' (panel discussion with Julia Peyton-Jones, Adrian Searle and Jane & Louise Wilson), Frieze Talks 2016, Frieze Art Fair, London, 7 October 2016.

'Artforum: David Velasco in conversation with Wolfgang Tillmans', Reading Room, Frieze Art Fair, London, 6 October 2016.

'In Conversation: Wolfgang Tillmans and Lily Cole', University of the Arts London, Chelsea College of Arts, London, 3 June 2016.

'1 Night, 12 Hours, 100 Questions – Interview Marathon', Forum on European Culture, De Balie, Amsterdam, 1 June 2016.

'Licht-Gestalten. Wolfgang Tillmans im Gespräch mit Benjamin Paul und Karlheinz Lüdeking', Universität der Künste, Berlin, 11 May 2016.

'No Limiar da Visibilidade und der Folkwang Raum', Museum Folkwang, Essen, 15 March 2016.

'Musik ausstellen' (panel discussion with Barbara London, Sven Beckstette and Matthias Mühling), Städtische Galerie im Lenbachhaus und Kunstbau, Munich, 19 February 2016.

2015

'Wolfgang Tillmans: What's wrong with redistribution? With Wolfgang Tillmans, Thomas McDonough and Bernd Scherer' (book presentation, video screening, lecture and talk), Haus der Kulturen der Welt, Berlin, 3 December 2015.

'Hasselblad Award Winner 2015 Artist Talk', Hasselblad Center, Gothenburg, 1 December 2015.

Artist Lecture, České Budějovice House of Art, DK Metropol, České Budějovice, 24 November 2015.

'Forum of the future: Untitled Happiness', Museu de Arte Contemporânea de Serralves, Porto, 4 November 2015.

'Dercon & Tillmans. Gespräche über Kooperation und Solidarität', Münchner Kammerspiele, Munich, 6 October 2015.

'Wolfgang Tillmans: Sound on Camera' (video screening and lecture), The Kitchen, New York, 14 September 2015.

'Architecture of books and photography' (in conversation with Dietmar Kohler), Hochschule für Bildende Künste, Braunschweig, 2 July 2015.

'Wolfgang Tillmans: A Lecture' (with Scott King, UAL Chair of Visual Communication), University of the Arts London, London College of Communication, Podium Lecture Theatre, London, 15 June 2015.

'The Hugh Edwards Lecture', Art Institute of Chicago, Rubloff Auditorium, 4 June 2015.

'Im Dialog VI', Sammlung Hoffmann, Berlin, 26 March 2015.

2014

'Positionen. Wolfgang Tillmans: 'Cladding / Verschalung'', Technische Universität Berlin, 20 November 2014.

'Wolfgang Tillmans in conversation with Daniel Buchholz', Art Basel Conversations, Art Basel, 18 June 2014.

2013

Artist Talk (in conversation with Sophie O'Brien), MAVI Santiago de Chile, 18 July 2013.

'From Black and White to Colour. Dialogue between artist Wolfgang Tillmans and Beatrix Ruf', Symposium at Rencontres d'Arles, Grande Halle, Parc des Ateliers, Arles, 3 July 2013.

Lecture, Kunstsammlung Nordrhein-Westfalen – K21, Düsseldorf, 16 May 2013.

2012

'Wolfgang Tillmans en Bogotá', Museo de Arte del Banco de la República, Bogotá, 10 December 2012.

'ÜBER ALLES' (in conversation with Frank Wagner), Kunsthochschule Weißensee, Berlin, 29 November 2012.

Lecture, Städelschule, Frankfurt am Main, 12 November 2012.

'Wolfgang Tillmans and Chris Dercon: Des images à l'infini' (projection of two short films by Alexander Kluge in the framework of 'Selon Chris Dercon'), Petite salle, Centre Pompidou, Paris, 6 November 2012.

Artist Talk, Museu de Arte Moderna de São Paulo, 28 March 2012.

2011

Lecture, Akademie der Bildenden Künste München, Munich, 27 October 2011.

Lecture, Moderna Museet, Stockholm, 24 March 2011.

'Ursuppe and Other Garden Pictures', Garden Marathon, Serpentine Gallery, London, 15 October 2011.

Lecture, Los Angeles County Museum of Art, Los Angeles, 9 March 2011.

'Busch-Reisinger Museum Lecture', Harvard Art Museums, Cambridge, MA, 2 March 2011.

'Royal Academy Schools Annual Lecture', Royal Academy of Arts, London, 22 February 2011.

The listing prior to 2010 is incomplete.

2010

Lecture, Slade School of Fine Arts, London, 17 November 2010.

'Frieze Talks: Wolfgang Tillmans', Frieze Art Fair, London, 14 October 2010.

'An Evening with Wolfgang Tillmans', International Center of Photography, New York, 7 October 2010.

2007

'BP Artist Talk: Wolfgang Tillmans', Tate Britain, London, 3 October 2007.

'Wolfgang Tillmans in conversation with Dr. Christof Siemes', k.m Talks, Kunstverein München, Munich, 3 June 2007.

2006

'Hammer Conversations: Wolfgang Tillmans & Mark Wigley', Hammer Museum, Los Angeles, 17 September 2006.

VII Political activism

'Meeting Place', series of weekly events focussed on the refugee crisis and the rise of anti-European and far-right sentiments. Organised by WT at Between Bridges, Berlin, 2016.

Pro-EU / anti-Brexit campaign, design and text of ten A1 offset posters, forty different self-print posters and social media images, twelve T-shirt designs, written statements, interviews and panel discussions, 2016.

'Why we must provide HIV treatment information', book publication distributed internationally as an advocacy tool by HIV i-Base, London and Treatment Action Campaign, Cape Town, 2006.

VIII Recorded music releases

'2016 / 1986 EP' (12" vinyl/digital, designed by WT), Fragile001, 2016.

'Naive Me', Fragile (streaming only), Fragile002, 2016.

'Device Control' on 'Frank Ocean – Endless', visual album, Def Jam Recordings, 2016.

'Device Control EP' (12" vinyl/digital, designed by WT), Fragile003, 2016.

'That's Desire / Here We Are EP' (12" vinyl/digital, designed by WT), Fragile004, 2016.

IX DJ Sets and concerts

DJ Set, 'Finest Berghain', Berghain, Berlin, 30 December 2016.

'Fragile' (concert), Union Pool, New York, 13 September 2016.

'Fragile' (concert), BOFFO Fire Island Performance Festival, Fire Island Pines, 27 August 2016.

DJ Set, 'Makumba Reloaded', Mehringdamm 61, Berlin, 27 May 2016.

DJ Set, 'Starship + Provence – Grand Joint Magazine Release Party', Südblock, Berlin, 16 January 2016.

DJ Set, 'Wrecked', Good Room, New York, 12 September 2015.

DJ Set, Maceos, Block 9, Glastonbury Festival, Glastonbury, 27 June 2015.

DJ Set, 'Finest Friday', Panorama Bar, Berlin, 27 February 2015.

DJ Set, closing event of Manifesta 10, Hermitage Museum, Saint Petersburg, 2014.

Occasional DJ Sets at Nerd, London and The Cock, London, 1999–2003, and at Möbel Olfe, Berlin since 2006.

X Record covers

'Various – Groove 163 / CD 72' (cover design and photography), 2016.

'Frank Ocean – Blonde' (cover photography), Boys Don't Cry, 2016.

'Ostgut Ton | Zehn' (CD and 12" vinyl box set cover), compilation, Ostgut Ton, 2015.

'Colourbox – Music of the band (1982–1987)' (CD compilation, limited edition, design and photography), 4AD, 2014.

'The Opiates – Hollywood Under The Knife' (CD cover and booklet), Disco Activisto, 2011.

'The Opiates – Rainy Days And Remixes' (photography), Disco Activisto, 2011.

'John Maus – A Collection of Rarities and Previously Unreleased Material' (CD and LP vinyl, design and photography), Ribbon Music, 2011.

'Barker & Baumecker – Candy-Flip' (12" vinyl cover photography), Ostgut Ton, 2010.

'Brett Anderson – Love is Dead' (CD cover photography), Drowned in Sound, BMG/EMI Music Publishing, 2007.

'Tiga – 3 weeks' (Two 12" vinyls, cover photography), PIAS Recordings, 2006.

'André Galluzzi – Berghain 01' (CD cover photography), Ostgut Ton, 2005.

'Miss Kittin – I Com' (photography), Novamute, 2004.

'Superpitcher – Here Comes Love' (CD and LP back cover photography), Kompakt, 2004.

'Pet Shop Boys – Disco 3' (CD and LP cover photography), EMI, 2002.

'Russell Haswell – Live Salvage 1997–2000' (CD back cover photography), Mego, 2001.

'Bamby – Wall Of Sugar' (photography), ElektroMotor, 1995.

'Sun Electric – Kitchen' (CD and LP cover photography), R & S Records, 1993.

XI Music videos

'Fragile – That's Desire / Here We Are EP', 27 min visual album, Fragile label, 2016.

'Pet Shop Boys – Home and Dry', music video, EMI, 2002.

'Goldfrapp – Lovely Head', music video, Mute Records, 2000.

'Film with music, words and singing', 45 min film commissioned by Tate and Egg Live, Tate Britain, 2003.

I refuse to be your enemy (TSC 232, TSC 233
and TSC 235, 2015) and Santa Marta, 2012 in
PCR, David Zwirner, New York, 2015

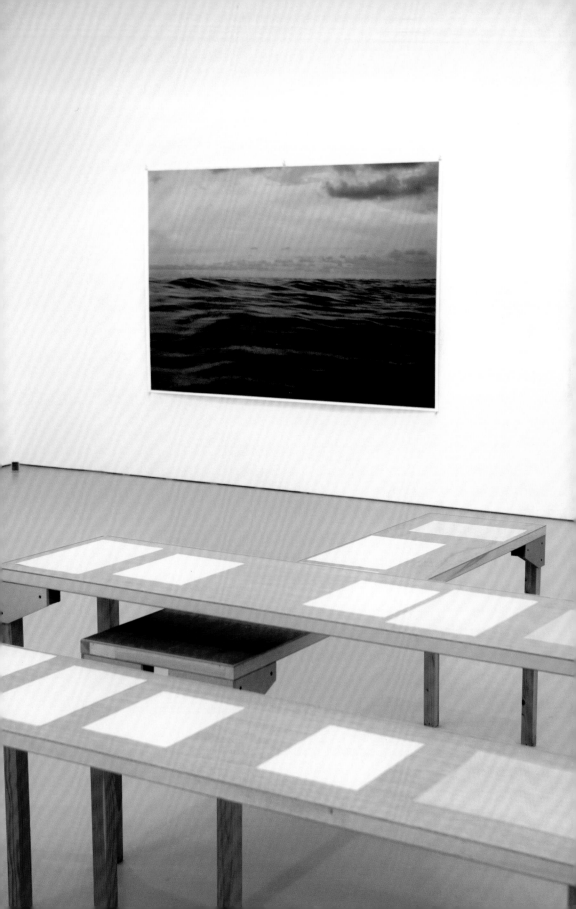

in a cloud, a, 2016 in *Wolfgang Tillmans*,
Regen Projects, Los Angeles, 2016

Collum, 2011

17 years' supply, 2014

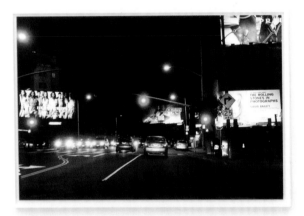

Daniel, mirrored, 2014; Sunset night drive, c, 2014; Silver 170, 2013 and Faroe Nowruz Eclipse B and A, 2015 in *PCR*, David Zwirner, New York, 2015

Weed, 2014

not yet titled, 2011; Wäsche (Laundry), 2016 and Washing, 2016 in
Wolfgang Tillmans, Regen Projects, Los Angeles, 2016

Installation view of *PCR*, David Zwirner, New York, 2015

238

Palmtrees Caprisun, 2014

Philip Wiegard, 2011

The State We're In, B, 2015; Stop Boko Haram demonstration, Berlin, 2015 and Atlantique, a, 2016 in *Wolfgang Tillmans*, Regen Projects, Los Angeles, 2016

Oscar Niemeyer, 2010

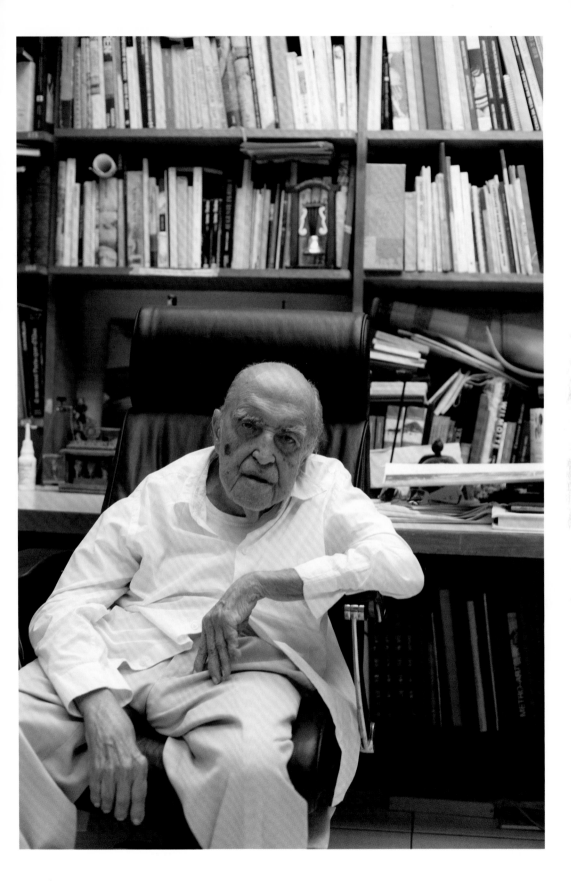

244

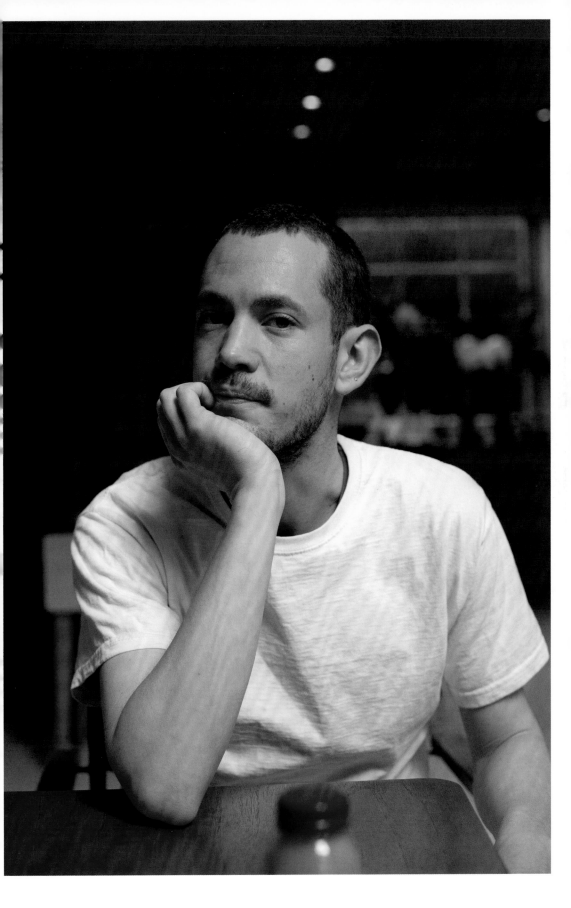

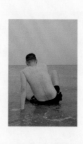
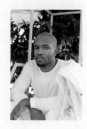

Installation view of *Wolfgang Tillmans*, House of Art České Budějovice, Budweis, 2015

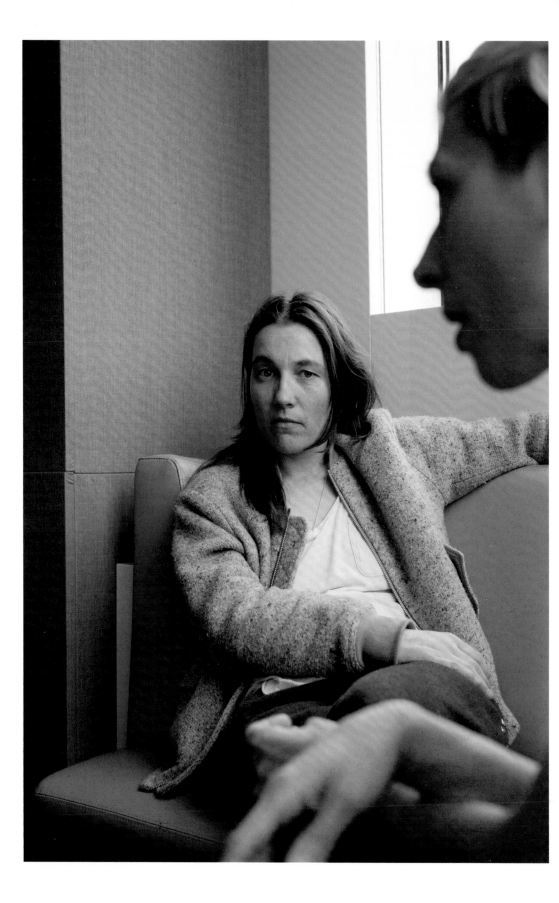

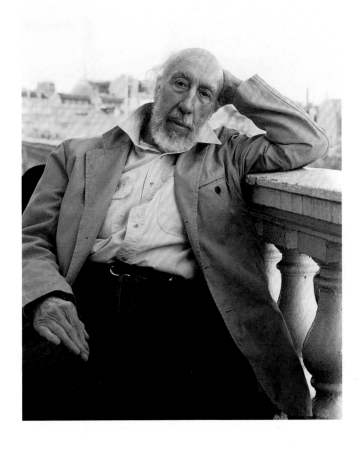

not yet titled, 2016

Richard Hamilton, 2005

Anders (Brighton Arcimboldo), 2005

Next pages:
Installation view of *Wolfgang Tillmans*,
House of Art České Budějovice, Budweis, 2015

Eleanor / Lutz, a, 2016

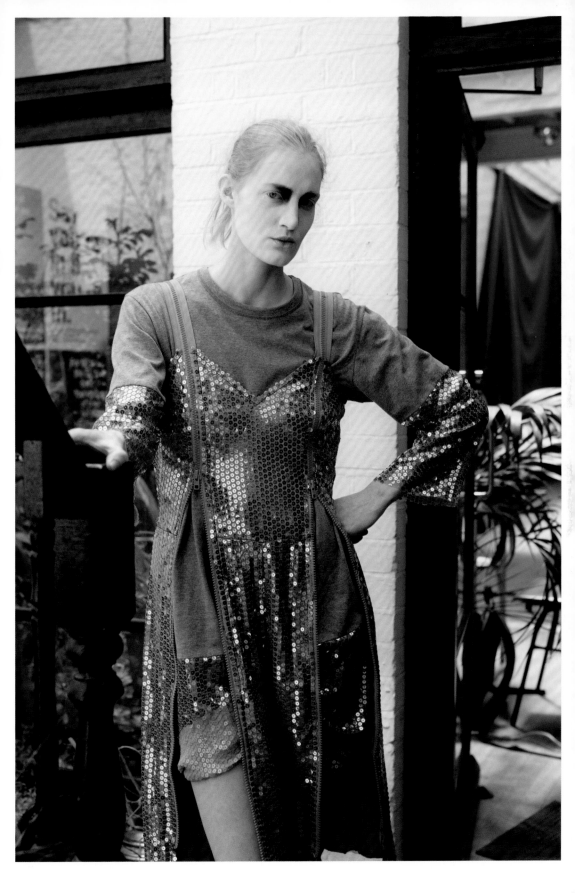

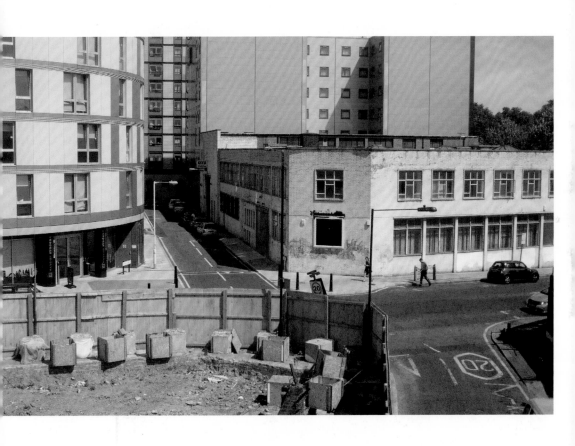

nackt, 2 (nude, 2), 2014

shit buildings going up left, right and centre, 2014

Next pages:
Dan, 2008 in *Wolfgang Tillmans*, Walker Art
Gallery, Liverpool, 2010

A Descent from the Cross.

FROM THE ROSCOE COLLECTION

Stoss

The Air Between, 2016

still life, Calle Real II, 2014

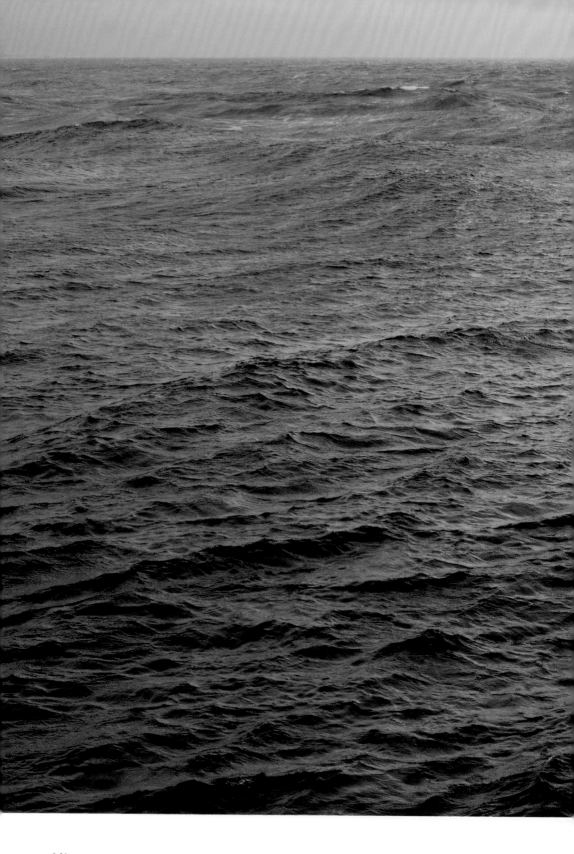

The State We're In, A, 2015

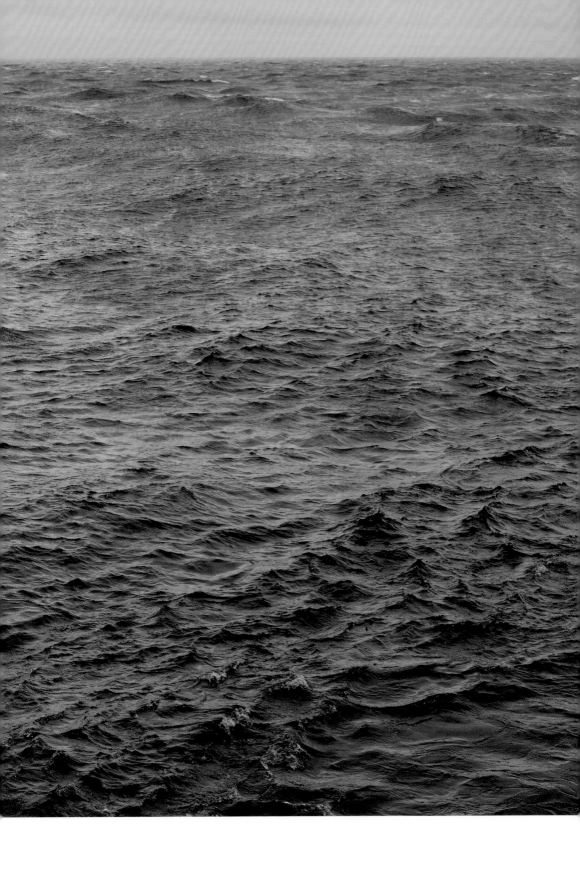

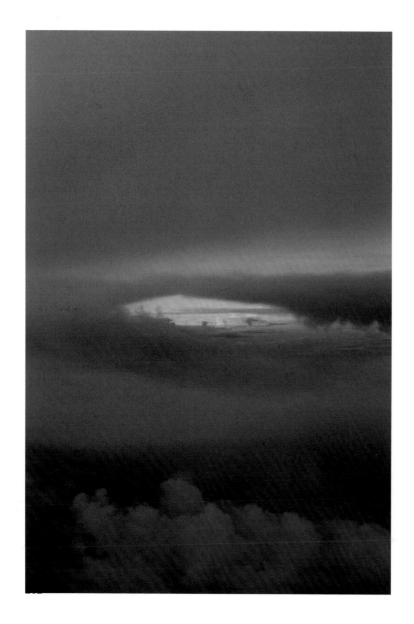

Previous pages:
Lima, 2013; Transient 2, 2015 and Tag/Nacht II (Day/Night II), 2010 in *On the Verge of Visibility*, Museu de Arte Contemporânea de Serralves, Porto, 2016

Lima, 2013

Tag/Nacht II (Day/Night II), 2010

These pages:
untitled (carton), 2012

Fire Island, 2015

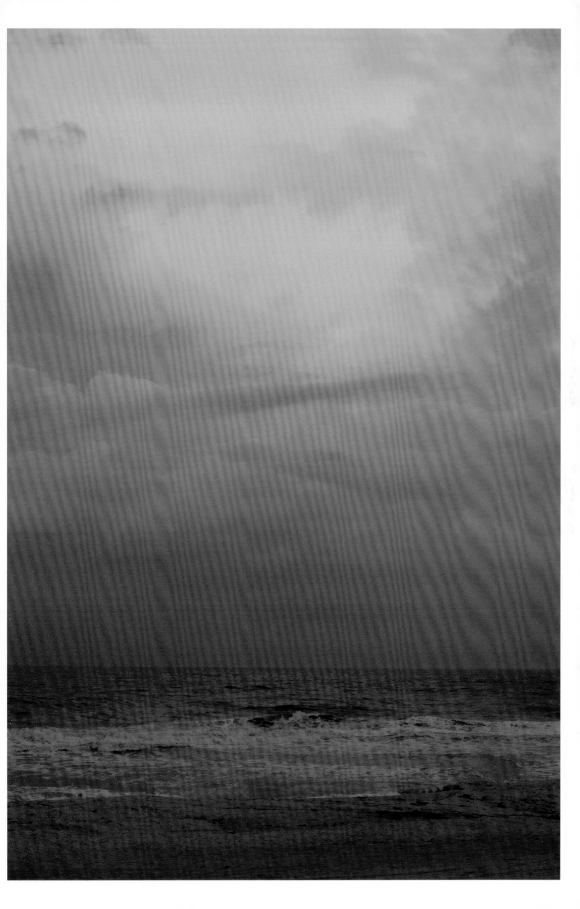

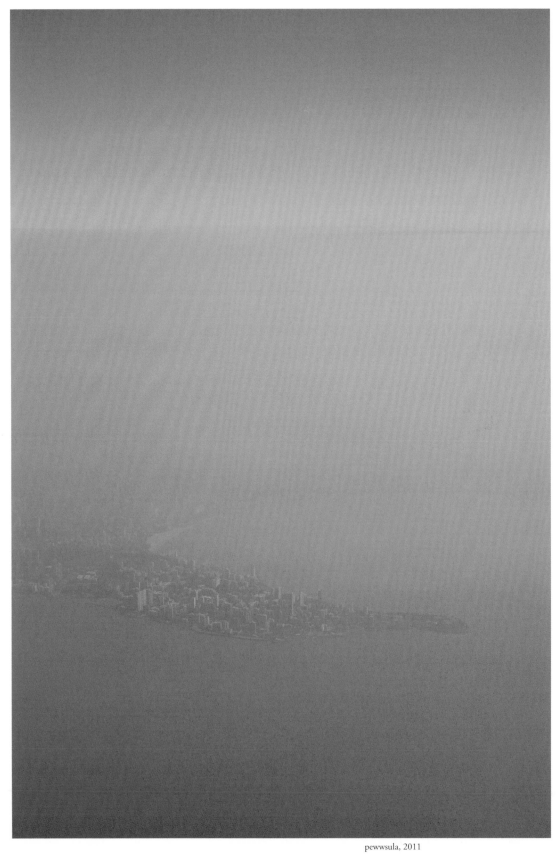

pewwsula, 2011
Transient 2, 2015

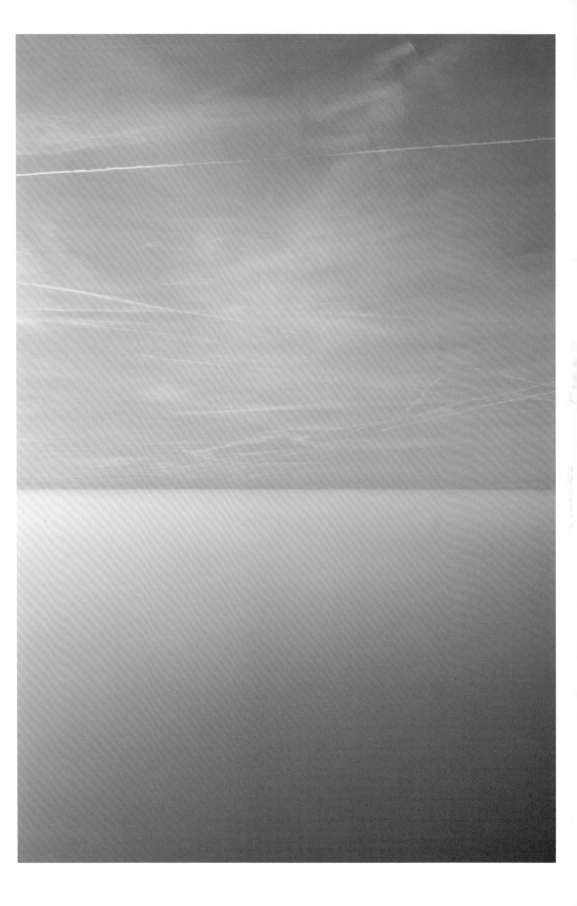

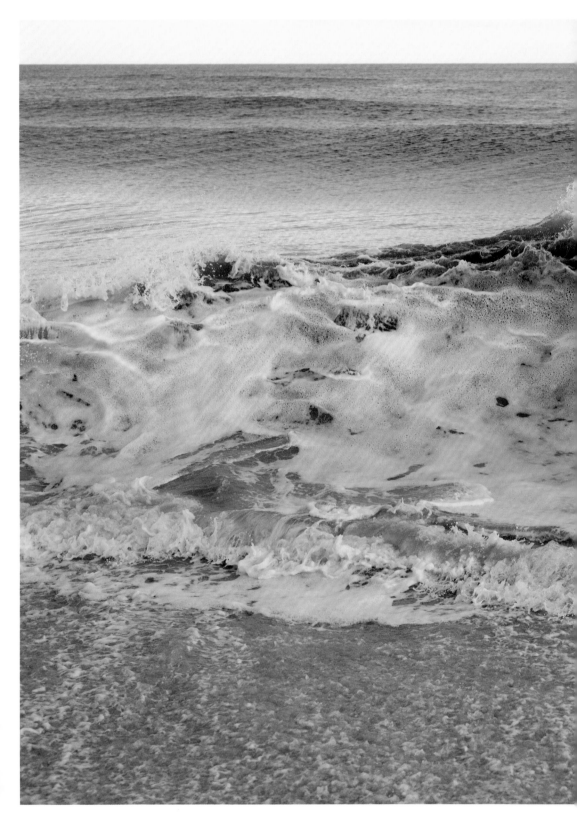

Atlantique, b, 2016

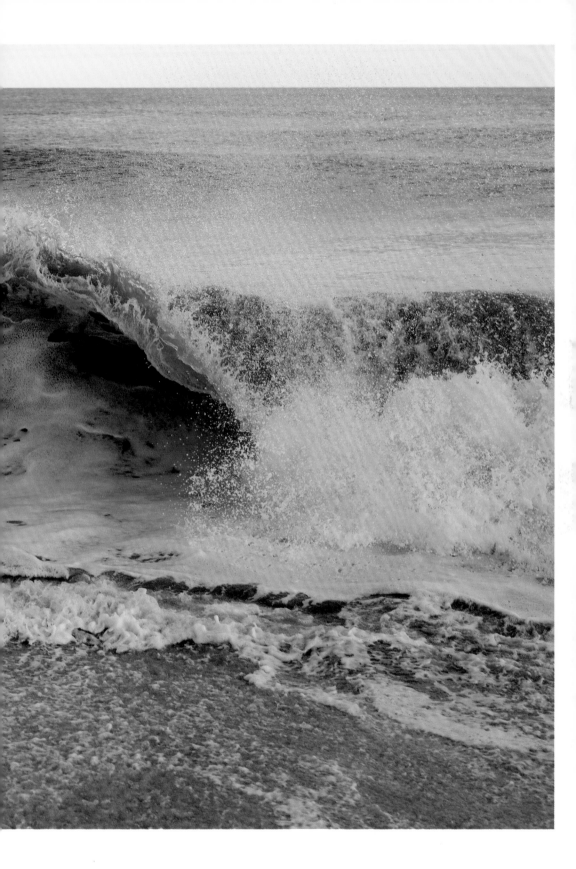

Tom Holert

Functions of the Studio: Wolfgang Tillmans as Performer and Listener

> I mean more the inner sensation that you feel yourself when you flex
> a muscle because there is no language for what we feel like inside.[1]

From the vantage point of writing this essay in late October 2016, the past two years have seen Wolfgang Tillmans expanding his practice in quite significant and unexpected ways. Probably most important in this emerging array of activities that is being added to (or rather folded into) the complex of visual-photographic and exhibitionary practices established by the artist over two and a half decades is a surprising, though not entirely unprecedented (as we will see) shift towards the performative. This emphasis becomes manifest on different levels and with varying degrees of straightforwardness and publicness. Having always been sensitively aware of the performative dimension of the act of photographing itself and of the time-based, affective and bodily nature of installing his shows – that is, of his visual practice as a complex of interrelated stages (the studio, the gallery, the museum, the book, the magazine, etc.) – Tillmans arrived at the decision to bring to the fore a certain, largely repressed passion for actually being visible as a moving, speaking, singing performer.

This process can be said to have reached a more definitive phase in 2015. *Instrument*, the single-projection, split-screen video work of that year, shows the artist himself, wearing only white briefs, dancing to the sound of his own feet hitting the floor. Watched from the back, Tillmans's body in the video on the left moves in front of a black spot on the wall. His arms flapping, his legs bopping, this dance looks strangely puppetry-like. On the right half of the screen, a shadow of what is presumably the same moving body on the left can be seen, suggesting that every physical action produces a trace, if a fleeting and ephemeral one. Even though the mind's perception wants to see the two halves as part of the same performance, they are clearly not in the same location and fall only occasionally in sync. The soundtrack, including some street noise, shifts back and forth from naturalistic sound to abstracted manipulations of the stepping noises, leaving it unclear to the viewer if this kind of music was actually audible at the time of filming. Elicited by two separate incidents three months apart involving morning light falling through the crack in a curtain in a hotel room in Los Angeles and an apartment in Tehran, the audiovisual diptych proposes to consider the body as 'instrument', and is thereby reminiscent of early performance and video art by artists such as Bruce Nauman or Vito Acconci. Pointing the camera towards himself rather than outward, towards the other, Tillmans discovered the possibility of putting himself, his body, in the front of the camera. Rather than hiding behind the photographic apparatus and re-maining a virtual, shadowy presence in the visual depiction of other people and phenomena, making himself appear on the stage effectively reshuffled the game of his art. Simply acknowledging the fact that he is inevitably performing when practicing as an artist proved to be not enough anymore. He also noticed how he had projected an image and a presence of himself as a performer when giving his often extensive artist talks or public interviews, unfailingly drawing large audiences of several hundreds.

Stills from *Instrument*, 2015, HD
5'40", digitally manipulated ambient
sound

Realising in what different ways an enunciation of his 'self' could – quite literally – take place, he reached for the particular pleasures of collaborating with others around music in a variety of spaces, and in particular in recording studios in Porto, New York and Berlin. The specificity of these cavernous, technological and purposefully furbished spaces was discovered, inhabited, explored and respectfully claimed by Tillmans – as extensions of his artist's studio, brimming with all kinds of professional knowledge, experiences in playing and listening, and traditions of hanging out.

In the course of 2015 and 2016, after a twenty-five-year hiatus in active music-making, he embarked on two parallel music projects: one is electronic and solo based, the other is a traditional band set up in changing constellations and locations. In 2016, Tillmans released two records under his own name and one under the band name Fragile. Bringing ideas, voice recordings and fragments of lyrics, melodies and field-recorded sounds, he works closely with engineer and musician Tim Knapp at the Trixx music studio in Berlin. One result of this collaboration is 'Make It Up As You Go Along', a song buckled on the rhythmic sounds of a printing press at Tillmans's favourite printing company where many of his books are being printed (emphasising, once more, the methodic interleaving of various sites of production throughout Tillmans's work). The track was further processed by musician friends such as deep house producers Daniel Wang and J.E.E.P. or American noise music project Salem who both provided (wildly differing) remixes.

Separate from this solo project is a practice with live musicians developed during travels to install exhibitions in Osaka, New York, Porto and Los Angeles, where he and his assistant Colombian artist Juan Pablo Echeverri would find musicians to jam and record with. Surely a breakthrough moment in Tillmans's performative turn was a concert he gave on 13 September 2016 at Union Pool, a music club in Brooklyn, New York, with his band Fragile. The fifty-minute gig on a small stage, with Tillmans as a singer fronting an outfit of five musicians – two keyboarders, a bass player, a guitarist and a drummer – all dressed up in cuddly sportswear in shades of greyish blue designed by London's avant-garde fashion duo Cottweiler, was the second live performance of the group. Before, they had only played – sporting batik sheets, T-shirt fabric and much uncovered skin – during a beach festival on Fire Island, one of the outer barrier islands parallel to the south shore of Long Island, New York, continuing to be a favourite summer retreat of New York's gay community since the days of Christopher Isherwood and W.H. Auden (albeit being hit by Hurricane Sandy in 2012). Tillmans had spent the three previous months living and working on Fire Island to fully pursue live music and to further the collaboration with Kyle Combs and Jay Pluck from New York as well as Echeverri. Regularly meeting with them and Tom Roach and Daniel Pearce, a substantial number of songs was written and recorded.

Judging from a video documenting the evening at Union Pool, the crowd attending the show seemed sympathetic, interested, well informed, ready to dance and anticipating at least some of Fragile's songs, notwithstanding the band's lack of experience in playing together on a stage. A sequence of releases over the summer – one on Soundcloud, others as Wolfgang Tillmans's first two, self-published EPs – prepared different audiences, from the music and the art worlds respectively, spreading an idea of what to expect from Fragile's public appearance. Even a moment of social-media hysteria was reached when news broke that R&B superstar Frank Ocean had included Tillmans's technopop track 'Device

Programme for *Sound on Camera*, The Kitchen, New York, 2015

The Kitchen presents

Sound on Camera

video works from 1987 to 2015 by Wolfgang Tillmans
September 14, 2:30, 5 and 7:30 PM

Kopierer, 2002
HD, 10'00"
ambient sound
London

Lights (body), 2000 / 2002
Mini DV, 5'00"
music: 'Don't be light'
by Air, Hacker Remix
Helsinki / London

video feedback, slowed
down, 1987
Portable VHS Recorder,
3'36"
ambient sound
Einbeck, Germany

Wind of Change, 2003
DVCAM, 5'00"
ambient sound
Berlin

self study, 1987
Portable VHS Recorder,
1'19"
ambient sound
Einbeck, Germany

Dylan in Pool, 2003
DVCAM, 3'00"
ambient sound
Hertfordshire, UK

balls out (of jeans), 1994
Video Hi8, 0'23" (loop)
ambient sound
London

Heartbeat / Armpit, 2003
DVCAM, 1'45"
no sound
London

14th Street, 1994 / 1995
Video Hi8, 28'
ambient sound
New York City

Superpitcher, 2003
DVCAM, 1'19" (excerpt)
ambient sound
('Fieber' by Superpitcher)
Cologne, Germany

Coca Cola bubbles, 1996
Video Hi8, 1'10" (loop)
no sound
London

Peas, 2003
DVACM, 2'42"
ambient sound
London

The 21st century,
1999 / 2000
Mini DV, 0'28" (loop)
mixed ambient sound
Hamburg, Germany

fibre optics, 2010
HD, 1'00"
ambient sound
Berlin

Goldfrapp
'Lovely Head', 2000
DVCAM, 1'58" (excerpt)
music video for
Mute Records, London,
Bristol, UK

Snax, 2012
HD, 0'56"
ambient sound
Berlin

Pet Shop Boys
'Home and Dry", 2002
DVCAM, 1'58" (excerpt)
music video for
EMI Records, London
London

Printing Press -
Total Solar Eclipse
2011 / 2015
HD, 7'58"
music: Wolfgang Tillmans
'As you go along'
Stuttgart / Faroer Island

This event is made possible with support in part by public funds from New York City Department of Cultural Affairs in partnership with the City Council and New York State Council on the Arts with the support of Governor Andrew Cuomo and the New York State Legislature.

Control' in its entirety in his 'visual album' *Endless* that went online in late August. Ocean's appropriation of the song (coupled with the usage of a portrait shot by Tillmans for the cover of the second 2016 album, *Blonde*, and a whole series of Tillmans's photographs in Ocean's one-off magazine, *Boys Don't Cry*) triggered enormous attention for the artist's involvement and led to considerable endorsements in the press, such as by *The New York Times*'s Wesley Morris, who called 'Device Control' (that features Tillmans singing bizarre faux advertisement copy for digital visual gadgetry over metallic synth stabs in a 134 bpm dance track) a 'dreamy electro-poetic position paper' and simply the 'best song on "Endless".[2]

Moving confidently on the stage of the Brooklyn club, Tillmans obviously enjoyed the situation and seemed only occasionally tinged by a streak of nervousness. Between songs he mused on the genealogy of the act and the reasoning behind particular song titles and lyrics. He candidly told the story of the traumatic event that for a long time marked his last public appearance as a singer, in 1991, when he was a member of a one-off college graduation ball band that foundered disastrously at their performance on a pier in Boscombe, a seaside resort near Bournemouth.

Years before, in 1985–86, Tillmans had experimented as one half of a synthpop duo (the other one was his friend, the late Bert Leßmann) in his hometown Remscheid. The original Fragile never performed live, however, some of their home-recorded songs, such as the intense, almost bombastic 'Time Flows All Over' or the pressingly percussive 'Fascinating this Time' survived on cassette tapes and have been restored and remastered under Tillmans's supervision in the Berlin studio of Klaus and Tim Knapp, to be released on the artist's first EP in 2016. The material from the mid-1980s, featuring the expressive voice of the seventeen-year-old Tillmans quivering in the background of the songs' mixes testifies to an eerie, post-punk sensibility, conjuring an atmosphere of glamorous rapture. When Leßmann left Remscheid after a short year of a productive collaboration, Tillmans did not muster up the courage to find a new musical partner and focused on his visual work, in particular with a digital laser photocopier in the local copy shop. Preceding the period of actually making music were teenage years spent on the development of the flamboyant, purely fictional and sexually ambiguous New Romantic alter ego 'Fragile' with painted face, dressed up in sculptural DIY apparel made of plastic bags and found pieces of fabric. Clearly invented for the camera's eye, this creature from Remscheid had posed, in all its proud vulnerability, in the streets of Düsseldorf, London and other places since 1983, emulating the likes of Boy George or Dead Or Alive's Pete Burns. Participating in the making of many of the dresses and most of the photographs documenting Tillmans's early ventures into extroverted performance and radical fashion were his close friends Lutz Huelle, Alexandra Bircken and Stephanie Hoffmann. Though somewhat driven by the ambitions, the inventions and the creations of young Tillmans, Fragile was a project of more than one, anticipating the ways in which Tillmans would negotiate the relationship between the individual and the collective under his name until today. While revisiting his biography for the primal scenes and original sins of his penchant for the performative, the artist decided in 2015 to reprocess Fragile's visual archive and go public with it.

Wolfgang Tillmans *2016 / 1986 EP* and *Device Control EP*, record covers and sleeves, 2016

Fragile *'Naive Me'*, Soundcloud and Instagram cover image, 2016

Next pages:
Stills from *Printing Press Heidelberg Speedmaster XL - Real Time Total Eclipse Nightfall and Exit*, 2011 / 2015, HD, 7'58", music: Wolfgang Tillmans 'As you go along' (using ambient sound of Heidelberg Speedmaster XL), Eclipse: no sound

Fragile

'Naive Me'

3'38" June 25, 2016

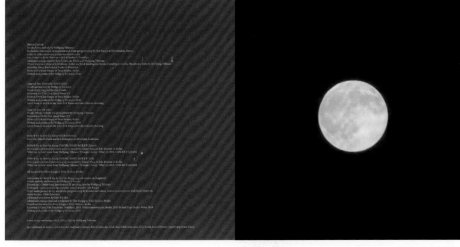

Editors Ashley Heath and Max Pearmain offered the pages of the Winter 2015/Spring 2016 issue of *ARENA Homme+* for a sixty-six-page spread on Fragile's life between 1983 and 1989 (selected and laid out by Tillmans), which Pearmain poignantly called a 'wonderful teenage mix of total assurance and utter experimentation' that shows the '[s]earching for a persona and then not being quite sure how to deal with the identity they find'.[3]

Opening the September 2016 Union Pool gig with the dramatic recitative 'Naive Me', supported by bowed cymbals and the work of timpani mallets, Tillmans started out in what appeared to be a confessional mode but what, at closer inspection, may be read as a smart critique addressed at an entire social stratum of transcontinental art-world people, cultural producers and intellectuals to which he belongs. Gently, but relentlessly accusing the lyrical 'me' of the tune to have been blind with regard to the nationalisms, fundamentalisms, populisms and, arguably, fascisms rising on a global scale since 1989, the immediate context of the song in the summer of 2016 comprised the Brexit vote in the UK, Donald Trump's candidature in the US and the recent successes of populist parties such as the German AfD (Alternative for Germany) in continental Europe.

In 'Naive Me', Tillmans does not shy away from pathos in his choice of words and their rendition alike. Thus he set the tone for a string of songs that were performed in order not only to transmit the pleasures and the fun of making music collectively (which certainly is one of the key motivations for everyone involved in this endeavour) but also to bring across a sense of urgency, anger and commitment to the issues addressed. Hints at the 12 June 2016 Orlando massacre in the gay nightclub Pulse – the most violent single case in the destruction of clubbing and nightlife and its production of social space in general to date – can be discerned in songs such as 'Angered Son' (based on a quote by the father of the Orlando terrorist from a *New York Times* article, stating that his son was 'angered' by the sight of 'two men kissing') and in 'Triangle/Gong/What' from the '2016/1986 EP' showcasing Tillmans's tweaked and scrambled voice addressing the criminalisation of non-normative lives that emerges towards the end of a track largely made up of modulated sounds of a special alloy triangle and a three-nines-fine gold gong. In a daring delivery of 'Anderes Osterlied' (Other Easter Song), based on a song written in 1970 by theologian Kurt Marti and religious composer Peter Janssens, the artist ambulates in the tracks of another former self, the enthusiastic participant in Protestant church convents and peace marches. The song's indignant accusation of the ruling elites and the mayhem they cause is probably harder to swallow for Germans of Tillmans's generation, many of whom are critical of such rhetoric and the Christian peace movement, than for a young international audience in Brooklyn clubs wondering about the possible meaning of the Teutonic-sounding lyrics.

The turn to performance and the emphasis on music can be counted among the various ruptures and reboots in Tillmans's career that are always carefully orchestrated and narrated by the artist: the decision to become a photographer in 1988, the temporary retreat from representational photography after 2001 or the stopping of using analogue photography in 2011. In early March 2016, he organised a presentation of critic Jörg Heiser's *Doppelleben* (Double Life) at his Between Bridges space. In the book, Heiser analyses the ways in which artists such as Andy Warhol, Yoko Ono, Brian Eno, Joseph Beuys, Laurie Anderson or Fatima Al Qadiri navigate the systems and interfaces of

Fragile *That's Desire / Here We Are EP*, record cover, 2016

Still from *Copier*, 2010

Fragile

That's Desire / Here We Are EP

That's Desire (featuring Ash B.)
Fast Lane
Anderes Osterlied

Here We Are
Naive Me
Warm Star

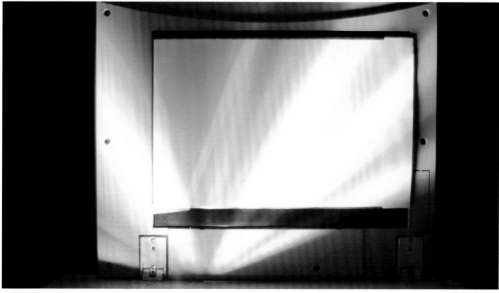

contemporary art and pop music. Rather than celebrating an ideology of 'crossover', he insists on the relative autonomy of these systems and the necessity to attend to their respective contextual specificity. Each 'context switch' – by a visual artist working as a musician, or by a musician making photographs or paintings – is therefore to be acknowledged for its particular intensity and its effects on the individual artistic project.[4]

For Tillmans, such a careful, distinguishing grasp of art and music is key. 'Each thing needs a different treatment', as he once said.[5] Yet this does not mean to strictly separate his visual practice from the performative and the musical work. Whilst trying to understand and to operate according to the codes ruling each form's practice, he links the two through shared themes and through an aesthetic sensibility that cannot be split. What is more, he draws connections between the various types of studios involved, the artist's studio as the main production site and the recording studios where Tillmans spent much time in 2016.[6]

In this networked studio practice, Between Bridges, the multi-purpose space in Keithstraße, Berlin, hosted by Tillmans, fulfils a particular, relevant role. It enables the artist and his collaborators to stage certain functions of the studio beyond the specialised studio spaces: by providing a malleable environment for aesthetic questions, research interests, political urgencies in which these can be negotiated in a public, yet intimate context.

A typical example of how this hybrid space can be read and activated is the Playback Room endeavour that started in September 2014 with an exhibition about the eclectic 1980s London experimental pop group Colourbox, discovered by Tillmans in 1985. In the front space, the material manifestation of studio music: original master tapes and the resulting records were exhibited alongside enlarged printouts of a list of all voice samples used in Colourbox's recording history, while the adjacent room had been converted into a hi-fi listening lounge where Colourbox's studio-based oeuvre from 1982 to 1987 could be experienced in a sequence of sixteen songs on a high-end system equipped with two Bowers & Wilkins speakers. Taking its cue from the simple but striking observation that '[l]ive music has dedicated spaces, whereas recorded music has none'[7], the Playback Room project was extended thereafter with an instalment titled 'American Producers' (15 November 2014 to 31 January 2015)[8], based on a twenty-three-track playlist by Tillmans (focusing on outstanding music producers ranging from Quincy Jones to Skrillex, from Timbaland to Abraham Orellana), and 'Bring Your Own', a program of film screenings, audio playbacks and other events curated by graphic designer Yusuf Etiman (who ponders a project for an 'acoustically optimised space for sound, featuring live and playback sound events in a community-based curatorial framework').[9]

The ultimate goal of the Playback Room project is to carve institutional, museum spaces for exhibiting recorded music of an auditive quality that is usually limited to the recording studio. A first step in this direction was made when Tillmans was given the opportunity to have purpose-built and curate a temporary listening space in Munich's Lenbachhaus in early 2016. Further pursuing the idea, he successfully lobbied to have a similar environment integrated in Berlin's Neue Nationalgalerie's new building project.[10] Playback Room can be counted among the important strategic-conceptual manoeuvres in the subtle, yet fundamental project of reconfiguring contemporary artistic practice and the modalities of experiencing art across sensorial and (sub-)cultural divisions. A project that Wolfgang Tillmans has been and will be pushing forward, incessantly.

Spreads from '(title ?) FRAGILE 1983 - 1989', *ARENA Homme+*, no.44, 2015, in *Wolfgang Tillmans*, Hasselblad Foundation, Gothenburg, 2015

(title?)FRAGILE
1983 - 1989

by
Wolfgang Tillmans

Edited and designed by Wolfgang Tillmans
Additional picture editing and design: Jonas Raam
Photography 1983 - 1989
Anonymous, Wolfgang Tillmans, Lutz Halle, Alexandra Bircken, Stephanie Hoffmann

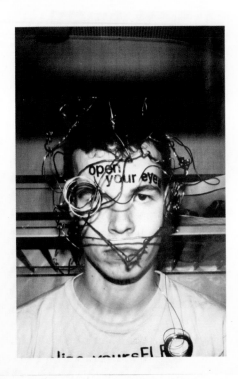

Fragile performing at BOFFO Fire Island
Performance Festival, Fire Island Pines,
2016; Kyle Combs, Wolfgang Tillmans,
Jay Pluck, Juan Pablo Echeverri, (Tom
Roach and Tim Knapp), photo: Jim Greene

Fragile performing at Union Pool,
Brooklyn, 2016; Tom Roach, Wolfgang
Tillmans, Kyle Combs, Juan Pablo
Echeverri, (Daniel Pearce and Jay Pluck),
photo: Daniel Dugoff

Next pages:
Stills from video for Fragile *That's Desire /
Here We Are EP*, 2016, featuring Matthew
Salinas, Hari Nef, Ash B., Wolfgang
Tillmans, Christopher Olszewski and
others not pictured here

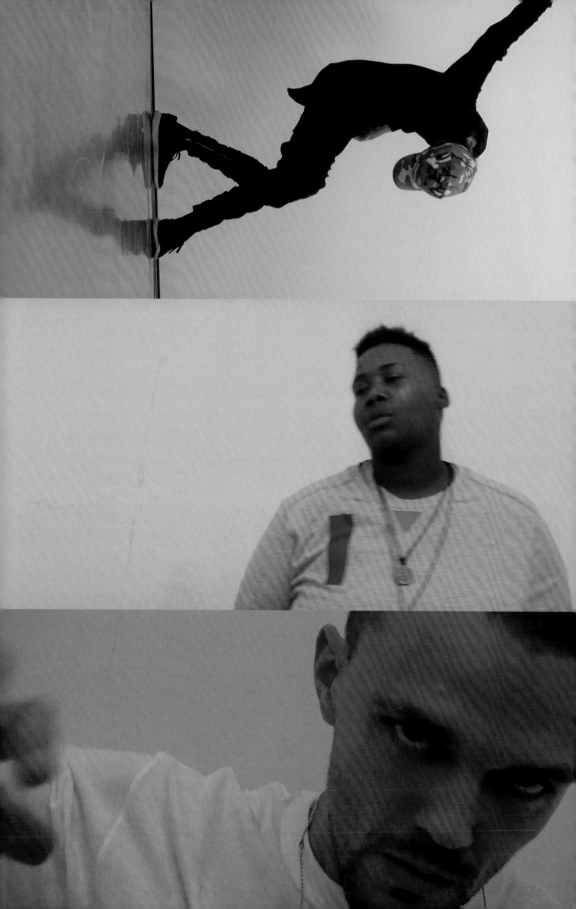

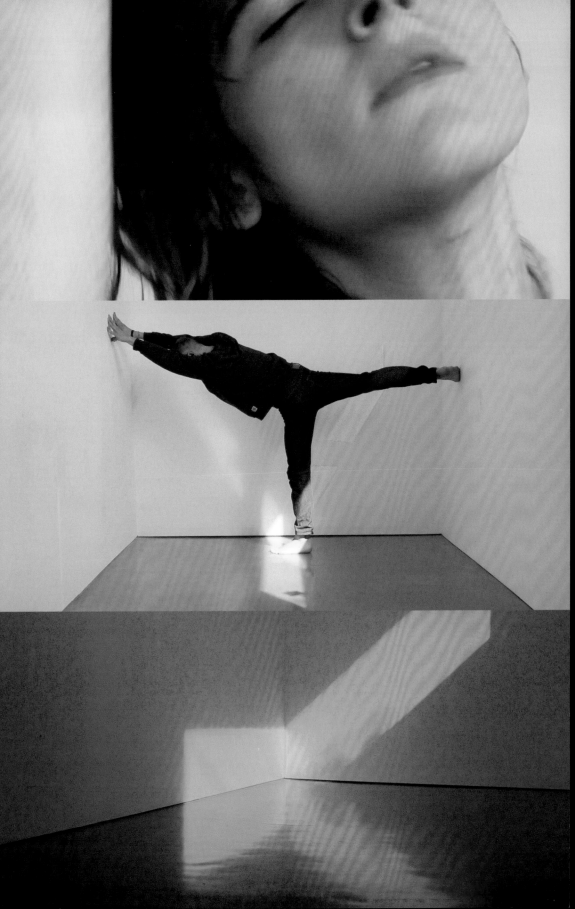

Stills from *Peas*, 2003

Kieler Straße (self), 1988

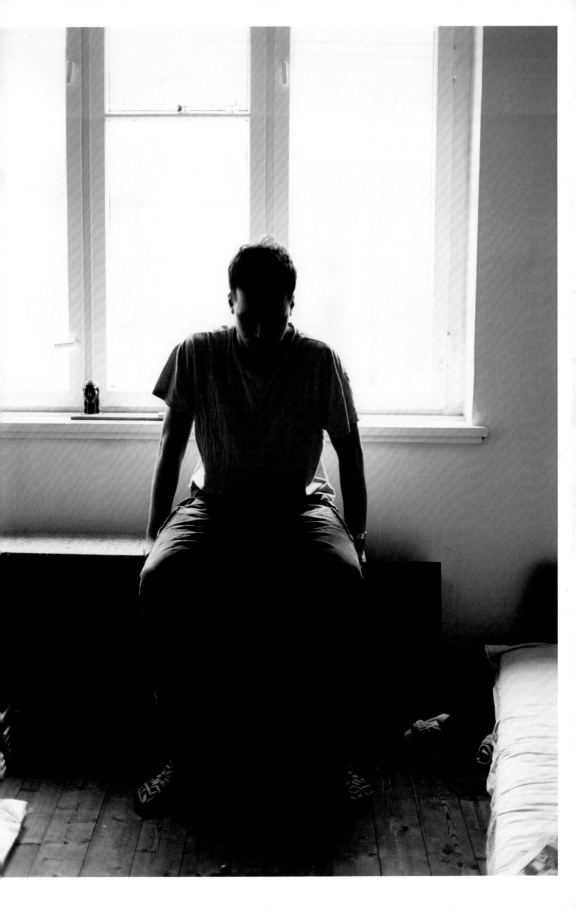

Book for Architects

Two-channel 4K video installation, 40'55''
2014

Architecture is an expression of desires, hopes and ambitions, but also practical needs and financial limitations. Over the past ten years, I have photographed buildings in ordinary and extraordinary contexts. When I look back at these pictures, I am always taken aback by the madness, the complexity and the irrationality – neither ironic nor bleak, they seem to me a little daunting, but always taken with a kind eye.

Book for Architects is presented in Venice as a projected sequence of still images displayed on two screens, the majority of which have never before been published. Rather than isolating individual buildings, which is commonly seen in architectural photography, my interest is in making images that echo what the built environment actually looks like to me. I don't use wide-angle or shift lenses, but a standard lens that most closely approximates the perspective of the human eye. The various elements of architecture encountered in the previous fourteen rooms appear here at times clearly and cleanly, and at other times in a layered and convoluted fashion. As such, the photographs represent the impurity and randomness as well as the beauty and imperfection that typify built reality, both past and present. WT

Book for Architects, plate 110, left, 2014
Book for Architects, plate 108, left, 2014

Book for Architects, plate 015, right, 2014

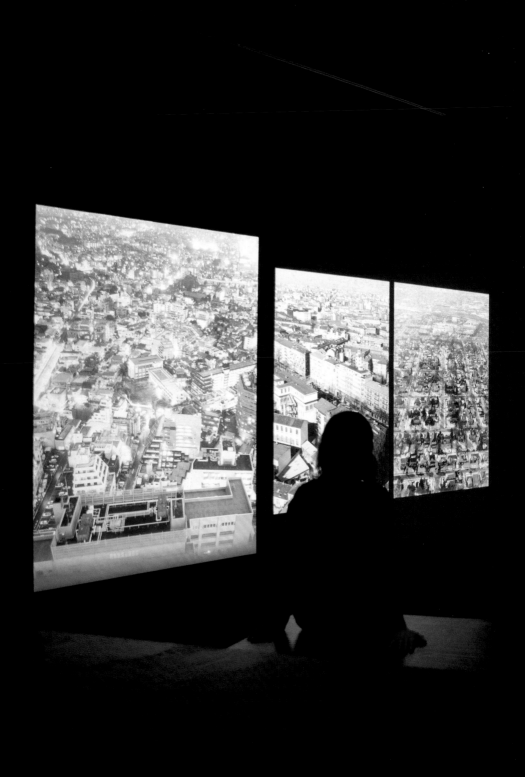

Installation view of Book for Architects, plates
031, left and right. Next pages: plates 001 left
and right, plates 040 left and right, 2014. in
the 14th International Architecture Exhibition
(directed by Rem Koolhaas), Venice, 2014

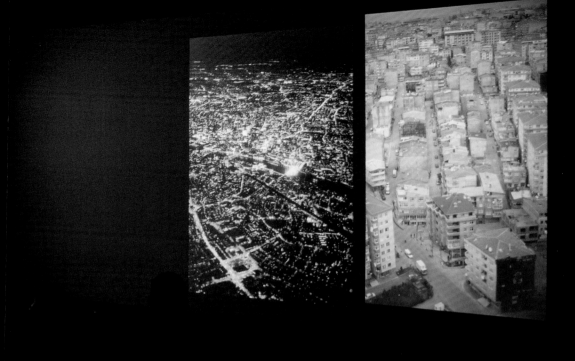

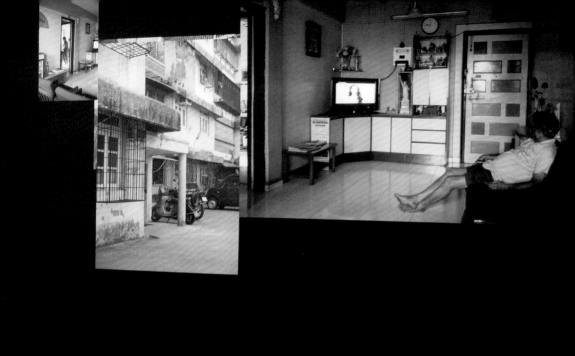

Next pages:
Book for Architects, plate 049, right, 2014

Poster for *Wolfgang Tillmans – Cladding /
Verschalung*, lecture at Technische Universität,
Berlin, 2014

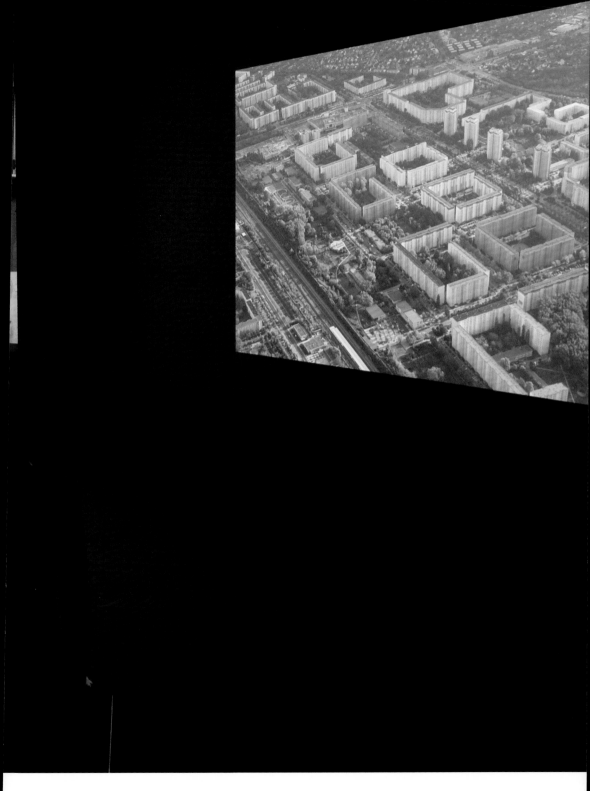

20. NOVEMBER 2014
19 Uhr | Raum A 151
TU Berlin Architekturgebäude
Straße des 17. Juni 152

WOLFGANG TILLMANS
CLADDING / VERSCHALUNG

POSITIONEN

TU Berlin | Institut für Architektur | Fachgebiet Baukonstruktion und Entwerfen | Prof. Regine Leibinger

Statements

Statements in support of 'Remain' in the run-up to and after the United Kingdom's
EU referendum

First email regarding the EU referendum, 24 April 2016

Dear Friends,

I'm sure you are also following with horror the rightwards drift and anti-EU sentiment
brewing across Europe. The Dutch referendum should be the final wake-up call, alerting
people to the real risk of the UK's EU referendum resulting in a victory for Leave.

The official 'Remain' campaign feels lame and is lacking in passion. It also lacks an active
drive to get voters registered – and with the deadline already falling two weeks before the
referendum, this should be an urgent priority.

I want to get involved and actively campaign. In particular, I want to work towards maxi-
mizing turnout among younger voters by focusing on the first, crucial step: voter registration
– the deadline for which is June 7! So anyone who hasn't registered before this date has no
chance of having a say, no matter how strongly they feel about the issue. So the really crucial
date is June 7. Everyone's grannies registered their vote long ago, but students no longer
get automatically registered by their unis. This is because of a new law brought in by the
Conservatives that makes it possible for them to disenfranchise up to 800,000 students, who
as a group tend to move around a lot more and so drop off the voter register easily. I feel
that we have reached a critical moment that could prove to be a turning point for Europe as
we know and enjoy it – one that might result in a cascade of problematic consequences and
political fall-out. Firstly, the weakening of the EU is a goal being actively pursued by strong-
men like Vladimir Putin and European parties on the far-right. Brexit could effectively spell
the end of the EU. It's a flawed and problematic institution, but on the whole it stands for a
democratic worldview, human rights and favours cooperation over confrontation.

It could prove to be a one-in-a-generation moment. Can you imagine the years of renegotia-
tions for undoing treaties, and all the negativity that would surround that.

Over the past few weeks, my assistants at my London and Berlin studios and Between
Bridges have been working with me on these texts and designs. Please feel free to share these
posters, they work as print-your-own PDFs, or on social media, or in any other way you can
think of. I consider them open-source, you can take my name tag off if more appropriate.

Let's hope for the best – but hope may not be enough.

Wolfgang

Statement on WT Website, 26 May 2016

The reasons why I felt compelled to get involved in the UK-EU referendum are personal – my lifelong involvement with the UK, my love for the UK and its culture, music and people, my career's groundedness in Britain and the always warm welcome I felt here as a German. I see myself as a product of the European post-war history of reconciliation, peace and exchange.

However, the more pressing reason why I morphed in recent months from an inherently political, to an overtly political person, lies in my observation of the larger geopolitical situation and an understanding of Western cultures, as sleepwalkers into the abyss. The term "Sleepwalkers" comes from the title of the book by Christopher Clark which describes Europe in 1914, when different societies ended up in a world war, which none of them wanted. Today, I see the Western world sleepwalking towards the demolition of the very institutions of democracy, negotiation and moderation that allow us to live the lives we are living.

In the US we are currently observing a rage which is threatening to wash away great American values, which anchor the world as we know it. These people claim to make America great again, but they embody the opposite. In the East of Europe, we see a surge in nationalist fervour, which wants to sweep away freedoms won only some twenty-five years ago. In western Europe and Britain, we see a wave of discontent with the outcome of globalisation, which turns its anger from the real perpetrators, say for example the tax-evading billionaires, to the weakest in our societies: refugees from terror and war.

The EU is a scapegoat in the midst of all this. For decades press and politicians have loaded blame on it, when in fact it does its best to deal with the fallout of the tectonic shifts in world politics. The EU takes upon itself the task to negotiate the affairs of twenty-eight member states. This can never be an easy task. I admire that this even works so well. We can exchange goods without having to probe product safety each and every time between the twenty-eight countries. Brussels bureaucracy deals with that, and actually quite efficiently. People can move and work in whichever EU country they like. In fact, 1.5 million Brits enjoy this right just now, and due to deregulation of air travel millions enjoy cheap air travel to Europe.

We have in the last decades become a European family, with much less dividing us than connecting us. EU laws, making up only ten per cent of laws made in the UK, enshrined rights like four weeks' paid holiday, health and safety and much more. The EU enforces standards that protect the environment. Water pollution doesn't respect borders, and here especially Brits benefit from rules that span the continent. There are frustrations with the very nature of compromise and shared decision-making.

The EU is well aware of its shortcomings and David Cameron has secured a clause for the UK to not partake in a move towards a European States. This is no longer on the cards. There is no longer a danger of giving up British sovereignty. I feel that the forces driving towards the UK leaving the EU are disregarding a most crucial point – the values the EU stands for are fragile in this world of extremism. The anti-democratic forces in eastern Europe, the Islamist forces around the Mediterranean, the big business interests in North America, are all poised to wash away the EU's laws of moderation.

The EU protects your rights against these enemies of freedom. To leave the EU now, in these dangerous political times, is not patriotic, it's simply foolish and it would send the wrong message to the enemies of European values. The EU is not perfect and it never was designed to be that way. The very nature of it being a negotiating chamber of twenty-eight nations is the key to its success. It is not in the security interests of the UK to weaken the EU at this point in time. Whatever your feelings towards the EU, be aware that voting for Brexit has catastrophic repercussions for the whole of Europe and the world.

Wolfgang

Second email regarding the EU referendum, 16 June 2016

Dear Friends,

This is the second email about the EU referendum you've received from me since I uploaded my posters at the end of April. We've now updated the posters, shifting the focus from voter registration to getting people out to vote Remain on 23rd June. Please go to my website www.tillmans.co.uk to download both jpgs for social media and a PDF to self-print posters. Please forward this mail and encourage friends to do the same. No need to hashtag me when posting.

A couple of nights ago I wrote a comment piece for *Time Out London* magazine and website to be published on Monday. In it I use an image that came to my mind the other day. Should a Leave vote happen next Thursday, Britain's message to the 444 million remaining EU members will feel a bit like this:

We lived together for over forty years in this apartment building of twenty-eight flats with every member having a key to their own flat and some having even an extra lock on like Britain. We lived together in peace and got used to each other's oddities. We even got down the utility bills, like phone and air travel and many more, but now I can't stand living with you any longer. I hate it so much that I want to move out.

Brexiters shelter the public from having to think about what a snub this would be. The EU is not a machine; it is the representation of 508 million people. Please post the posters and messages, maybe one a day to keep Brexit away. The xenophobic Vote Leave campaign is part of an international mood to break things. Whether it's Trump or Johnson, these attacks on the pillars of our society all reflect the same divisive mood.

Best wishes,
Wolfgang

PS: A large number of artists and designers have uploaded pro-EU anti-Brexit posters onto this fantastic website: www.eu-uk.info. Please check it out and tell others about it.

I'm not feeling depressed today. I had a profoundly sad moment the evening before last when, leaving Tate Modern, I looked at the building and after sunset walked over the Millennium Bridge. Both were opened in 2000, both symbols of a new openness. That same month I was nominated for the Turner Prize for British art alongside two other non-Britons and one Briton. This was the new London that had been taking shape since the early 90s. The London that had self-confidently taken its place at the very centre of Europe. I looked at the yellow-red sky to the west and my eyes filled with tears, realising that this could be the final evening before a new era. That sixteen years later we should have got to a situation where half the population rejects this open and international spirit is hard to comprehend. This all happened when there was still the general feeling that the vote would favour remain. The fact that, unlike many others this morning, I'm not feeling deeply depressed about the way the English and Welsh voted, makes me realise that the sorrow I'd felt two days previously was the emotional manifestation of something that I had sensed for a long time; which Tony Blair put into words on 29 August last year in the Guardian. Blair who had completely lost touch with reality over Iraq, suddenly showed a moment of lucidity, as he wrote to fellow party members in an effort to persuade them not to elect the populist left-wing candidate, Jeremy Corbyn, as leader of the Labour Party. Reading the last paragraph, the hairs stood up on the back of my neck as Blair admitted that his generation would have to rethink everything, because what we are currently seeing is part of something even bigger: 'But people like me have a lot of thinking to do. We don't yet properly understand this. It is about to transform a political institution we spent our whole lives defending. But it is part of something much bigger in politics.

Because it is a vast wave of feeling against the unfairness of globalisation, against elites, against the humdrum navigation of decision-making in an imperfect world, it persuades itself that it has a monopoly on authenticity. They're "telling it like it is", when, of course, they're telling it like it isn't.'

Now ten months after Blair wrote these words, the first big wave has breached one of these institutions. He was writing about left-wing populism in his own party, but the larger picture is of course the more damaging right-wing populism, which yesterday's vote is so much part of. We still have more of this to go through.

The only thing that helps is not to lose courage, because what's being attacked by populists is not in fact the real evil, instead it's substitutes that get attacked – refugees, the UN, the EU, or simply politicians. It's now the duty of us all to defend the pillars of the free world order that was created over the last seventy years.

To hold the centre ground, and not to contribute to the centrifugal energies around us. And I know that we're still the majority.

Statement on WT website, 4 July 2016

Please see below a recap of the pro-EU / anti-Brexit campaign in the form of a mail, which kept growing longer and longer as I was writing it, to Cornelia Parker, who sent me the attached photograph:

Dear Cornelia,

Thank you so much for the photo taken on referendum day in Chichester. It means a lot to me that our posters made it to outside London. It was an uphill struggle. Annett Kottek at my London studio literally wrote to fifty different student unions and just got three replies. One regional Labour Party office requested posters and said they would forward our email to relevant people but we never heard back. Charities and faith groups, like the Quakers, liked them a lot but said, because of their charitable status, they were not allowed to express a political opinion. The same went for many of the arts organisations and colleges we wrote to. However a good number of them across the country didn't seem to be troubled by this and displayed and distributed the posters vigorously. Respect to you! There were many individuals who adopted poster tubes and distributed them. Volunteers Chester Kottek and John Cronin made endless runs to the post office mailing tubes. Martinspeed, the art shippers, did a great job storing the twenty-one industrial size pallets of poster tubes, and delivering them to Sebastian Street one by one, all free of charge. The self-print and social media parts of the campaign were the most visible, but I'm glad I insisted on having old fashioned A1 posters. Thanks to the financial help of Evelyn Stern, David Chipperfield and Ruth and Richard Rogers we printed 25,000 of them. Daniel Mason of Something Else Press handled the logistics of this printing job in London.

After having designed the first twenty-five online posters, released 23rd April, Paul Hutchinson and myself at the Berlin studio tirelessly kept texting and designing new and adapting existing posters, including specialised versions for different target groups. Also at the Berlin studio Armin Gerold Lorenz doubled up as website manager and together with Evelyn Marwehe as organisers of the numerous press requests. Freelance editor Graham Fallowes was available online to instantly copy-edit any new statements and poster texts.

In the run up to the 7th June registration deadline I realized the potential of T-shirts, which we then hastily produced thanks to Merch and Destroy. These then went to various famous people or people who know them, with mixed results – many did not respond, others did. Juergen Teller's photo of Vivienne Westwood went viral, and so did the one of 'James Bond' on the last day of the campaign. David Cameron re-tweeted it two hours after I posted it on my Instagram account.

In the last ten days of the campaign a larger print run of T-shirts made in London were distributed around art galleries and book shops as well as through Lily Cole's site impossible.com. *i-D* magazine and Dazed Digital held drop-in online shoots with the shirts and the Boiler Room DJ site got strongly behind the cause.

Always in the good hands of Eugen Ivan Bergmann at the Between Bridges space in Berlin, we held events around Brexit and related subjects, the refugee crisis and the rise of populism and right-wing extremism across Europe.

EU referendum poster in Chichester,
23 June 2016, photo: Cornelia Parker

Needless to say almost all involved have a 'migrant status', are 'immigrants' of some sort: three British living in Germany, two Germans living in London, a German born to an Irish father, an Austrian in Berlin, a Kazakh-born German and so on.

Also a big thank you to all at the studio who were working on my other projects and who found time to contribute greatly, through feedback and advice and by keeping a good spirit in the midst of the madness.

To all who consider getting involved in activism, I can only encourage you to do so. It was a great and rewarding experience, despite not reaching our goal. It brings people from different backgrounds together in unexpected and friendly ways and creates friendships that hopefully will last. For myself I plan to take this further and to other places as right-wing populism and extremism will be with us for some time to come. Please get in touch if you would like to contribute in whatever way in the future. I was not the only artist generating messages and imagery: In the light of the dull official IN campaign it was great to see that artists can have a different and often more direct voice. Check out the eu-uk.info website.

My heartfelt thanks and respect to all supporters!

Below is the new Between Bridges programme which promises to be a strong series of events before the summer break. Please come by daytime, or on Thursday evenings and other dates advertised below.

Wolfgang

Please visit the archive section www.tillmans.co.uk/campaign-eu to see and download all parts of the campaign.

Endnotes

Mark Godfrey

Worldview

1 'Step into Liquid: Michelle Kuo talks with Wolfgang Tillmans about the ascendancy of ink-jet printing', *Artforum*, September 2012, p.425.

2 Kaja Silverman has recently argued that creating analogies, rather than understanding the world through identity or antithesis, can be the beginning for a progressive ethics and politics. 'An analogy is a relationship of greater or lesser similarity between two more ontologically equal terms – a corresponding *with*, rather than a corresponding *to*. Everything relates to everything else in this way, because analogy is the structure of Being … Because we are constantly refusing to acknowledge the resemblances that connect us to certain people or groups of people, we are almost always physically estranged from the totality to which we belong. This refusal has disastrous consequences for them and for us.' (Kaja Silverman, 'Primal Siblings: George Baker in conversation with Kaja Silverman', *Artforum*, February 2010. p.179.) Elsewhere she clarifies that 'An analogy is a very different thing from a metaphor. A metaphor entails the substitution of one thing for another. This is a profoundly undemocratic relationship, because the former is a temporary stand-in for the latter and it has only a provisional reality. In an analogy, on the other hand, both terms are on an equal footing, ontologically and semiotically.' (Kaja Silverman, *Flesh of My Flesh*, Stanford 2009, p.173).

3 In his text introducing the monograph on Jochen Klein published by the Kunstraum München and Cubitt, London, Tillmans used the word 'empathetic' to discuss the artist's outlook. Wolfgang Tillmans, 'Foreword', reprinted in Bernhart Schwenk and Wolfgang Tillmans (eds), *Jochen Klein*, exh. cat., Pinakothek der Moderne, Munich, Ostfildern 2011, p.220.

4 Wolfgang Tillmans, 'Paper Drop/Lighter' in Jan Verwoert et al., *Wolfgang Tillmans*, 2nd edn, London 2014, p.154.

5 Nathan Kernan, 'What They Are: A Conversation with Wolfgang Tillmans' in *View from Above*, exh. cat., Ostfildern 2001, p.9.

6 Tillmans's approach to photographic materiality differs from that of Tacita Dean, who is more interested in analogue and outmoded photographic practices, and from that of James Welling, who has been concerned with photography's vulnerability to light at the moment of exposure, rather than after the photograph has been printed.

7 It has been argued that Gerhard Richter took on the tradition of the still life and vanitas painting to show that it was only a convention, emptied of all power. Tillmans would not see things this way and instead starts from the point of view that people still bring feelings to images of fruit and flowers; he would not claim that his still lifes are original in the history of photography, but nor are they exercises in revealing the exhaustion of conventions.

8 In his concentration on the fragility of everyday surfaces, Tillmans departs from Stephen Shore's approach in *American Surfaces*, 1972, and connects instead to Zoe Leonard's use of fruits in her sculpture *Strange Fruit (for David)*, 1992–7. The work was devoted to her friend David Wojnarowicz, after his death from AIDS. This was not a work Tillmans knew when he made his photographs of fruit peels, despite his admiration of its dedicatee.

9 'Peter Halley in Conversation with Wolfgang Tillmans' in Jan Verwoert et al., *Wolfgang Tillmans*, London 2002, p.21.

10 Miwon Kwon, 'The Becoming of a Work of Art: FGT and the Possibility of Renewal, a Chance to Share, a Fragile Truce' in Julie Ault (ed.), *Félix Gonzalez-Torres*, Göttingen 2006, pp.281–317. Gonzalez-Torres's importance to Tillmans could be tracked in many other ways too – primarily through the similar ways they are both interested in affect, and a poignant beauty. But Gonzalez-Torres's impact also registers in terms of the kinds of images Tillmans *did not* make: for instance, for all his photographs of crumpled clothes, there are none of crumpled sheets, because the empty bed was an image so much associated with the older artist.

11 'Wolfgang Tillmans', Interview by Bob Nickas, *Interview*, September 2011.

12 Wolfgang Tillmans, 'Neville Wakefield in Conversation with Wolfgang Tillmans' in *Wolfgang Tillmans*, exh. cat., Portikus, Frankfurt am Main 1995, unpag.

13 Dominic Eichler and Wolfgang Tillmans, 'Look, again', *frieze*, no.118, October 2008, p.233.

14 Interview with the artist, 3 December 2015.

15 Another image that shows this grounding recently appeared in Tillmans's collection of photographs from 1983–9 titled *Fragile* and published in *ARENA Homme+* in Winter 2015. Most of these early images record garments Tillmans created and show him wearing these around London; there are also pictures of Soft Cell, Culture Club and Bronski Beat. It is an exuberant representation of gay teenage life in a new city, but in the mix as well is a picture of the Tillmans family and friends, lined up for a Christmas photograph in the snow.

16 In conversation with Nan Goldin in 1990, Wojnarowicz stated 'I've been in rage all my life at this thing we call "society".' 'Nan Goldin with David Wojnarowicz', in *David Wojnarowicz: Brush Fires in the Social Landscape*, New York 2015, p.159.

17 For an interesting discussion connecting Tillmans's early sexual experiences to his later sympathy with Quakerism, see Stuart Comer, 'Deutscher Top Künstler aus London fickt Keyboard Player von Bronski Beat', *BUTT*, no.17, 16 August 2006.

18 Julia Peyton-Jones and Hans Ulrich Obrist, 'Interview with Wolfgang Tillmans' in *Wolfgang Tillmans*, exh. cat., Serpentine Gallery, London 2010, p.23.

19 'New World / Life is astronomical: Wolfgang Tillmans in conversation with Beatrix Ruf' in *Neue Welt / Wolfgang Tillmans*, Berlin/London 2012, unpag. It should be said that while Tillmans does photograph strangers unobserved, he never makes a spectacle of 'otherness' nor indulges in the kind of concerned but ultimately exploitative documentary photography that Rosler criticised. See Martha Rosler, 'In, Around, And Afterthoughts (on Documentary Photography)' (1981) in Martha Rosler, *Decoys and Disruptions: Selected Writings, 1975–2001*, Cambridge, MA 2004, pp.175–206.

20 Wolfgang Tillmans to Lord Marshall of Knightsbridge, 17 December 2002. First reproduced in *WT: Wako Book 3*, Tokyo 2004.

21 Tillmans's first major installation was at Buchholz and Buchholz in Cologne in 1993. In the small gallery space, Tillmans covered the walls with C-prints and magazine spreads, showing some images as prints that had already been published in *i-D*. The photographs were neither randomly scattered, nor gridded up according to types, but were precisely arranged – his *Chemistry Squares*, for instance – in a neat horizontal row. Tillmans extended the images right into the corner, even pasting two pictures over a column. In Buchholz's bookshop, Tillmans pinned an enlarged Xerox to a kind of line, where it hung between nineteenth-century prints; in a separate space, he showed large-scale bubble-jet prints pasted onto loosely hanging fabrics (some of the

images had also been shown in smaller formats in the main space). The spatialisation of photography for exhibition goes back to El Lissitzky's *Pressa* pavilion in Cologne in 1928 and the *Film und Foto* show in Stuttgart in 1929; at the time of Tillmans's Buchholz show, several artists were already thinking about photographs as objects (not just as images) that could be arranged as installations in relation to architecture – Christopher Williams, for instance, who in 1991 left the entire floor of Max Hetzler's gallery in Cologne empty, installing a single photograph on a false wall built on the second floor, and in a different way, General Idea. However, Tillmans's 1993 show seems not to have been a response to historical or prevailing display tactics but instead a self-motivated kind of arrangement that some have compared with the teenage bedroom wall. Within the next few years, with landmark exhibitions including the 1995 Portikus show, the 1997 Chisenhale installation and his 2000 Turner Prize show, Tillmans worked out a kind of approach to an arrangement that has continued in his practice ever since: different scaled prints, some very large; different framing and fixtures; and a full use of the height and width of the walls as well as other architectural features.

22 In this respect, Tillmans's tables function somewhat differently to those of Francis Alÿs, where most material that is not his tends to directly relate to his production, whether as source material or parallel material.

23 When Tillmans designed the spread for *Die Zeit*, he knew an advert would appear beside the photograph from Iran, but he could not anticipate what it would be.

24 Tillmans's tables might be contrasted with Thomas Hirschhorn's installations where the artist is often at pains to push the viewer's body into close proximity with images of destroyed bodies – images that are available on the internet but too gruesome for news media.

25 Tom McDonough, 'The Ethics of Not-Knowing: Wolfgang Tillmans's *truth study center*' in *Wolfgang Tillmans: What's wrong with redistribution?*, Wolfgang Tillmans (ed.), Cologne 2015, pp.8–23.

26 Wolfgang Tillmans, *manual*, Cologne 2007, text on sleeve.

27 Ibid.

28 *Wolfgang Tillmans / Hans Ulrich Obrist – The Conversation Series*, no.6, Cologne 2007, p.91.

29 Dominic Eichler and Wolfgang Tillmans, 'Look, again', *frieze*, no.118, October 2008, p.235.

30 See the self-portrait in the selection from 1983–9 in *ARENA Homme+* in Winter 2015 where the left side of the image is covered by an orange flare.

31 Ibid., p.232.

32 'Week 30: August 14–19, 2000: Wolfgang Tillmans', Interview with Christabel Stewart in Mark Francis (ed.), *FIG 1: 50 Projects in 50 Weeks*, 2001, unpag.

33 Tillmans's photocopies can also be related to Gonzalez-Torres's work, particularly to his wall-filling black and white image of a bird flying across the sky whose affect is all the more poignant because the picture is so grainy.

34 See *Untitled*, 1996, in *Jochen Klein*, exh. cat., Pinakothek der Moderne, Munich, Ostfildern 2011, p.161.

35 See page 189 of *If one thing matters, everything matters*, exh. cat., Tate, London 2003.

36 Wolfgang Tillmans, 'Excerpts from Interviews, Lectures, and Notes' in *Wolfgang Tillmans: Abstract Pictures*, Ostfildern 2011, p.24.

37 It should be noted that Tillmans's *Silvers* predate Wade Guyton's paintings made with Epson printers, where scan lines and printer rollers create similar textures.

38 There are some examples of this kind of 'abstraction' in Tillmans's work, such as his images of tube seats.

39 The exhibition was mounted in spring 2016 and included images made from 1986 to 2016.

40 Nathan Kernan, 'What They Are: A Conversation with Wolfgang Tillmans' in *View from Above*, Ostfildern 2001, p.10.

41 See 'New World / Life is astronomical: Wolfgang Tillmans in conversation with Beatrix Ruf' in *Neue Welt / Wolfgang Tillmans*, Berlin/London, 2012, unpag.

42 Ibid.

43 Ibid.

44 Ibid.

45 The photograph anticipates Tillmans's song 'Device Control', released in 2016 on his second record and also featured on Frank Ocean's *Endless*, where Tillmans sings a series of lines that seem taken from Apple, Sony, Samsung and other promotional material, appearing to laud new smartphones' facilities, but actually reveal the way we are controlled by our devices.

46 Tillmans's conclusions about the predicament of responding to the world through photography corresponds with the way Benjamin Buchloh describes the situation Tillmans's friend Isa Genzken faces responding to the world through objects. 'Genzken confronts one of the prime calamities of sculpture in the present: a terror that emerges from both the universal equivalence and exchangeability of all objects and materials and the simultaneous impossibility of imbuing any transgressive definition of sculpture with priorities or criteria of selection, or choice, let alone judgment.' Benjamin H.D. Buchloh, 'All Things Being Equal', *Artforum*, November 2005, p.224. For Buchloh, Genzken submits to this situation; I would argue that Tillmans registers it, but offers a different way of being.

47 For instance, *Calendar Leaves*, 1994, an image of golden trees in upstate New York in late summer.

48 This aspect of Tillmans's work can be contrasted with Gerhard Richter's late 1960s paintings of clouds, seascapes and night skies. I have argued elsewhere that in these works Richter posed the question how an artist of his generation could or could not connect back to Caspar David Friedrich following the calamity of mid-century German history. Tillmans makes his works under very different conditions. See Mark Godfrey, 'Damaged Landscapes' in Mark Godfrey and Nicholas Serota (eds), *Gerhard Richter: Panorama*, exh. cat., Tate, London 2011.

49 Felix Gonzalez-Torres, '1990: L.A., "The Gold Field"' in Julie Ault (ed.), *Felix Gonzalez-Torres*, Göttingen 2006, p.150.

50 Dominic Eichler and Wolfgang Tillmans, 'Look, again', *frieze*, no.118, October 2008, p.231.

51 'New World / Life is astronomical: Wolfgang Tillmans in conversation with Beatrix Ruf' in *Neue Welt / Wolfgang Tillmans*, Berlin/London, 2012, unpag.

52 Wolfgang Tillmans, 'The State We're In, A, 2015' in *Canadian Art*, Fall 2016, p.148.

53 Wolfgang Tillmans, statement published in the *Süddeutsche Zeitung*, 24 June 2016, http://tillmans.co.uk/campaign-eu, accessed 23 October 2016.

Endnotes

Tom Holert

Sensate Life in the Public Sphere: The Polypolitical World of Wolfgang Tillmans

1 Wolfgang Tillmans, letter to Cornelia Parker, 25 June 2016, http://tillmans.co.uk/; see also Jefferson Hack, 'Talking Politics, Posters and Techno with Wolfgang Tillmans', in *Dazed Digital*, 21 July 2016, http://www.dazeddigital.com/artsandculture/article/32079/1/talking-politics-posters-and-techno-with-wolfgang-tillmans, accessed 11 October 2016.

2 Wolfgang Tillmans, 'The UK Must Stay in the EU', in *Dazed Digital*, 26 May 2016, http://www.dazeddigital.com/artsandculture/article/31258/1/wolfgang-tillmans-on-why-the-uk-must-remain-in-the-eu, accessed 11 October 2016.

3 See for example 'Europe's Success Irritates Its Enemies' [interview with Wolfgang Tillmans], *Der Spiegel*, 24, 11 June 2016, p.130.

4 Wolfgang Tillmans with Allie Biswas, *The Brooklyn Rail*, 11 June 2016, http://www.brooklynrail.org/2016/07/art/wolfgang-tillmans-with-allie-biswas, accessed 11 October 2016.

5 'Europe's Success Irritates Its Enemies', p.130.

6 Saim Demircan, 'Wolfgang Tillmans and the EU', in *Art Monthly*, 397, June 2016, p.35.

7 Yates McKee, *Strike Art. Contemporary Art and the Post-Occupy Condition*, London and New York, 2016, p.26.

8 See for example *But Is It Art? The Spirit of Activism*, Nina Felshin (ed.), Seattle 1995; Gregory Sholette, *Dark Matter. Art and Politics in the Age of Enterprise Culture*, London 2011; *Living as Form: Socially Engaged Art From 1991–2011*, Nato Thompson (ed.), New York and Cambridge, MA/London 2012; Alana Jelinek, *This Is Not Art. Activism and Other 'Non-Art'*, London and New York 2013; *Global ACtIVISm. Art and Conflict in the 21st Century*, Peter Weibel (ed.), Karlsruhe and Cambridge, MA/London 2013.

9 Matthew Friday, David Joselit, Silvia Kolbowski, 'Roundtable: The Social Artwork', *October*, no.142, Fall 2012, p.82.

10 Joe Roberts, 'An Under-the-Radar Queer Safe Space Pushing the Boundaries of Music and Art: How Five Years of The Spectrum Breathed Color Back into New York Nightlife', *Red Bull Music Academy Daily*, 1 February 2016, http://daily.redbullmusicacademy.com/2016/02/nightclubbing-the-spectrum-new-york-city, accessed 11 October 2016.

11 Ibid.

12 Michael Bullock, 'The Spectrum' [interview with Gage of the Boone and Raúl de Nieves], *apartamento. an everyday life interiors magazine*, no.17, 2016, p.127.

13 Wolfgang Tillmans, Hasselblad Award Winner 2015, Artist Talk, 1 December 2015, Gothenburg, https://www.youtube.com/watch?v=yCpSiB0PS2w, accessed 11 October 2016.

14 Ariella Azoulay, *Civil Imagination. A Political Ontology of Photography*, London and New York 2012, p.19.

15 See Dominic Eichler, 'Look, again' [Interview with Wolfgang Tillmans], *frieze*, no.118, October 2008, p.234.

16 Azoulay 2012, p.22.

17 Roberts 2016.

18 See for example Laam Hae, 'Gentrification and Politicization of Nightlife in New York City', *ACME: An International Journal for Critical Geographies*, vol.10, no.3 (2011), http://ojs.unbc.ca/index.php/acme/article/view/911, accessed 11 October 2016.

19 Michael Warner, *Publics and Counterpublics*, New York 2002, pp.7–8.

20 Ibid., pp.11–12.

21 Ibid., p.120.

22 Ibid.

23 Ibid., p.121.

24 Ibid., p.124.

25 Wolfgang Tillmans, lecture, 4 November 2015, Museu de Arte Contemporânea de Serralves, Porto.

26 John Paul Ricco, *The Decision Between Us. Art and Ethics in the Time of Scenes*, Chicago and London 2014, p.57.

27 Interestingly, the nightlife photographs from Tillmans's oeuvre, regardless how much they are objects of admiration and debate among followers and critics, rarely succeed in the commercial art marketplace (cf. Wolfgang Tillmans, email to the author, 30 July 2016). Often private collectors seem not to be interested in acquiring these renditions of subcultural life directly, though one may argue that other families in Tillmans's catalogue raisonné indirectly benefit from being affected by their existence in the work and their function as contributing significantly to the artist's public image.

28 Because Tillmans made sure not to publish the majority of these photographs whilst the clubs were in operation but only after they closed down, at the time of their publication they already served as melancholic epitaphs to worlds just vanished.

29 Wolfgang Tillmans, *Conor Donlon*, intro. Alex Needham, Cologne 2016.

30 See Wolfgang Tillmans, 'Spectrum Montrose Ave', *apartamento. an everyday life interiors magazine*, no.17, 2016, pp.129–37 (the spread includes *The Spectrum/Dagger* as well as *Entrance*, 2015, both exhibited in the 2015 Zwirner show).

31 Diane Smyth, 'Everything Is Illuminated. Interview Wolfgang Tillmans', *British Journal of Photography*, July 2010, p.34.

32 Martin Herbert, 'Wolfgang Tillmans: The World Through My Lens', *Art Review*, 67, April 2013, p.69.

33 Prior to exhibiting *The Spectrum/Dagger*, Tillmans reached out to the club and to its regular attendees, seeking to establish the identities of the vaguely recognisable figures – to no avail (Wolfgang Tillmans, email to the author, 30 July 2016). Only months after the opening did the artist get a response; people accustomed to constant exposure in social media have become rather indifferent to being photographed in public or semi-public situations.

34 Brian Massumi, *Politics of Affect*, Cambridge, UK and Malden, MA 2015, p.ix.

35 See Bruno Latour, 'On Some of the Affects of Capitalism', lecture given at the Royal Academy, Copenhagen, 26 February

2014, http://www.bruno-latour.fr/sites/default/files/136-AFFECTS-OF-K-COPENHAGUE.pdf, accessed 11 October 2016.

36 'Wolfgang Tillmans in Conversation with Jon Savage', *ARENA Homme+*, Winter 2015/Spring 2016, p.322.

37 Cf. the eponymous title of Tillmans's 2003 Tate Britain exhibition and catalogue.

38 Boris Groys, *In the Flow*, London and New York 2016, p.19.

39 See especially Claude Lefort, *Democracy and Political Theory*, trans. David Macey, Cambridge 1988; for a helpful introduction to Lefort in the context of post-foundational political theory, see Oliver Marchart, *Post-Foundational Political Thought. Political Difference in Nancy, Lefort, Badiou and Laclau*, Edinburgh 2007, pp.85–108 and passim.

40 Emmanuel Levinas, *Totality and Infinity*, trans. Alphonso Lingis, The Hague and Pittsburgh 1979, p.76.

41 On this notion from the writings of philosopher Jacques Rancière in relation to the work of Wolfgang Tillmans, see Tom Holert, 'The Unforeseen. On the Production of the New, and Other Movements in the Work of Wolfgang Tillmans', in *Wolfgang Tillmans*, exh. cat., Moderna Museet, Stockholm, and Kunstsammlung Nordrhein-Westfalen – K21, Düsseldorf, 2012, online resource: http://www.modernamuseet.se/stockholm/wp-content/uploads/sites/3/2012/03/ddfa8b917c7841069f-6d4eedb6b5ab15.pdf, accessed 11 October 2016; and Tom McDonough, 'The Ethics of Not-Knowing: Wolfgang Tillmans's *truth study center*', in *Wolfgang Tillmans. What's wrong with redistribution?*, Wolfgang Tillmans (ed.), exh. cat. Hasselblad Foundation, Gothenburg, Cologne 2015, p.19.

42 Savage 2015–2016, p.316.

43 For more about the particularities of Tillmans's exhibitionary and curatorial strategies see Julie Ault, 'The Subject Is the Exhibition', in *Wolfgang Tillmans*, Amy Teschner and Kamilah Foreman (ed.), exh. cat., Hammer Museum, Los Angeles and Museum of Contemporary Art, Chicago, New Haven and London 2006, pp.119–37; and Holert 2012, passim.

44 Herbert 2013, p.63.

45 Savage 2015–2016, p.316.

46 Rosalyn Deutsche, 'The Art of Non-Indifference', in *The Artist as Public Intellectual?*, Stephan Schmidt-Wulffen (ed.), Vienna, 2008, p.20.

47 Ibid.

Functions of the Studio: Wolfgang Tillmans as Performer and Listener

1 Wolfgang Tillmans, quoted from '"Two people on stage don't always mean a relationship": Michael Clark and Wolfgang Tillmans', in *Magazin im August* [booklet for Tanz im August festival 2014, HAU Hebbel am Ufer, Berlin], Berlin, 2014, p.11.

2 Wesley Morris, 'The Lonely Toil of Frank Ocean: Is It Art, or Denial?', in *The New York Times*, 31 August 2016, http://www.nytimes.com/2016/09/01/arts/music/frank-ocean-blond-blonde-endless.html, accessed 8 November 2016.

3 'Fragile. Wolfgang Tillmans in Conversation with Max Pearmain', in *ARENA Homme+*, 44, Winter 2015/Spring 2016, p.328.

4 See Jörg Heiser, *Doppelleben – Kunst und Popmusik*, Hamburg, 2016.

5 'Peter Halley in Conversation with Wolfgang Tillmans', in Jan Verwoert, Peter Halley, Midori Matsui, *Wolfgang Tillmans*, London, 2002, p.29.

6 Tillmans's 2016 solo show at Galerie Buchholz, Berlin (29 April to 18 June 2016), was entirely devoted to the theme of the 'studio'; the seven-minute video accompanying 'Device Control' collects impressions of the song's recording session at Trixx studios, Berlin, and Studio G, New York; 'Fragile Fiction', a fifty-six-page spread in the Winter 2016/Spring 2017 issue of *ARENA Homme+*, is partly comprised of pictures made in recording studios during various sessions in 2016.

7 'Colourbox: Music of the Group (1982–1987)', press release, Between Bridges, Berlin, September 2014, http://www.between-bridges.net/colourbox.html, accessed 8 November 2016.

8 See http://www.betweenbridges.net/American_Producers.html, accessed 8 November 2016.

9 'Bring Your Own (Playback Room part III): A Month of Sonic Adventures Programmed by Yusuf Etiman', press release, Between Bridges, Berlin, February 2015, http://www.between-bridges.net/Bring_Your_Own.html, accessed 8 November 2016.

10 See Selim Bulut, 'Watch Wolfgang Tillmans at the Controls in His New Video', *Dazed Digital*, September 2016, http://www.dazeddigital.com/music/article/32651/1/wolfgang-tillmans-device-control-video, accessed 8 November 2016.

Biography

1968
Born in Remscheid, Germany

1987–1990
Lives and works in Hamburg

1990–1992
Studies at Bournemouth and Poole College
of Art and Design, Bournemouth, UK

1992–1994
Lives and works in London

1994–1995
Lives and works in New York

1995
Ars Viva Prize, Germany
Kunstpreis der Böttcherstraße, Bremen

1996–2007
Lives and works in London

1998–1999
Visiting professorship at the Hochschule für
bildende Künste, Hamburg

2000
Turner Prize, Tate Britain, London

2001
Honorary Fellowship at The Arts Institute
at Bournemouth, UK

2003–2009
Professorship of interdisciplinary art at
Städelschule, Frankfurt am Main

Since 2006
Exhibition space 'Between Bridges', until
2011 in London, since 2013 in Berlin

2007–2011
Lives and works in London and Berlin

2009
Kulturpreis der Deutschen Gesellschaft für
Photographie, Heidelberg, Germany

2009–2014
Artist Trustee, Board of Trustees, Tate, London

Since 2011
Lives and works in Berlin and London

Since 2012
Member of the Akademie der Künste, Berlin

Since 2013
Member of the Royal Academy of Arts,
London

2014
Wollaston Award, Royal Academy of Arts,
London

2015
Hasselblad Foundation International Award
in Photography, Gothenburg

2015
Centenary Medal and Honorary Fellowship
Award, Royal Photographic Society, London

2016
The Gold Medal of Honorary Patronage of
the University Philosophical Society, Trinity
College, Dublin

Index

Page numbers in *italic* type refer to illustrations.

Greifbar 43 (Tangible 43), 2015

Abigail and Joseph Baratta
Blavatnik Family Foundation
Lauren and Mark Booth
The Deborah Loeb Brice Foundation
The Lord Browne of Madingley, FRS, FREng
John and Michael Chandris, and Christina Chandris
James Chanos
Paul Cooke
The Roger De Haan Charitable Trust
Ago Demirdjian and Tiqui Atencio Demirdjian
Department for Culture, Media And Sport
George Economou
Stefan Edlis and Gael Neeson
Edward and Maryam Eisler
English Partnerships
Mrs Donald B. Fisher
Jeanne Donovan Fisher
Mala Gaonkar
The Ghandehari Foundation
Thomas Gibson in memory of Anthea Gibson
Lydia and Manfred Gorvy
Noam Gottesman
The Hayden Family Foundation
Peter and Maria Kellner
Madeleine Kleinwort
Catherine Lagrange
Pierre Lagrange
London Development Agency
LUMA Foundation
Allison and Howard W. Lutnick
Donald B. Marron
Scott and Suling Mead
Anthony and Deirdre Montagu
Mrs Minoru Mori
Elisabeth Murdoch
The Eyal Ofer Family Foundation
Maureen Paley
Simon and Midge Palley
Stephen and Yana Peel
Daniel and Elizabeth Peltz
Catherine Petitgas
Franck Petitgas
Barrie and Emmanuel Roman
The Dr Mortimer and Theresa Sackler Foundation
The Sackler Trust
Lily Safra
Stephan Schmidheiny / Daros Collection
Helen and Charles Schwab
London Borough of Southwark
John J Studzinski, CBE
Tate Americas Foundation
Tate Members
Julie-Anne Uggla
Lance Uggla
Viktor Vekselberg
Nina and Graham Williams
Manuela and Iwan Wirth
The Wolfson Foundation
and those who wish to remain anonymous

Tate Modern Benefactors and Major Donors

We would like to acknowledge and thank the following benefactors who have supported

Tate Modern prior to August 2016
acb Gallery
AGC Equity Partners
Raad Zeid Al-Hussein
Fernando Luis Alvarez
The Ampersand Foundation
The Fagus Anstruther Memorial Trust
Artangel
Art Fund
Art Mentor Foundation Lucerne
Arts Council England
Arts and Humanities Research Council
Artworkers Retirement Society
Charles Asprey
The Estate of Mr Edgar Astaire
Roger Ballen
Lionel Barber
The Estate of Peter and Caroline Barker-Mill
Margaret Bear
Corrine Bellow Charity
Big Lottery Fund
Anton and Lisa Bilton
Blavatnik Family Foundation
Bloomberg Philanthropies
Estate of Louise Bourgeois
Frances Bowes
Frank Bowling, Rachel Scott, Benjamin and Sacha Bowling, Marcia and Iona Scott
Pierre Brahm
Ivor Braka Limited
The Estate of Dr Marcella Louis Brenner
Rory and Elizabeth Brooks Foundation
The Estate of Mrs KM Bush
Jamal Butt
Mr and Mrs Nicolas Cattelain
Trustees of the Chantrey Bequest
The Chaplaincy to the Arts and Recreation in North East England, Durham
CHK Charities Limited
Radhika Chopra and Rajan Anandan
The Clore Duffield Foundation
The Clothworkers' Foundation
R and S Cohen Foundation
Steven Cohen
Sadie Coles Gallery
Pilar Corrias Gallery
Douglas S Cramer
Abraham Cruzvillegas
Dimitris Daskalopoulos
Sir Mick and Lady Barbara Davis
Mrs Tiqui Atencio Demirdjian
Department for Business, Innovation and Skills
Department for Culture, Media and Sport
The Estate of F N Dickins
Braco Dimitrijevic
James Diner
Anthony d'Offay
Peter Doig
The Easton Foundation
Carla Emil and Richard Silverstein
Tracey Emin
European Union
The Estate of Maurice Farquharson
The Estate of Mary Fedden and Julian Trevelyan
Wendy Fisher
Eric and Louise Franck

Freelands Foundation
The Estate of Lucian Freud
Frith Street Gallery
Froehlich Foundation, Stuttgart
Gagosian Gallery
Gaia Art Foundation, UK
Laura Gannon
Adrian Ghenie
The Hon HMT Gibson's Charitable Trust
The Giles Family
Estate of Kaveh Golestan
Nicholas and Judith Goodison
Marian Goodman Gallery
Antony Gormley
Lydia and Manfred Gorvy
Noam Gottesman
The Granville-Grossman Bequest
Dr Joana Grevers
Sarah and Gerard Griffin
Guaranty Trust Bank Plc
Calouste Gulbenkian Foundation
Marcus Bury and Sascha Hackel
The Estate of Mr John Haggart
The Hakuta Family
Paul Hamlyn Foundation
The Ray and Diana Harryhausen Foundation
Hauser & Wirth
Barbara Hepworth Estate
Heritage Lottery Fund
Mauro Herlitzka
The Hinrichsen Foundation
The Hintze Family Charitable Foundation
Damien Hirst
David Hockney
Trustees of Lord Howard of Henderskelfe's Will Trust
Michael and Ali Hue-Williams
Vicky Hughes and John A Smith
Huo Family Foundation (UK) Limited
Bernard Huppert
Institut français
Iran Heritage Foundation
The J Isaacs Charitable Trust
IV.O Foundation
Jabre Capital Partners SA Geneva
JPI Cultural Heritage
Kikuji Kawada
Dr Martin Kenig
J Patrick Kennedy and Patricia A Kennedy
David Knaus
Leon Kossoff
Andreas Kurtz
Mary Lambert
The Estate of Jay and Fran Landesman
The New York Community Trust AB/Avi and Maya Lavi Fund
The Leathersellers' Company Charitable Fund
The Leche Trust
Agnès and Edward Lee
Legacy Trust UK
The Leverhulme Trust
Ruben Levi
Dominique Lévy
The Henry Luce Foundation
LUMA Foundation
Mace Foundation

Simon A Mackintosh
The Manton Foundation
Rebecca Marks
Danica and Eduard Maták
David Mayor
Lord McAlpine of West Green
Fergus McCaffrey
The Estate of Deborah Jane Medlicott
Andrew W Mellon Foundation
Paul Mellon Centre For Studies In
British Art
Sir Geoffroy Millais
Mondriaan Fund, Amsterdam
Henry Moore Foundation
Elisabeth Murdoch
National Heritage Memorial Fund
Andrew Nikou Foundation
Simon Norfolk
Averill Ogden and Winston Ginsberg
Outset Contemporary Art Fund
Pace Gallery
The Pasmore Estate
Yana Peel
Mr Jan-Christoph Peters
Catherine Petitgas
Clive Phillpot
The Stanley Picker Trust
The Estate of R V Pitman
The Pivovarov Family
The Porter Foundation
Mr Thibault Poutrel
Gilberto Pozzi
Massimo Prelz Oltramonti
Andrey Prigov
Emilio Prini
Qatar Museums Authority
Anthony Reynolds
Michael Ringier
The Estate of Michael Brinley
Holmes Roberts
Matthew Orr and Sybill Robson Orr
Valeria Rodnyansky
Barrie and Emmanuel Roman
The Estate of Eugene and Penelope
Rosenberg
Judko Rosenstock and Oscar Hernandez
Edward Ruscha
The Estate of Simon Sainsbury
Muriel and Freddy Salem
Julião Sarmento
John Schaeffer
Jake and Hélène Marie Shafran
Stephen Shore
Uli and Rita Sigg
Keren Souza Kohn, Francesca Souza
and Anya Souza
Sterling Ruby Studio
Mercedes and Ian Stoutzker
Galeria Luisa Strina
Swiss Arts Council Pro Helvetia
Tate 1897 Circle
Tate Africa Acquisitions Committee
Tate Americas Foundation
Tate Asia-Pacific Acquisitions Committee
Tate International Council
Tate Latin American Acquisitions

Committee
Tate Members
Tate Middle East and North Africa
Acquisitions Committee
Tate North American Acquisitions
Committee
Tate Outreach Appeal
Tate Patrons
Tate Photography Acquisitions Committee
Tate Russia and Eastern Europe Acquisitions
Committee
Tate South Asia Acquisitions Committee
The Taylor Family Foundation
Terra Foundation for American Art
The Estate of Mr Nicholas Themans
Phillip Trevelyan
Hiromi Tsuchida
Luc Tuymans
Cy Twombly Foundation
V-A-C Foundation
Vitra Design Foundation
Marie-Louise von Motesiczky
Charitable Trust
Alexa Waley-Cohen
Anthony Whishaw
Jane and Michael Wilson
Wolfgang Wittrock
The Lord Leonard and Lady Estelle
Wolfson Foundation
The Estate of Mrs Monica Wynter
Yuz Foundation
The Zabludowicz Collection
The Estate of Mr Anthony Zambra
and those who wish to remain anonymous

The 1897 Circle
Marilyn Bild
David and Deborah Botten
Geoff Bradbury
Charles Brett
Sylvia Carter
Eloise and Francis Charlton
Mr and Mrs Cronk
Alex Davids
Jonathan Davis
Professor Martyn Davis
Sean Dissington
Ronnie Duncan
Joan Edlis
V Fabian
Lt Cdr Paul Fletcher
Mr and Mrs RN and MC Fry
Richard S Hamilton
LA Hynes
John Janssen
Dr Martin Kenig
Isa Levy
Jean Medlycott
Susan Novell
Martin Owen
Simon Reynolds
Dr Claudia Rosanowski
Ann M Smith
Graham Smith
Deborah Stern
Jennifer Toynbee-Holmes

Estate of Paule Vézelay
D von Bethmann-Hollweg
Audrey Wallrock
Professor Brian Whitton
Simon Casimir Wilson
Andrew Woodd
Mr and Mrs Zilberberg
and those who wish to remain anonymous

Tate Modern Corporate Supporters
Bank of America Merrill Lynch
Bloomberg
BMW
Christie's
Credit Suisse
Deutsche Bank AG
EY
Hildon Ltd
Hyundai Card
Hyundai Motor
IHS Markit
Kvadrat
Laurent Perrier
Qantas
Solarcentury
Sotheby's
Tiffany & Co.
Uniqlo
and those who wish to remain anonymous

Tate Modern Corporate Members
Allen & Overy LLP
Ashmore Group
Bank of America Merrill Lynch
BCS Consulting
Bloomberg
Citi
Clifford Chance LLP
The Cultivist
Deutsche Bank AG London
Dow Jones
EY
Finsbury
Holdingham Group
HSBC
Hyundai Card
Imperial College Healthcare Charity
JATO Dynamics
Kingfisher plc
Linklaters
Macfarlanes LLP
Max Fordham
McGuire Woods London LLP
Milbank, Tweed, Hadley & McCloy LLP
The Moody's Foundation
Morgan Stanley
Oliver Wyman
Otis Elevator Company
QBE
Saatchi & Saatchi
Siegel + Gale
Slaughter and May
Tishman Speyer
Wolff Olins
and those who wish to remain anonymous

...shed 2017 by order of the Tate Trustees
... Publishing, a division of Tate Enterprises Ltd,
...illbank, London SW1P 4RG
www.tate.org.uk/publishing

on the occasion of the exhibition
Wolfgang Tillmans: 2017
Tate Modern, London
14 February – 11 June 2017

The exhibition is sponsored by Hyundai Card

With additional support from Tate International Council and Tate Patrons

A catalogue record for this book is available from the British Library

ISBN 978 1 84976 445 2

Distributed in the United States and Canada by ABRAMS, New York

Library of Congress Control Number applied for

Designed by Wolfgang Tillmans and Paul Hutchinson
Additional assistance by Armin Lorenz Gerold
Editorial assistance by Jennifer Hope Davy and Shahin Zarinbal
Repro photography by Sarah Bohn, Dan Ipp and Samuel Jeffery
Typesetting by Anne-Katrin Ahrens

Colour reproduction by Hausstätter Herstellung, Berlin
Printed and bound in Italy by Industria Grafica SI.Z. S.r.l

Front cover: Wolfgang Tillmans, Greifbar 29 (Tangible 29), 2014
Back cover: Wolfgang Tillmans, still life, Calle Real, II, 2014
Frontispiece: Wolfgang Tillmans, Faltenwurf (skylight), 2009
Images on pp.2, 4, 6 and 8: Lighter, orange blue I, 2011; Lighter, yellow up I, 2010; Lighter, green IV, 2010 and Lighter, blue up IX, 2013
Photo of Wolfgang Tillmans on p.311: Carmen Brunner, 2013
Installation views on pp.230, 237 and 242: © Wolfgang Tillmans, Courtesy Regen Projects, Los Angeles
Installation view on p.176 of Greer Lankton, Between Bridges, Berlin, 2015, photo: Stefan Korte
Book for Architects on pp.288–99 kindly lent by Collection Niedersächsische Sparkassenstiftung at Sprengel Museum Hannover to be part of the exhibition *Wolfgang Tillmans: 2017* at Tate Modern

MIX
Paper from
responsible sources
FSC® C130819